SUPE

ANDREW BOLTON

HEI

THE **METROPOLITAN** MUSEUM OF ART, NEW YORK

FASHION A

ER

WITH AN ESSAY BY MICHAEL CHABON

ROES

YALE UNIVERSITY PRESS, NEW HAVEN AND LONDON

D FANTASY

This volume is published in conjunction with the exhibition
"Superheroes: Fashion and Fantasy" held at The Metropolitan
Museum of Art, New York, from May 7 to September 1, 2008.

The exhibition and its accompanying book are made possible by

GIORGIO ARMANI

Additional support is provided by

CONDÉ NAST

Published by The Metropolitan Museum of Art, New York
John P. O'Neill, Publisher and Editor in Chief
Gwen Roginsky, General Manager of Publications
Joan Holt, Editor
Paula Torres and Christopher Zichello, Production Managers

Abbott Miller and Johnschen Kudos, Pentagram, book design
Color separations by Professional Graphics Inc., Rockford, Ill.
Printed by Graphicom Srl, Verona, Italy

Cataloging-in-Publication Data is available from the Library of Congress.
ISBN 978-1-58839-279-4 (HC: The Metropolitan Museum of Art)
ISBN 978-1-58839-280-0 (PBK: The Metropolitan Museum of Art)
ISBN 978-0-300-13670-8 (HC: Yale University Press)

FASHION DESIGNERS have always been fascinated by the idea of how clothing can transform the body, and even the perceived character, of the wearer.

In fiction this metamorphosis is the province of the superhero, a character who symbolizes man's desire to go beyond the boundaries of mortal limitations. In this comic-book context, the superhero's ability to do so is always signified by a change of costume.

As a designer who has long been concerned with exploring how body-conscious clothing can enhance our appearance, it gives me great pleasure to partner with The Costume Institute of The Metropolitan Museum of Art in support of "Superheroes: Fashion and Fantasy."

This compelling and timely exhibition explores the relationship between the fashionable body and the superhero body as sites of splendor and seduction. The power of fashion, like the power of the superhero, lies in its ability to transcend the humdrum and commonplace. Fashion and the superhero are bound by whimsy and fantasy, and this exhibition, while a celebration of the fashionable body as well as the superhero body, is ultimately a celebration of the body fantastic.

Fashion, like the superhero, allows you to dream and escape into a world of unfettered imagination.

Giorgio Armani

DIRECTOR'S FOREWORD

"SUPERHEROES: FASHION AND FANTASY" examines the influence on fashion of the costumes of superheroes such as Superman, Batman, Wonder Woman, Catwoman, Captain America, and Spider-Man, as represented in comic books, film, and television. Superman's blue unitard, flowing red cape, and distinctive "S" emblem, Batman's black cape and bat cowl, The Flash's red suit with gold lightning bolt, Wonder Woman's red bustier and star-spangled shorts, not only proclaimed their amazing powers, but they also provoked new designs in avant-garde haute couture, ready-to-wear, and high-performance sportswear. One has only to look at Bernhard Willhelm's T-shirts, featuring the familiar red and yellow "S" emblem, or J.J. Hudson's ensemble with its large black spider symbol on the bodice, to recognize the influential reach of comic-book superheroes on contemporary tastemakers.

"Superheroes" includes movie costumes as well as radical fashions in which designers go beyond iconography to explore issues of identity, sexuality, and patriotism. As Andrew Bolton has noted, "Fashion shares with the superhero an inherent metaphorical malleability that fuels its fascination with the idea and ideal of the superhero." Thus the visitor will not be surprised to find the Thierry Mugler motorcycle bustier, with its polychrome handlebars and side-view mirrors evoking Ghost Rider, or the "Airplane" dress by Hussein Chalayan, with its battery-operated flaps referencing the streamlined aero-dynamics of The Flash. Along more practical lines is a selection of skintight sportswear of the type used by skiers, skaters, and swimmers, all derived from the superhero's iconic bodysuit.

The exhibition has been organized by Andrew Bolton, curator of The Costume Institute, with the support of Harold Koda, curator in charge. Nathan Crowley, a production designer of films, including *Batman Begins* and the upcoming *The Dark Knight*, is the exhibition's creative consultant. Andrew Bolton has also provided the texts for this catalogue. The introductory text, "Second Skin: An Essay in Unitard Theory," is by Michael Chabon, author of *The Amazing Adventures of Kavalier & Clay*, which won the Pulitzer Prize for fiction in 2001.

The exhibition and this accompanying book would not have been possible without the remarkable, if not superheroic, generosity of Giorgio Armani. We must also recognize Condé Nast for their additional support of this project and for their legacy as champion of The Costume Institute.

Philippe de Montebello
Director, The Metropolitan Museum of Art

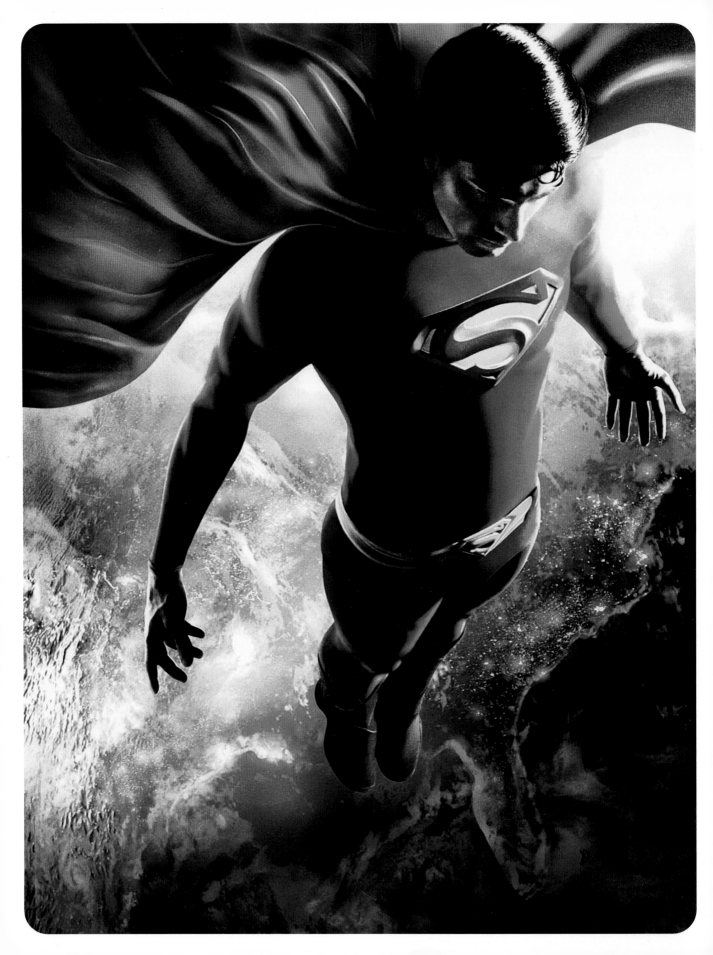

PREFACE

SINCE THE FIRST APPEARANCE of Superman, in 1938, the superhero has exercised a powerful influence over our collective imagination. Like the biblical and mythological heroes who are their lofty ancestors, superheroes have served as avatars of or conduits for our hopes, dreams, and desires. Perhaps because they emerged out of dime novels and pulp magazines and evolved in comic books, superheroes have been dismissed, until relatively recently when they were co-opted by high art, as frivolous and superficial, the trifling fantasies of childhood. But superheroes should not be underestimated. Their apparent triviality is the very thing that gives them the ability to address serious issues of merit and worth under the guise of entertainment. It is the subterfuge, like Clark Kent's nerdiness or Bruce Wayne's playboy disaffection, that frees them to respond to and comment upon shifting attitudes toward self and society, toward identity and ideology, simply and directly.

The superhero is most effective as metaphor. Through the successive "Ages" of superhero comics—Golden (1938–56), Silver (1956–71), Bronze (1971–80), Iron (1980–87), and beyond—the superhero has been used to embody through metaphor our social and political realities. At the same time, it has been used to represent concepts reflective of sexuality and corporeality, a fact that is not surprising when one considers that superheroes exemplify idealized, objectified, and hyperbolic visualizations of the human body. As close to physical perfection as is attainable, the superhero body is forever youthful and forever awe inspiring. Constantly redefined and reworked according to popular canons of beauty, superheroes embody the superlative.

Fashion mirrors the superhero's obsessive preoccupation with the ideal body, signaling changes, both subtle and obvious, in prevailing standards of perfection. Moreover, it presents bodily narratives in terms of metaphor and not only shares the superhero's metaphoric malleability, but actually embraces and responds to the particular metaphors that the superhero represents, notably that of power and more specifically that of the power of transformation. Fashion, like the superhero, celebrates metamorphosis, providing unlimited opportunities to remake and reshape the flesh and the self. It offers entrance into another world, a world of grandiose posturings and unfettered imaginings. Through fashion and the superhero, we gain the freedom to fantasize, to escape the banal, the ordinary, and the quotidian. The fashionable body and the superhero body are sites upon which we can project our fantasies, offering a virtuosic transcendence beyond the moribund and utilitarian.

OPPOSITE
Superman Returns, 2006

OVERLEAF
Superman, No. 1, Summer 1939

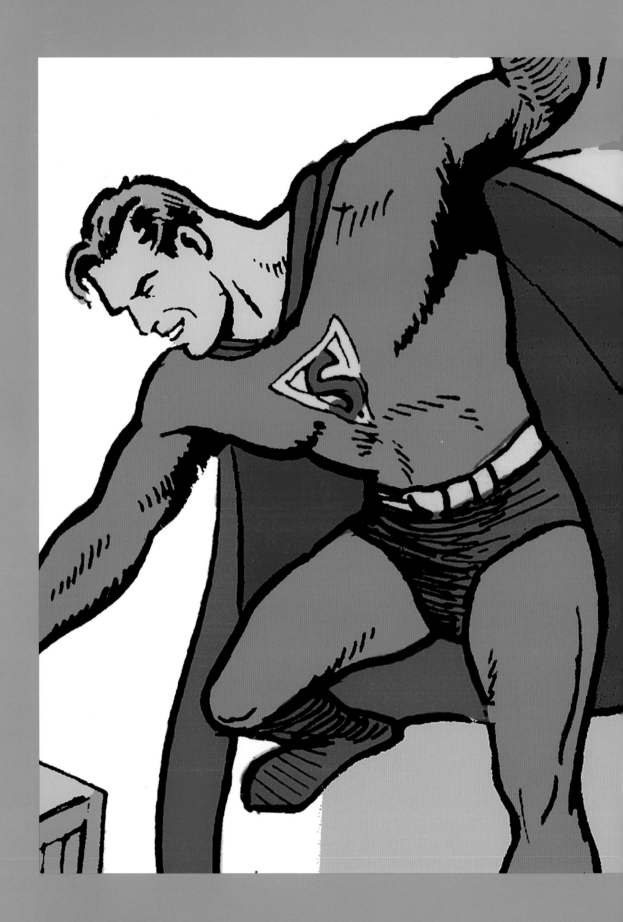

SECRET SKIN

AN ESSAY IN UNITARD THEORY

Michael Chabon

When I was a boy I had a religious-school teacher named Mr. Spector whose job was to confront us with the peril we presented to ourselves. Jewish Ethics, was the name of the class. We must have been eight or nine.

Mr. Spector used a workbook to guide the discussion; every Sunday we began by reading a kind of modern parable or cautionary tale, and then contended with a series of imponderable questions. One day, for example, we discussed the temptations of shoplifting; another class was devoted to all the harm to oneself and to others that could be caused by the telling of lies. Mr. Spector was a gently acerbic young man with a black beard and black roentgen-ray eyes. He seemed to take our moral failings for granted and, perhaps as a result, favored lively argument over engaging in reproach or condemnation. Thus I enjoyed our discussions, while remaining perfectly aloof at my core from the issues they raised. I was, for example, an awful liar, and quite a few times had stolen chewing gum and baseball cards from the neighborhood Wa-Wa store. None of that seemed to have anything to do with Mr. Spector or the cases we studied in Jewish Ethics. All nine-year-olds are sophists and hypocrites; I found it no more difficult than any other to withhold my own conduct from consideration while passing measured judgment on the human race.

The one time I felt my soul to be in danger was the Sunday when Mr. Spector raised the ethical problem of escapism, particularly as it was consumed in the form of comic books. (Who *was* this Mr. Spector, I wonder now, and what lost pedagogy informed his lessons?) That day we started off with a fine story about a boy who loved Superman so much that he tied a red towel around his neck, climbed up to the roof of his house, and leaped with a cry of "Up, up and away" to his death. There was known to have been such a boy, Mr. Spector informed us — at least one verifiable boy, so enraptured and so betrayed by the false dream of Superman that it killed him.

The explicit lesson of the story was that what passed between the covers of a comic book was fantasy, and "fantasy" meant pretty lies, the consumption of which failed sadly to prepare you for what lay outside those covers. Fantasy

rendered you unfit to face "reality" and its hard pavement. Fantasy betrayed you. And thus by implication your wishes, your dreams and longings, everything you carried around inside of your head that only you and Superman and Elliot S! Maggin[1] could understand—all these would betray you, too. There were ancillary arguments to be made, as well, about the culpability of those who produced such fare, sold it to minors, or permitted their own children to bring it into the house.

These arguments were mostly lost on me, a boy who with rapt urgency devoured a dozen comic books a week, all of them cheerfully provided to him by his (apparently iniquitous) father. Sure, I might not be prepared for reality—point granted—but on the other hand if I ever found myself in the Bottle City of Kandor, I would know not to confuse Superman's Kryptonian double (Van-Zee) with Clark Kent's (Vol-Don). Rather, what struck me, with the force of a blow, was recognition, a profound moral recognition of the implicit, indeed the secret premise of the behavior of the boy on the roof. For that fool of a boy had not been doomed by the deceitful power of comic books, which after all were only bundles of paper, staples, and ink, and couldn't hurt anybody. That boy had been killed by the irresistible syllogism of Superman's cape.

One knew, of course, that it was not the red cape, blazoned with a small golden version of the shield on his chest, that gave Superman the ability to fly. That ability derived from the effects of the rays of our yellow sun on Superman's alien anatomy, evolved under the red sun of Krypton. And yet you had only to tie a towel around your shoulders to feel the strange vibratory pulse of flight stirring in the red sun of your heart.

I, too, had climbed to a dangerous height, with my face to the breeze, and felt magically alone of my kind. I had imagined the streak of my passage like a red-and-blue smear on the windowpane of vision. I had been Batman, too, and the Mighty Thor. I had stood cloaked in the existential agonies of the Vision, son of a robot and grandson of a lord of the ants. A few years after that Sunday in Mr. Spector's class, at the pinnacle of my career as a hero of the imagination, I would briefly transform myself (more about this later) into the super-powered warrior-knight known as Aztec. And in every instance all that was ever required in order to effect the change was for me to fasten a terry-cloth beach towel around my neck.

THE SECRET ORIGIN OF UNITARD THEORY

It was not about escape, I wanted to tell Mr. Spector, thus unwittingly plagiarizing in advance the well-known formula of a (fictitious) pioneer and theorist of superhero comics, Sam Clay. It was about *transformation*.

AND THE SECRET ANXIETY OF ORIGIN

It is commonplace to assert the heritage of the costumed heroes of comic books in the misty mythosphere of the ancient world, and it's tempting to view accounts of superhero origins, the sine qua non of the superhero narrative, as proof of that legendary inheritance.[2] Hyperbolic myths of origin have from the mistiest times served to lend a paradoxical plausibility to the biographies of heroes. Baskets found floating in the bullrushes, oracle-doomed infants abandoned on hillsides, babies born with hammers in their hands. Traditional origin myths affirm the constant, even prenatal, presence of the marvelous in the hero's life, of a vein of wonder that marbles it from one end to the other like the words embedded in a stick of Brighton rock candy.

But apart from a marked tendency to orphanhood, the superhero generally disappoints the expectations of mythology. The costumed hero—if not a mutant—is born powerless and unheralded like the rest of us.[3] It takes the bite of a radioactive spider, or some other form of half-disaster (a lab explosion, a brutal act of street violence, a secret government experiment, an emergency transfusion of mongoose blood) to give birth to the hero, who then springs, full-grown like Athena, from the prised-open cranium of everyday life. The superhero works long hours at a day job (even that playboy Bruce Wayne puts in a lot of time at the office) and struggles in every way—legally, socially, emotionally—to fit into the expectations of the quotidian world. The superhero in general has no overt or obligatory sense of destiny and none of the lust for glory and fame and treasure that characterize the classical hero.[4] Superheroes spend a lot of time wishing they could just stay home, hang out with their families and loved ones, date the girl

they love, be like everybody else. They excel because they cannot help it, or because it would be wrong not to, or because they need to prove their worth, or to exonerate themselves, or to repay the debt they feel to society, their parents, the wizard in a subway tunnel who endowed them with magic might. Above all, superheroes have secret identities; they have lives and natures that their pursuit of heroism obliges them to conceal, to downplay, to deny. They cannot engage in the boastful trumpeting of one's name and parentage so beloved among traditional heroes.

It is for this reason, and not out of their legendary heritage in the mythosphere, that the comic-book superhero, the bastard child of newspaper strips and pulp magazines, has always displayed an arriviste fixation on questions and mysteries of origin. The superhero is a parvenu in the house of adventure, an immigrant on the shores of myth.

This general fixation with the origin story[5] goes beyond the particulars of Kryptonian birth or gamma-ray exposure to encompass the origin of the idea of the costumed superhero itself. Fans and historians of comic books (those synonymous creatures) have devoted loving years and pages in the thousands to isolating with some kind of precision the moment and the conditions that led to the birth of the costumed hero. And when they faltered in their efforts, in have strode the psychologists, the critics, the analysts, and, with mixed results, the comic-book writers and artists.

The comic book, which descended from the glorious newspaper strip of the early twentieth century like an ape from an angel, preexisted the superhero, but so barely and with so little distinction that the medium has seemed indistinguishable in the cultural mind from its first stroke of brilliance. There were costumed crime fighters before Superman (the Phantom, Zorro), but only as there were pop quartets before the Beatles. As Proust said, more or less, about great works of literature, Superman invented and exhausted his genre in a single bound. All the tropes, all the clichés and conventions, all the possibilities, all the longings and wishes and neuroses that have driven and fed and burdened the superhero comic over the past seventy years were implied by and contained within that little red-and-blue rocket ship hurtling toward Earth. That moment—Krypton exploding, *Action Comics* No. 1—is generally seen to be minute zero of the superhero idea.

About the reasons for the arrival of Superman at that moment there is less agreement. In the theories of origin put forward by fans, critics, and other origin-obsessives, the idea of Superman has been accounted the offspring or recapitulation, in no particular order, of Friedrich Nietzsche; of Philip Wylie (in his novel *Gladiator*); of the strengths, frailties, and neuroses of his creators, Jerry Siegel and Joe Shuster of Cleveland, Ohio; of the aching wishfulness of the Great Depression; of the (Jewish) immigrant experience; of the mastermind stratagems of popular texts in their sinister quest for reader domination; of repressed Oedipal fantasies and homoerotic wishes; of fascism; of capitalism; of the production modes of mass culture (and not in a good way); of celebrated strongmen and proponents of physical culture like Eugene Sandow; and of a host of literary not-quite-Supermans (chief among them Doc Savage) who preceded him.

Most of these rationales of origin depend, to some extent, on history; they index the advent of Superman in late 1938 to various intellectual, social, and economic trends of the Depression years, to the influence or aura of contemporary celebrities and authors, to the structure and demands of magazine publishing and distribution, et cetera. To suit my purpose here I might construct a similar etiology of the superhero costume, making due reference, say, to professional wrestling and circus attire of the early twentieth century, to the boots-cloak-and-tights ensembles worn by swashbucklers and cavaliers in stage plays and Hollywood films, to contemporary men's athletic wear, with its unitard construction and belted trunks, to the designs of Alex Raymond and Hal Foster and the amazing pulp-magazine cover artist Frank R. Paul. I could cite the influence of Deco and Streamline aesthetics, with their roots in fantasies of power, speed, and flight, or posit the costume as a kind of fashion alter ego of the heavy, boxy profile of men's clothing at the time.

Thus while claiming, on the one hand, a dubiously ahistorical, archetypal source for the superhero idea in the Jungian vastness of legend, we dissolve its true universality in a foaming bath of periodized explanations, and render the superhero and his costume a time-fixed idea that is always already going out of fashion. In fact the point of origin is not a date or a theory or a conjunction of cultural trends but a story, the intersection of a wish and the tip of a pencil.

Now the time has come to propose, or confront, a fundamental truth: like the being who wears it, the superhero costume is, by definition, an impossible object. It cannot be.

One may easily find evidence for this claim at any large comic-book convention by studying the spectacle of the brave and bold convention attendees, those members of the general comics-fan public who show up in costume and go *shpatziring* around the ballrooms and exhibition halls dressed as Wolverine, say, or the Joker's main squeeze, Harley Quinn. Without exception even the most splendid of these get-ups is at best a disappointment. Every seam, every cobweb strand of duct-tape gum, every laddered fishnet stocking or visible ridge of underpants elastic — every stray mark, pulled thread, speck of dust — acts to spoil what is instantly revealed to have been, all along, an illusion.

The appearance of realism in a superhero costume made from real materials is generally recognized to be difficult to pull off, and many such costumes do not even bother to simulate the presumable effect on the eye and the spirit of the beholder were Black Bolt to stride, trailing a positronic lace of Kirby crackle, into the Shawnee Ballroom of the Overland Park Marriott. In part, then, this disappointing air of saggy trouser seats, bunchy underarms, and wobbly shoulder vanes may be the result of imaginative indolence, the sort that would permit a grown man to tell himself he will find gratification in walking the exhibition floor wearing a pair of Dockers, a Jägermeister hoodie, and a rubber Venom mask complete with punched-out eyeholes and flopping rubber bockwurst of a tongue.

But realism is not, in fact, merely difficult; it is hopeless. A plausibly heroic physique — rarely as it may be found among us convention-goers — is of no avail in this regard nor, cruelly, is even the most fervent willingness to believe in oneself as the man or woman in the cape. Even those costumed conventioneers who go all out, working year round to amass, scrounge, or counterfeit cleverly the materials required to put together, with glue gun, soldering iron, makeup, needle and thread, an accurate Black Canary or Ant-Man costume, find themselves prey to forces, implacable as gravity, of tawdriness, gimcrackery, and unwitting self-

ridicule. And in the end they look no more like Black Canary or Ant-Man than does the poor *zhlub* in the Venom mask with a three-day pass hanging around his neck.

This sad outcome even in the wake of thousands of dollars spent and months of hard work given to sewing and to packing foam rubber into helmets has an obvious, an unavoidable explanation: A superhero's costume is constructed not of fabric, foam rubber or adamantium but of halftone dots, Pantone color values, inked containment lines, and all the cartoonist's sleight of hand. The superhero costume *as drawn* disdains the customary relationship in the fashion world between sketch and garment. It makes no suggestions. It has no agenda. Above all it is not waiting to find fulfillment as cloth draped on a body. A constructed superhero costume is a replica with no original, a model built on a scale of x:1. However accurate and detailed, such a work has the tidy airlessness of a model train layout but none of the gravitas such little railyards and townscapes derive from making faithful reference to homely things. The graphic purity of the superhero costume means that the more effort and money you lavish on fine textiles, metal grommets, leather trim, the deeper your costume will be sucked into the silliness singularity that swallowed, for example, Joel Schumacher's Batman and Robin and their four nipples.

In fact the most reliable proof of the preposterousness of superhero attire whenever it is translated, as if by a Kugelmass device, from the pages of comics to the so-called real world, can be found in film and television adaptations of superhero characters. George Reeves's stodgy pajama-like affair in the old *Superman* TV series, and Adam West's go-go doll clothes from *Batman* have lately given way to purportedly more "realistic" versions in rubber, leather, and plastic, pseudo-utilitarian coveralls that draw inspiration in equal measure from spacesuits, catsuits, scuba suits, and from (one presumes) regard for the dignity of actors who have seen the old George Reeves and Adam West shows and would not be caught dead. In its attempts to slip the confines of the paneled page the superhero costume betrays its nonexistence, like one of those deep-sea creatures that evolved to thrive in the crushing darkness of the benthos, so that when you haul them up to the dazzling surface they burst.

One might go farther and argue not only that the superhero costume has (and needs) no referent in the world of textiles and latex but also that, even within its own proper comic-book context, it can be said not to exist, not to *want* to exist—can be said to advertise, even to revel in, its own notional status. This illusionary quality of the drawn costume can readily be seen if we attempt to delimit the elements of the superhero wardrobe, to inventory its minimum or requisite elements.

THE SILVER GLUTEAL CLEFT OF THE SPACEWAYS

We can start by throwing away our masks. Superman, arguably the first and the greatest of all costumed heroes, has never bothered with one, nor have Captain Marvel, the Human Torch, Wonder Woman, the Mighty Thor, Storm, or Supergirl. All of those individuals, like many of their peers (Hawkman, Giant-Man), go around barehanded, which suggests that we can also safely dispense with our gauntlets (whether finned, rolled, or worn with a jaunty slash at the cuff). Capes have been an object of scorn among discerning superheroes at least since 1974, when, having abandoned his old career as an act of protest over Vietnam and Watergate, Captain America briefly took on the nom de guerre of Nomad, dressed himself in a piratical ensemble of midnight blue and gold, and brought his first exploit as a stateless hero to an inglorious end by tripping over his own flowing cloak.[6]

So let's lose the cape. As for the boots—we are not married to the boots. After all, Iron Fist sports a pair of kung-fu slippers, the Spirit wears black brogues, Zatanna works her magic in stiletto heels, and the Beast, Ka-Zar, and Mantis wear no shoes at all. Perhaps, though, we had better hold onto our unitards, crafted of some nameless but readily available fabric that, like a thin matte layer at once coats and divulges the splendor of our musculature. Assemble the collective, all-time memberships of the Justice League (and Society) of America, the Avengers, the Defenders, the Invaders, the X-Men, and the Legion of Superheroes (let us not forget the Legion of Substitute Heroes), and you will probably find that almost all of them, from Nighthawk to the Chlorophyll Kid, arrive wearing some version

of the classic leotard-tights ensemble. And yet—not everyone. Not Wonder Woman, in her star-spangled hot pants and WPA bustier; not the Incredible Hulk or Martian Manhunter or the Sub-Mariner.

Consideration of the last-named leads us to cast a critical eye, finally, on our little swim trunks, worn typically with a belt, pioneered by Kit Walker,[7] the Phantom of the old newspaper strip, and popularized by the supertrendsetter of Metropolis. The Sub-Mariner wears nothing but a Eurotrashy green Speedo, suggesting that, at least by the decency standards of the old Comics Code, this minimal garment marks the zero degree of superheroic attire. And yet of course The Flash, Green Lantern, and many others make do without trunks over their tights; the eschewal of trunks in favor of a continuous flow of fabric from legs to torso is frequently employed to lend a suggestion of speed, sleekness, a kind of unadorned modernism. And the Hulk never goes around in anything but those tattered purple trousers.

So we are left with, literally, nothing at all: the human form, unadorned, smooth, muscled, and ready, let's say, to sail the starry ocean of the cosmos on the deck of a gleaming surfboard. A naked spacefarer, sheathed in a silvery pseudoskin that affords all the protection one needs from radiation and cosmic dust while meeting Code standards by neatly neutering the wearer, the shining void between the legs serving to signify that one is not (as one often appears to be when seen from behind) naked as an interstellar jaybird.

Here is a central paradox of superhero attire: from panther black to lantern green, from the faintly Hapsburg pomp of the fifties-era Legion of Superheroes costumes to the *Mad Max* space-grunge of Lobo, from sexy fishnet to adamantium; for all the mad recombinant play of color, style, and materials that the superhero costume makes with its limited number of standard components, ultimately it takes its deepest meaning and serves its primary function in the depiction of the naked human form, unfettered, perfect, and free. The superheroic wardrobe resembles a wildly permutated alphabet of ideograms conceived only to express the eloquent power of silence.

A public amnesia, an avowed lack of history, is the standard pretense of the costumed superhero. From the point of view of the man or woman or child in the street, looking up gape-mouthed at the sky and skyscrapers, the appearance of a new hero over Metropolis or New York or Astro City is always a matter of perfect astonishment. There have been no portents or warnings, and afterward one never learns anything new or gains any explanations.

The story of a superhero's origin must be kept secret, occulted as rigorously from public knowledge as the alter ego, as if it were a source of shame. Superman conceals, archived in the Fortress of Solitude and unvisited by any but him, not only his own history—the facts and tokens of his birth and arrival on Earth, of his Smallville childhood, of his exploits and adventures—but the history of his Kryptonian family and indeed of his entire race. Batman similarly hides his own story and its proofs in the trophy chambers of the Batcave.

In theory, the costume—as different from the dull garb of our former existence as we have become from those abandoned selves—forms a part of the strategy of concealment. But in fact the superhero's costume often functions as a kind of magic screen onto which the repressed narrative may be projected. No matter how well he or she hides its traces, the secret narrative of transformation, of rebirth from the confines of the ordinary, is given up by the costume. Sometimes this secret is betrayed through the allusion of style or form: Robin's gaudy uniform hints at the murder of his circus-acrobat parents; Iron Man's at the flawed heart that requires a life-support device, which is the primary function of his armor.

More often the secret narrative is hinted at with a kind of enigmatic, dreamlike obviousness right on the hero's chest or belt buckle, in the form of the requisite insignia. Superman's "S" shield, we have been told, only coincidentally stands for Superman: in fact the emblem is the coat of arms of the ancient Kryptonian House of El from which he descends. A stylized bat alludes to the animal whose chance flight through an open window sealed Bruce Wayne's fate; a lightning bolt encapsulates the secret history of Captain Marvel; an eight-legged

glyph immortalizes the bug whose bite doomed Peter Parker to his glorious and woebegone career.

We say "secret identity," and adopt a series of cloaking strategies to preserve it; but what we are actually trying to conceal is a narrative; not who we are, but the story of how we got that way — and, by implication, of all that we lacked, and all that we were not, before the spider bit us. And yet at the same time, as I have suggested, our costume conceals nothing, reveals everything: it is our secret skin, exposed and exposing us for all the world to see. Superheroism is a kind of transvestism; our superdrag serves at once to obscure the exterior self that no longer defines us while betraying, with half-unconscious panache, the truth of the story we carry in our hearts, the story of our transformation, of our story's recommencement, of our rebirth into the world of adventure, of the story itself.

MY SECRET ORIGIN

I became Aztec in the summer of 1973, in Columbia, Maryland, a planned suburban utopia halfway between Smallville and Metropolis. It happened while I was on my way to our neighborhood swimming pool in the company of a friend. My friend had on a pair of solid, dark blue bathing trunks; mine had patches of pink, orange, gold, and brown in an abstract pattern that struck us both as somehow Aztec. In those days a pair of bathing trunks did not in the least resemble the baggy board shorts that boys and men wear swimming today. They were made of dense, elastic doubleknit material that barely reached the top of the thigh, and they featured a built-in belt, of stretchy webbing, that buckled at the front with a metal clasp. As we walked along neither of us resembled a costumed superhero in the least, except, perhaps, in our essential loneliness and in our readiness, our aptitude for transformation. But in our belted trunks, with our towels, those enchanted cloaks whose power Mr. Spector had failed to understand or recall, knotted at our throats and fluttering out behind us, my friend and I rose together, talking ourselves up, up and away into the dizzying blue halftone sky.

The cicadas throbbed. The trees seemed to move without moving, as if the Maryland summer were so intense as to force them to oscillate, minutely, between parallel dimensions. My friend and I took no notice. We were too busy being transformed, by the green lantern rays of fancy, by the spider bite of inspiration, by the story we were telling each other and ourselves about two costumed superheroes, Darklord and Aztec, becoming them a little more surely with every step we took. And as that transformation occurred, another one, deeper and even more secret, was taking place: we became the chroniclers of those characters, artist and writer, planning out the stories we were going to tell about the new selves that had been revealed by our secret skin.

Talking, retying the knots of our capes, flip-flops steadily slap-slapping against the bottoms of our feet, it was not only ourselves that we transformed. In the space of that fifteen-minute walk to the pool we also transformed the world, shaping it, as the trees shimmered in the interdimensional blast of Maryland summer heat, into a place in which such things were possible: A reincarnated Arthurian knight, complete with wonder sword, could team up with a reincarnated Aztec knight, knowledgeable in the ancient Mesoamerican martial arts. An entire world of superheroic adventure could be dreamed up by a couple of boys from Columbia, or Cleveland, Ohio. And the self you knew you contained, the story you knew you had inside you, might find its way like an emblem onto the spot right over your heart. All we needed to do was accept the standing invitation that superhero comics extended to us by means of a towel. It was an invitation to enter into the world of story, to join in the ongoing business of comic books, and to begin, with the knotting of a magical beach towel, to wear what we knew to be hidden inside of us.

THE GRAPHIC BODY

Superman, the creation of writer Jerry Siegel and artist Joe Shuster, was the first character to embody the definition of the superhero. Starting with *Action Comics* No. 1, June 1938, he established the principal conventions of the superhero genre, which the scholar Peter Coogan has identified as a heroic character with a prosocial mission, extraordinary powers or abilities, and a code name and costume that usually express his or her origin, powers, and character. Superman's costume, made from the blankets in which he was swaddled on his journey from Krypton to Earth, became the standard upon which successive superheroes were styled. With its flowing cape and skintight unitard, inspired by sources as diverse as the costumes worn by circus acrobats and Douglas Fairbanks in his period pictures of the 1920s, it combined the male fantasies of an idealized classical nudity with a flamboyant, performative intemperance.

Beyond its components, the iconicity of Superman's costume lies in its colors and "S" emblem, both of which serve to abstract and amplify Superman's representation in comics as well as in film and television. The "S" emblem inscribed on his chest and cape functions as a simplified statement of his identity. As the artist Chipp Kidd observed, "The 'S' on Superman's chest is the monogram made monolithic, the family crest as modern logo." Almost every superhero carries a bodily marking that is similarly expressive of his or her character. Some, like Superman, are simply branded with their initials, as is Daredevil, whose costume is stamped with the letters "DD." Others are marked with pictograms that symbolize their code names, such as Spider-Man. Created by writer Stan Lee and artist Steve Ditko, Spider-Man, who made his first appearance on the cover of *Amazing Fantasy* No. 15, August 1962, sports a webbed costume with an insectan ideogram on the front and back that serves to embody his origin story and externalize his spiderlike and spider-derived powers. Just as Superman's costume proclaims him a super man, Spider-Man's costume proclaims him a spider man.

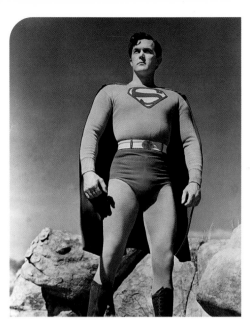

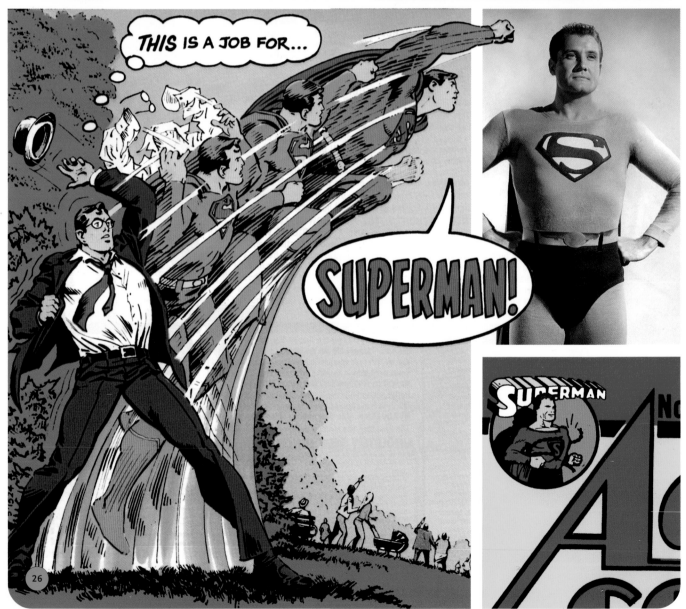

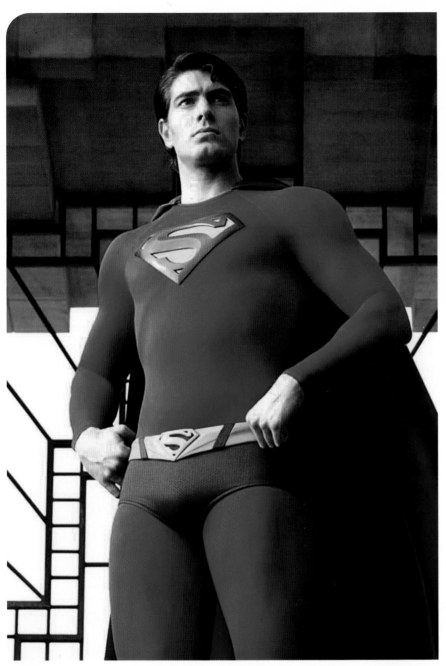

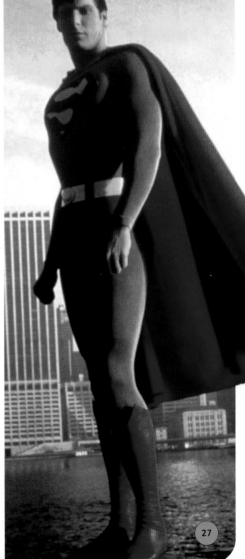

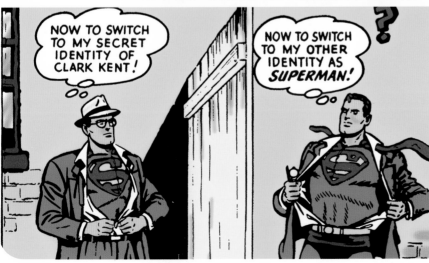

NOW TO SWITCH TO MY SECRET IDENTITY OF CLARK KENT!

NOW TO SWITCH TO MY OTHER IDENTITY AS *SUPERMAN!*

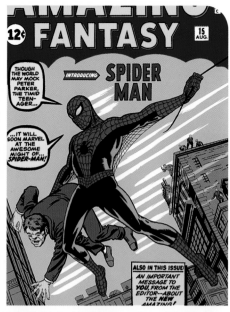
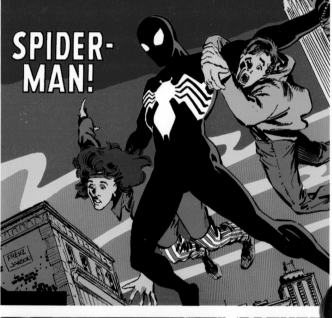
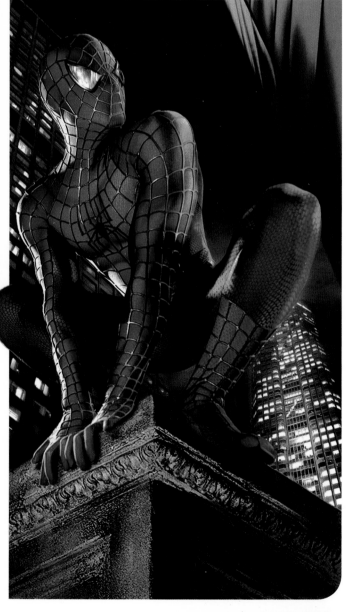
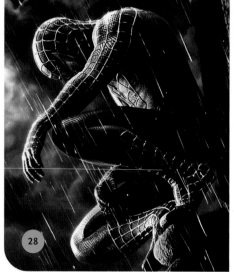

In these postmodern times in which signs and symbols are becoming more and more indeterminate, there is a semiotic specificity to superhero costumes, one that has been exploited by numerous designers. Perhaps because of its iconicity, many are attracted to Superman's "S" emblem, if only as an exercise in iconoclasm. Bernhard Willhelm, in collaboration with the artist Carsten Fock, produced interpretations of the insignia that suggested the hurried handiwork of a graffitist. While Jean-Charles de Castelbajac's treatment of the talisman is more traditional, that of Rossella Jardini for Moschino is typically mischievous. Both designers reference the moment when Clark Kent turns into Superman by ripping off his clothes to reveal his "S" emblem. Jardini, however, has substituted the letter "S" with the letter "M," the design house's logo, and transformed the pentagon into a heart shape, a symbol closely associated with the Moschino label, a wry comment on the cultural currency of the branded body. J.J. Hudson, whose label Noki was established as a critique of mass-produced fashions by creating customized clothing from recycled fashion brands, provided a similar statement with his "Spider-Man" ensemble. Featuring a large black spider symbol on the bodice, and an actual depiction of Spider-Man on the facemask, Hudson extended his critique of depersonalized, homogenous commodities to incorporate the superhero.

So strongly is the spider symbol associated with Spider-Man that even when designers employ it without any direct or deliberate reference to the superhero, he cannot help but be invoked, as in the ensembles by Jun Takahashi for Undercover. The same holds true for decorative webbing, whether rendered by Jean Paul Gaultier with all the skills of the haute couture, or spun from the remarkable imaginations of John Galliano, Giorgio Armani, and Julien Macdonald. In the way it clings to the body like a second skin, Macdonald's ensemble recalls the black Spider-Man costume worn by Tobey Maguire in *Spider-Man 3* (2007). Designed by James Acheson, who also created the more typical red-and-blue costumes worn by Maguire in the previous two films of the Spider-Man franchise, it was based on the "alien" costume first sported by Spider-Man on the cover of *The Amazing Spider-Man* No. 252, May 1984. While the film version differed from its comic-book prototype, most notably in the color of the spider symbol and the addition of webbing, it retained its strong graphic appeal. In fact, Acheson, by adding a webbed pattern to his design, actually enhanced the semiotic potency of the original. Fashion designers also magnify the bravado of superhero costumes in an allusive shorthand. When they cite a symbol associated with a superhero, designers extend the conceptual reach of their designs and deploy the graphic body for its most resonant and evocative power.

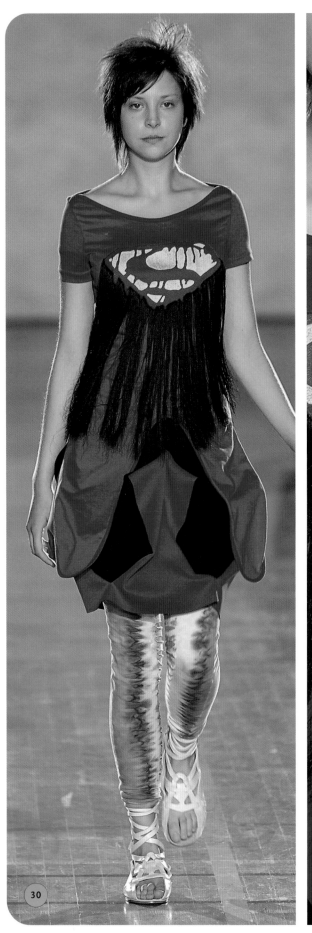

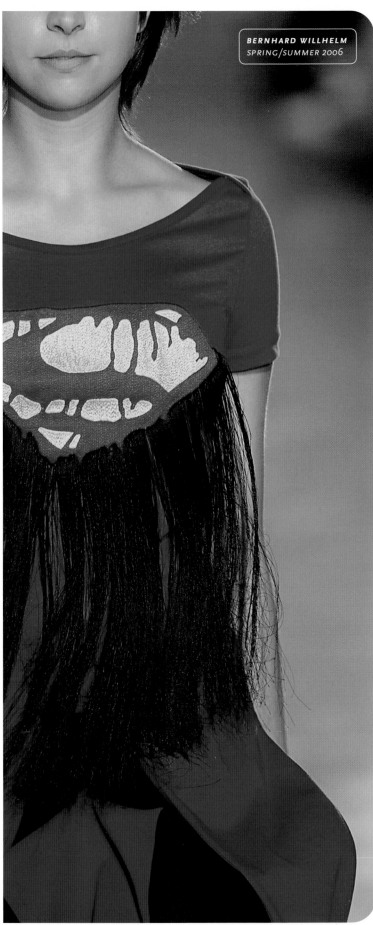

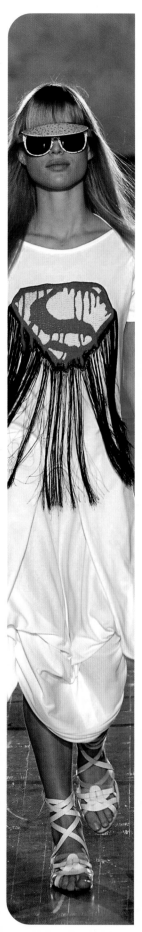
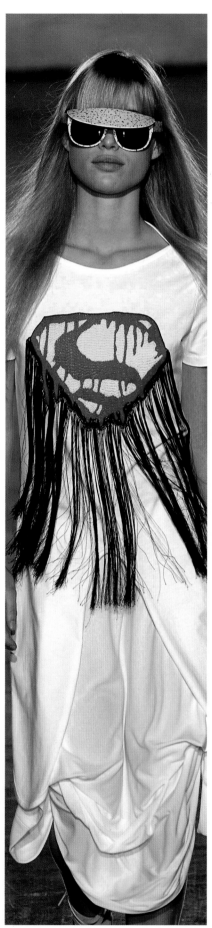
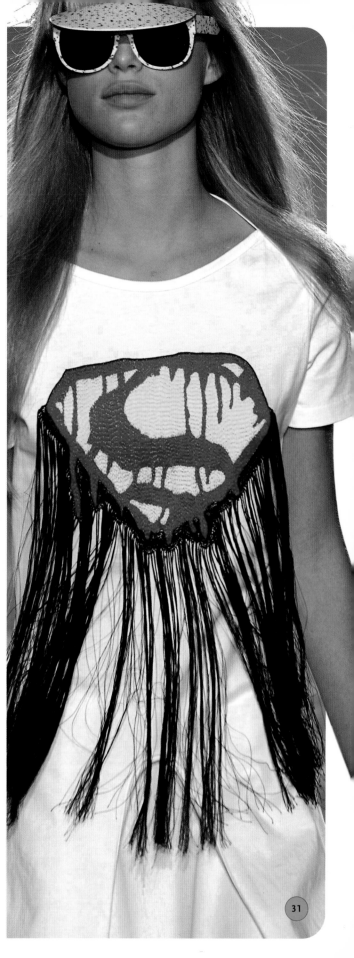

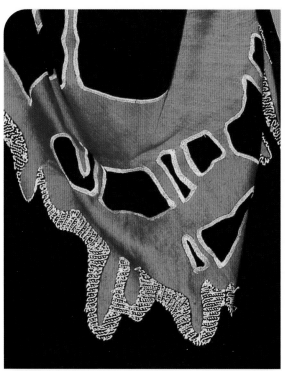

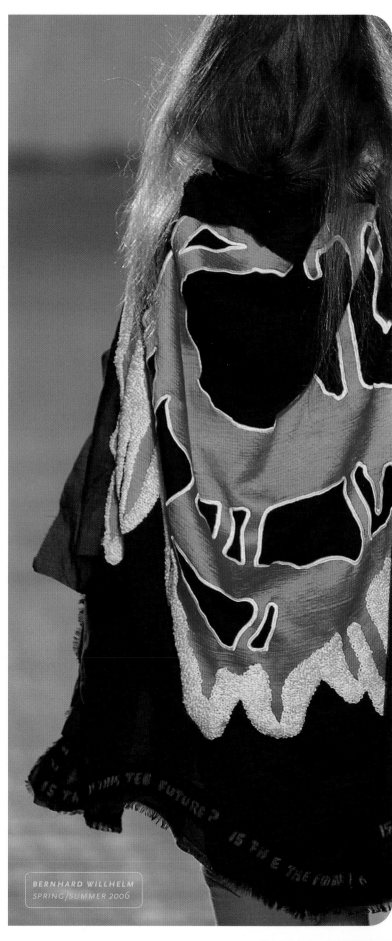

BERNHARD WILLHELM
SPRING/SUMMER 2006

IS THIS THE FUTURE? IS THIS THE FUTURE? IS THIS THE FUTURE?

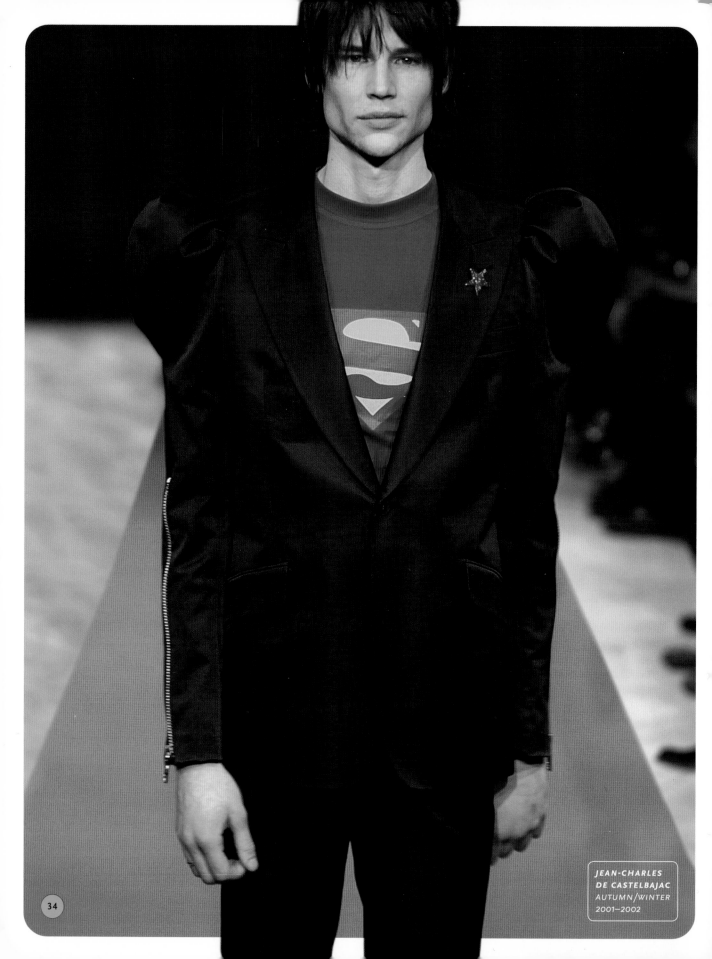

JEAN-CHARLES
DE CASTELBAJAC
AUTUMN/WINTER
2001—2002

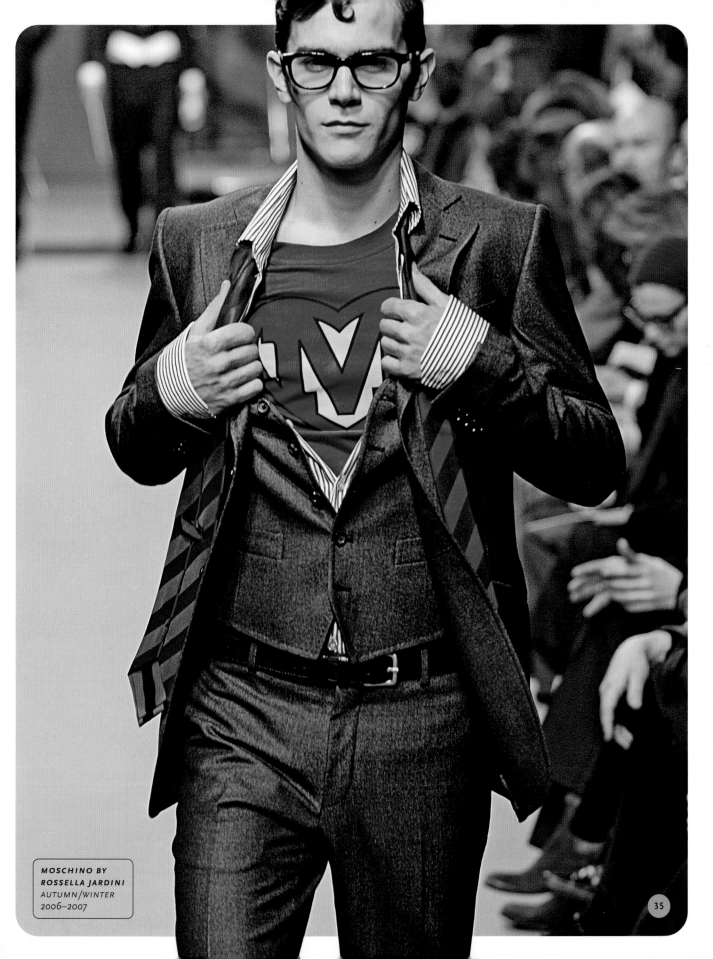

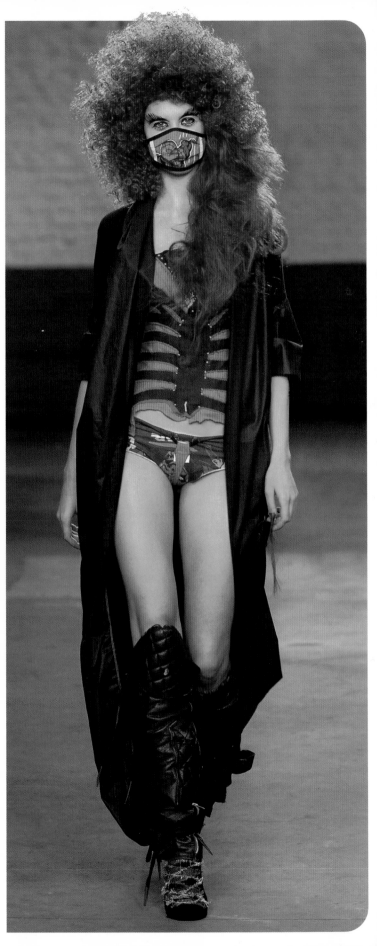

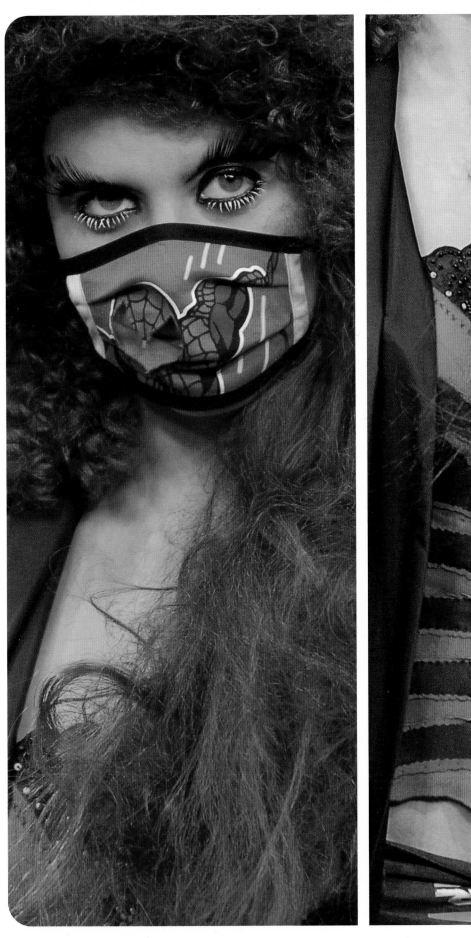

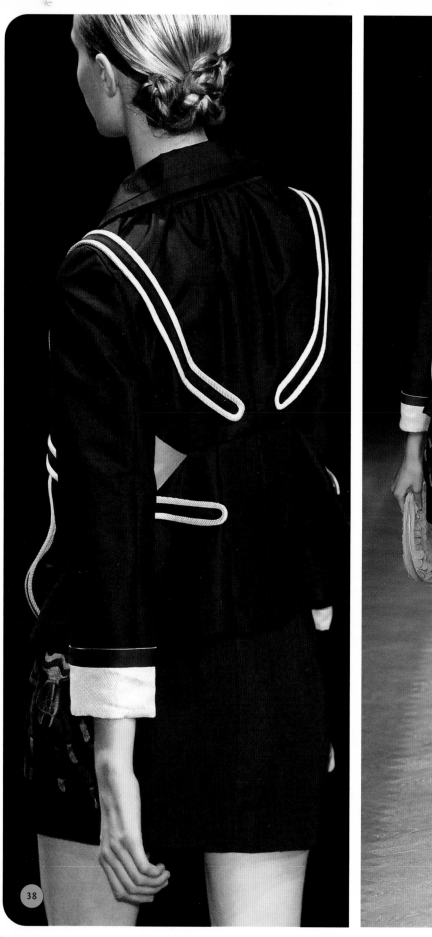
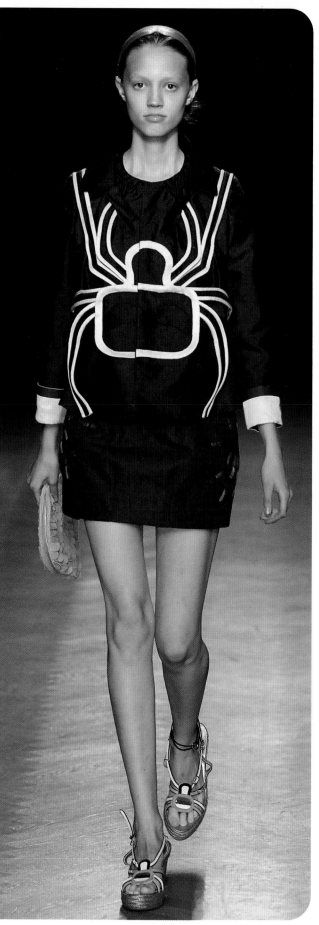

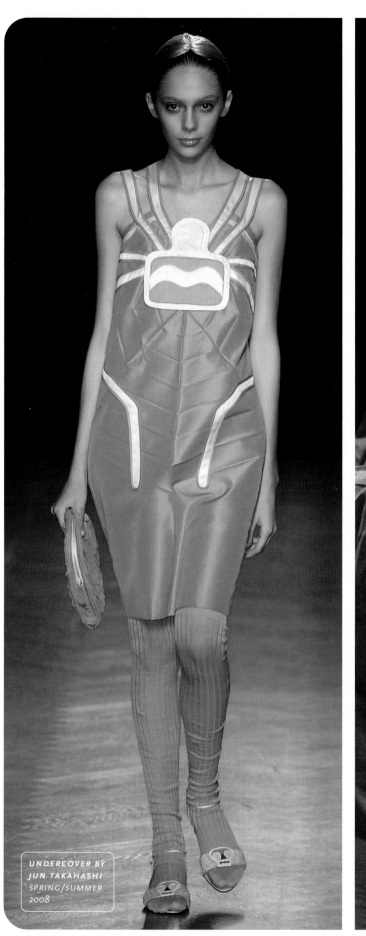

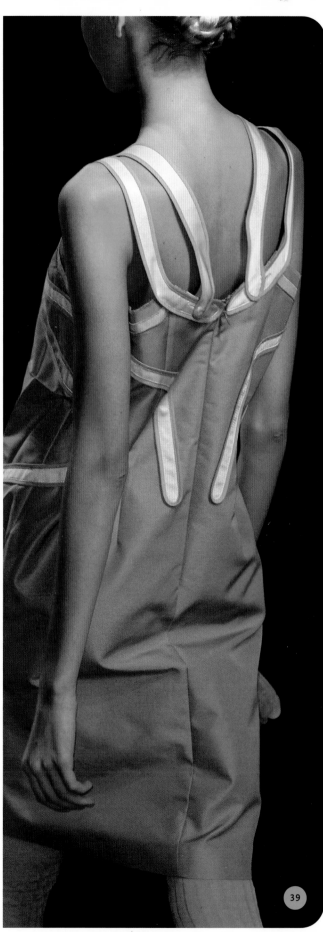

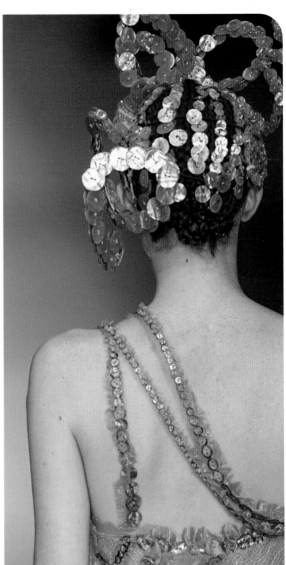

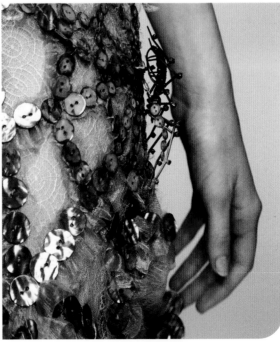

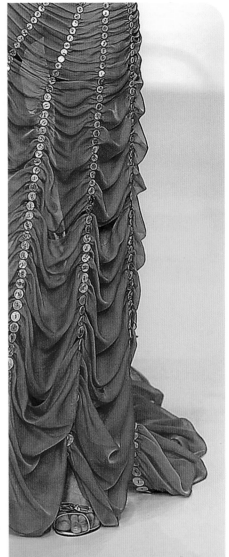

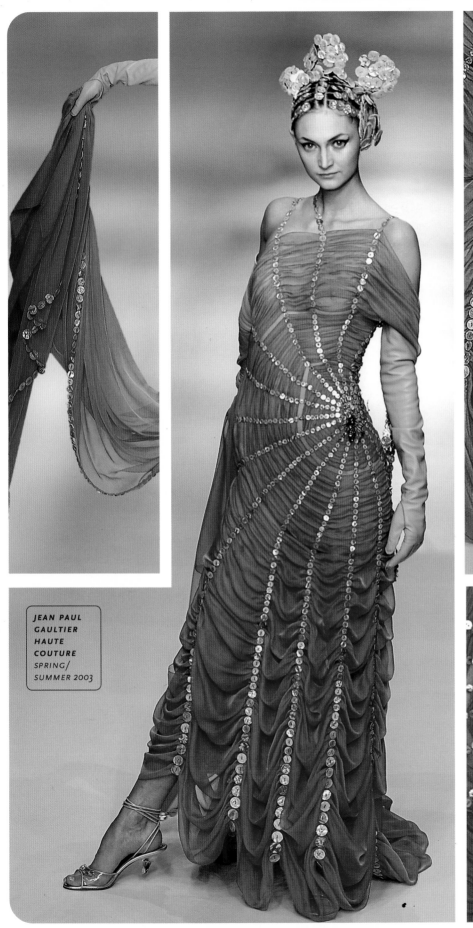

JEAN PAUL
GAULTIER
HAUTE
COUTURE
*SPRING/
SUMMER 2003*

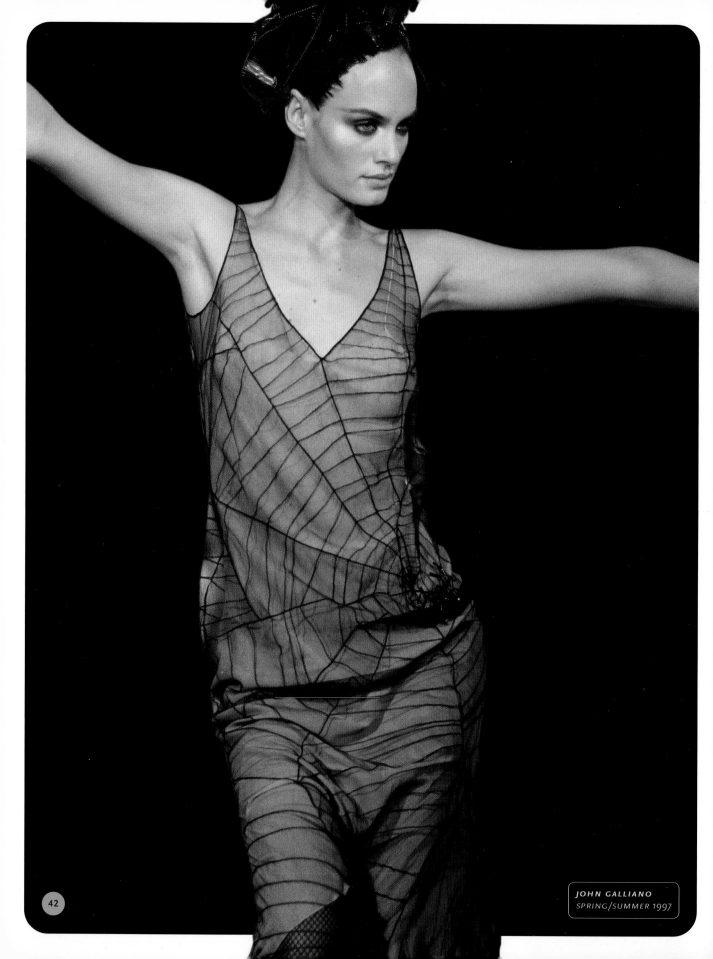

JOHN GALLIANO
SPRING/SUMMER 1997

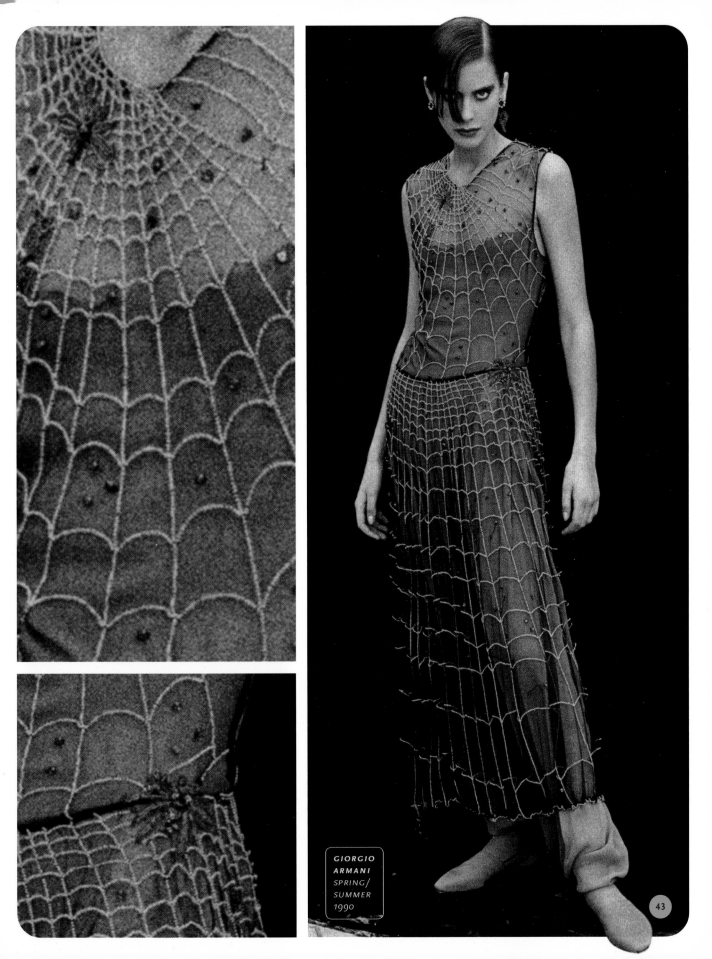

GIORGIO
ARMANI
SPRING/
SUMMER
1990

43

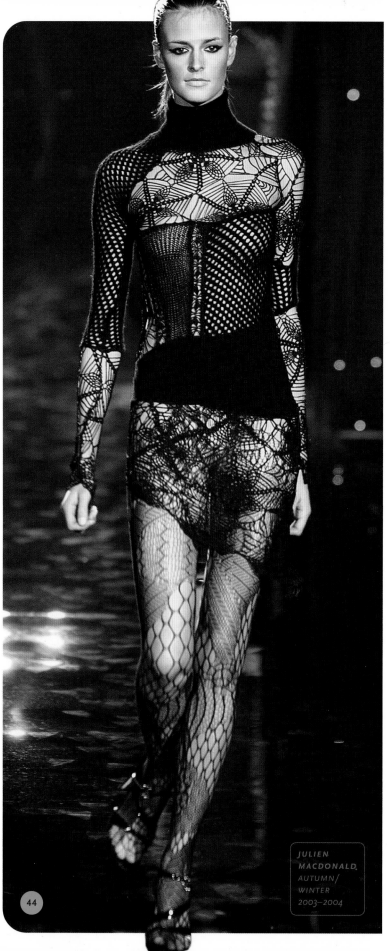

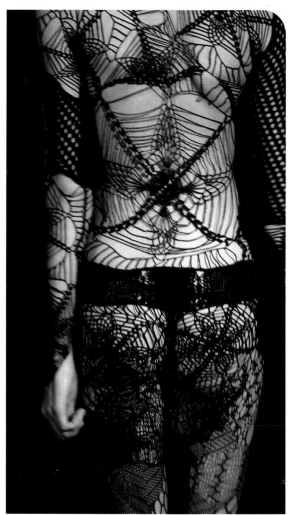

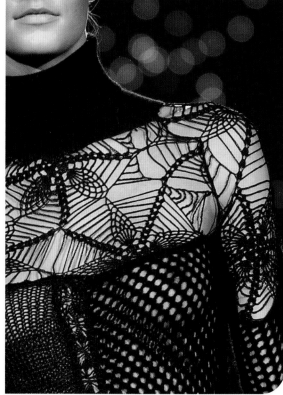

JULIEN
MACDONALD,
AUTUMN/
WINTER
2003–2004

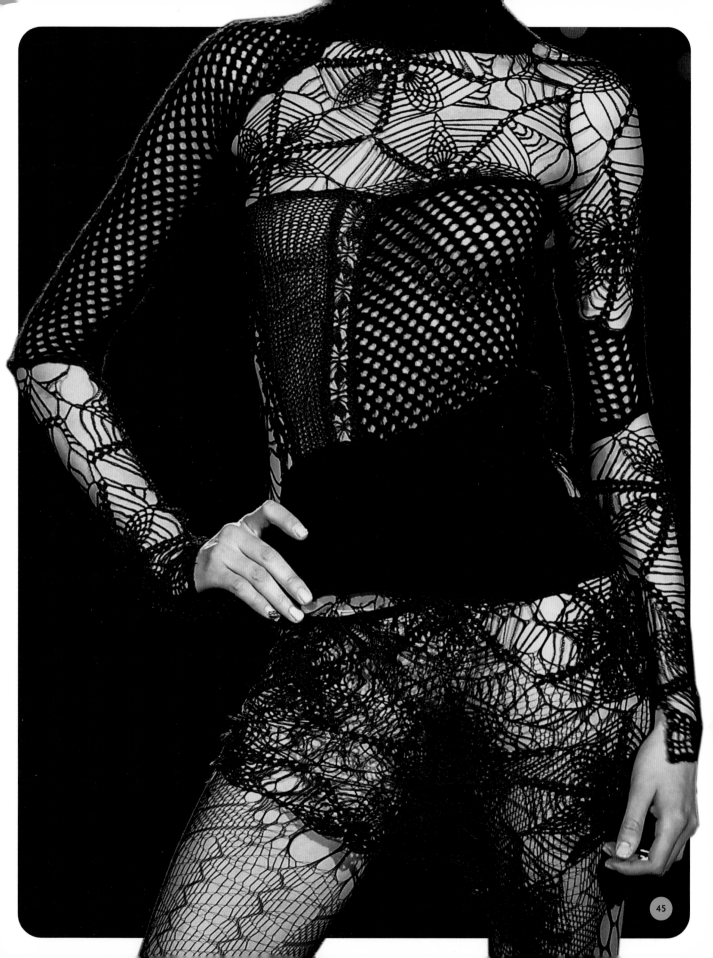

THE PATRIOTIC BODY

Superheroes, like jazz, movies, and baseball, are quintessentially American. Not only do they embody the ideals and values as well as the myths and beliefs of American society, but they also reflect them back in ways that have shaped that society. Since superheroes, by definition, are avatars of law and order, justice and authority, equality and tolerance, they are concerned primarily with the preservation of the social order. In the conflict between good and evil, on which traditional superhero narratives are based, the cause for which comics heroes are enlisted is the good fight, which usually involves upholding American utopianism as expressed in the Declaration of Independence and the Constitution.

Like most pop-culture phenomena, superhero comics both reflect and respond to real-world social and political conflicts. During the Golden Age (1938–56), they responded to World War II by co-opting their heroes to fight fascism. Some, notably Captain America and Wonder Woman, made this fight their entire mission. In his debut on the cover of *Captain America Comics* No. 1, March 1941, Captain America, the creation of writer Joe Simon and artist Jack Kirby, is depicted punching Hitler in the face. Similarly, Wonder Woman, the brainchild of William Moulton Marston, made her cover debut in *Sensation Comics* No. 1, January 1942, against a montage of Washington buildings including the Capitol and the White House. Story after story, both heroes battled the Nazis and the "Japs" (the denigration employed during the war years) with dialogue straight out of Vaudeville. Captain America and Wonder Woman, quite literally, wore their flag-waving fervor on their sleeves. Appropriating and mobilizing the patriotic emotions attendant on their creations, both characters sported red, white, and blue costumes that were composites of the American flag.

Wonder Woman, in her comic-book as well as her television representations, was the point of departure for John Galliano's ensemble for Christian Dior. Consisting of a red-and-white striped jacket and bustier punctuated

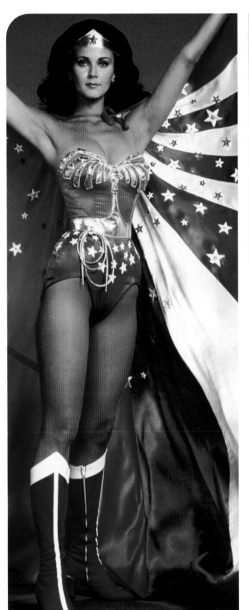

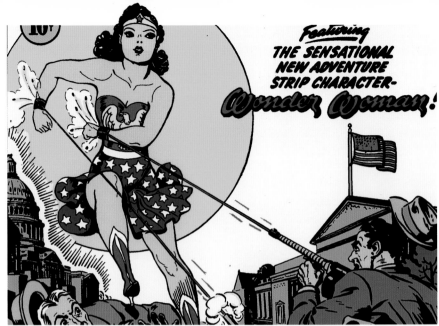

Featuring
THE SENSATIONAL
NEW ADVENTURE
STRIP CHARACTER-
Wonder Woman!

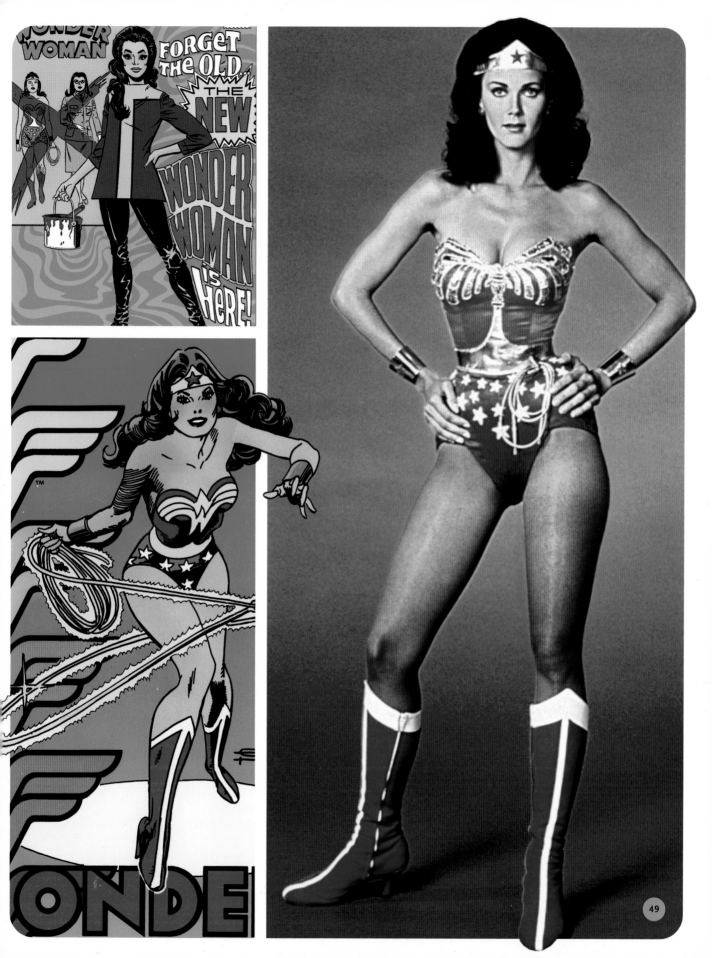

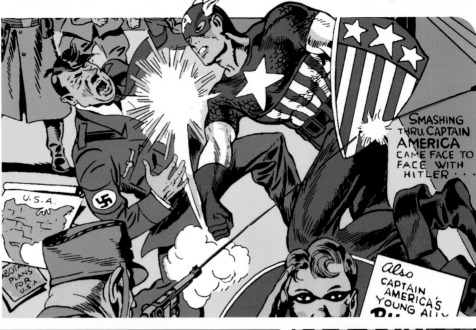

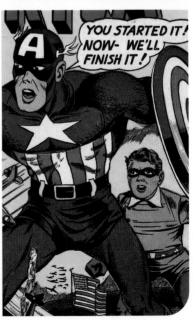

with gold and white stars, and a pair of scanty gold briefs with a pink ribbon lacing their front, it captured not only the politicized but also the sexualized overtones of Wonder Woman's costume, especially the versions she sported after she swapped the golden eagle that had cupped her breasts since her debut for a stylized letter "W" in 1982. Far from constant, Wonder Woman's costume, like her character and physique, has been, over the years, reworked and, on occasion, reinvented according to prevailing fashions. One of the more drastic redesigns appeared on the cover of *Wonder Woman* No. 178, October 1968, where the heroine wears an implausibly short mini-dress and a pair of impossibly high thigh-high boots. Bernhard Willhelm evoked this "Mod" look in ensembles from his spring/summer 2008 collection, although with their star-spangled patterns they also suggested Wonder Woman's original patriotic costume. One dress was based on Old Glory, as were the dresses of John Galliano and Jeremy Scott, although the explicit flaglike appearance of Willhelm's design is muted slightly in Galliano's, and considerably so in Scott's, by their tailored finesse. Scott's dress, which was styled with a rifle, was the finale of a collection entitled "Right to Bear Arms," a politicized statement that emphasized the disquieting underbelly of nationalism.

What was intended as a playful commentary on patriotism, Catherine Malandrino's "Flag" dress from her autumn/winter 2001–2002 collection, took on more poignant associations after September 11, when it was seen as a poetic tribute to the tragedy. In their ensemble, Viktor & Rolf presented a distinctly unpartisan construal of the Stars and Stripes. Part of their first prêt-à-porter collection, which they dedicated to "the art of the commercial sell-out," it expressed their anxieties about moving away from the world of haute couture to the world of ready-to-wear and mass production. The perception of America as a country of exacerbated commercialism also underlay the ensembles by Walter van Beirendonck and Bernhard Willhelm. Those by Willhelm, which included garments in acidic and muted Stars-and-Stripes patterns, formed part of a collection entitled "I Am The One And Only Dominator." While a reference to the song used to accompany the presentation, the collection could also be read as a critique of America's foreign policy. Superheroes, even superpatriots like Captain America, are not above criticizing the government. Captain America's disgust over the Watergate scandal prompted his rejection of his patriotic persona and the adoption of the identity-denying Nomad, a character created by writer Steve Englehart and artist Sal Buscema, who made his debut on the cover of *Captain America* No. 180, December 1974. Tellingly, however, the superhero resumed his flag-clad identity after only four issues. Readers, it seems, missed the traditional Captain America as conveyed through mass media such as film and television. While the emphasis of Captain America and Wonder Woman narratives fluctuates in tune with societal dialectics, they remain, through their costumes, powerful metaphors of patriotism.

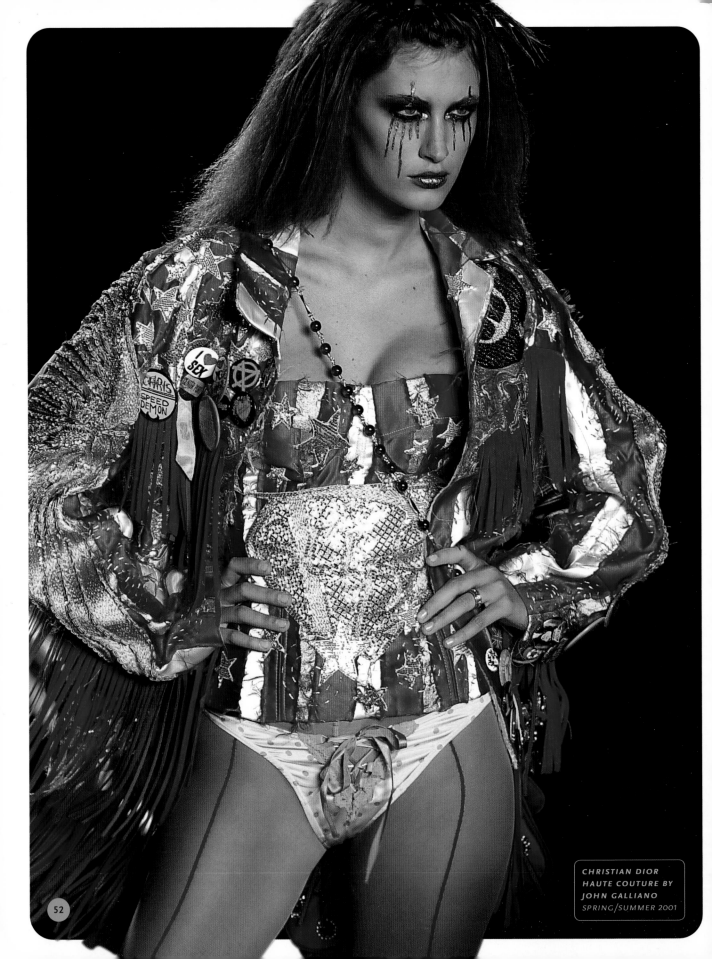

CHRISTIAN DIOR
HAUTE COUTURE BY
JOHN GALLIANO
SPRING/SUMMER 2001

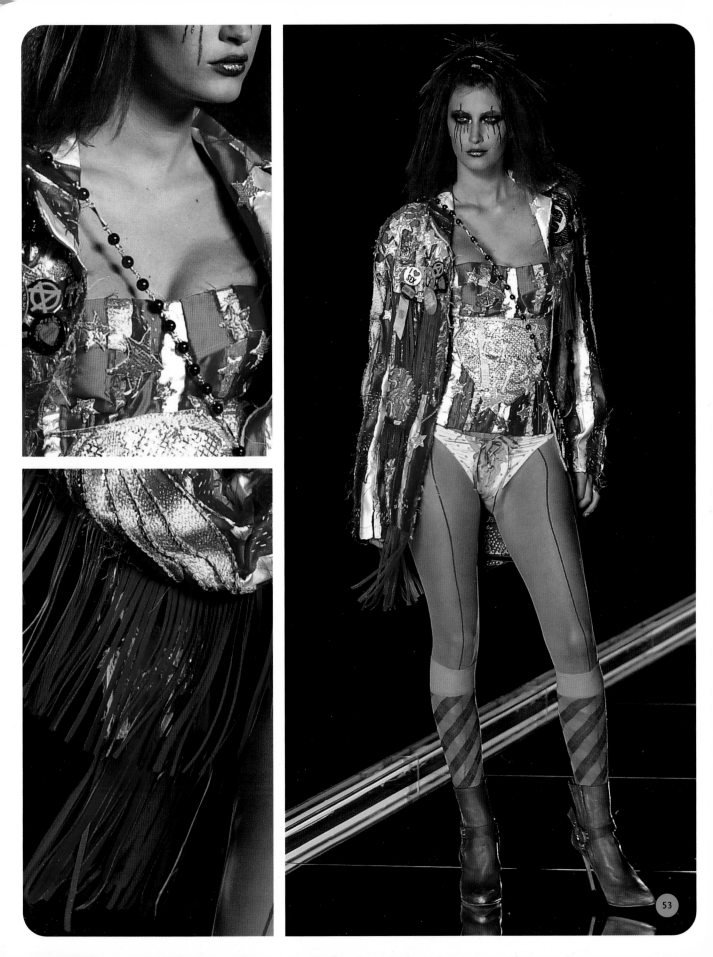

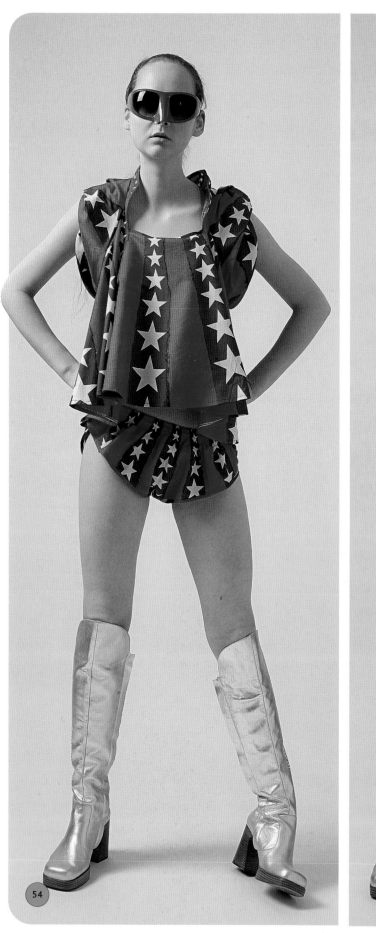
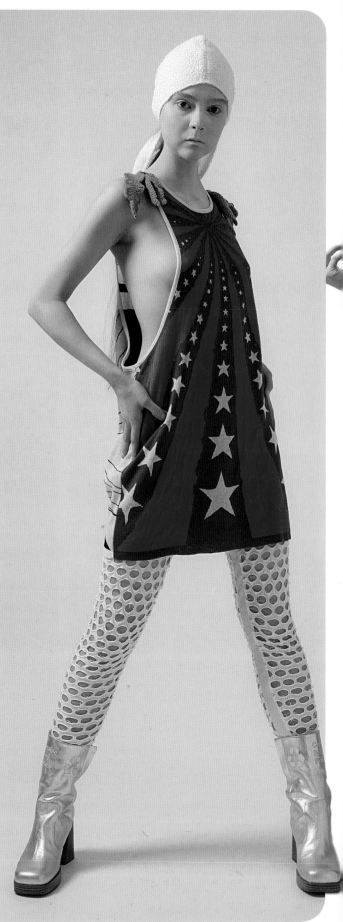

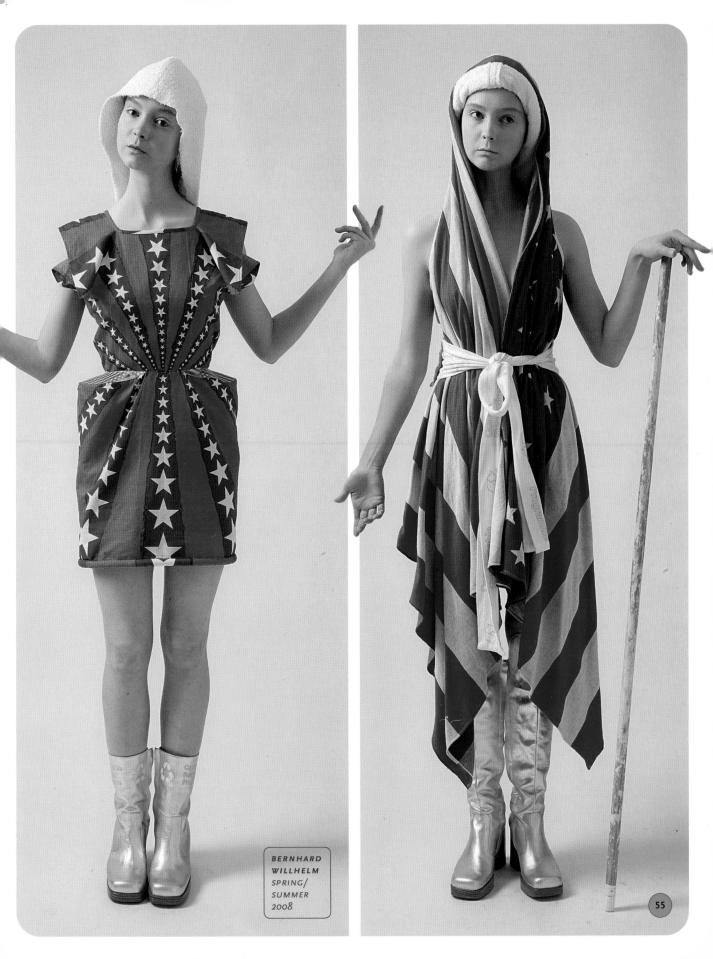

BERNHARD
WILLHELM
SPRING/
SUMMER
2008

55

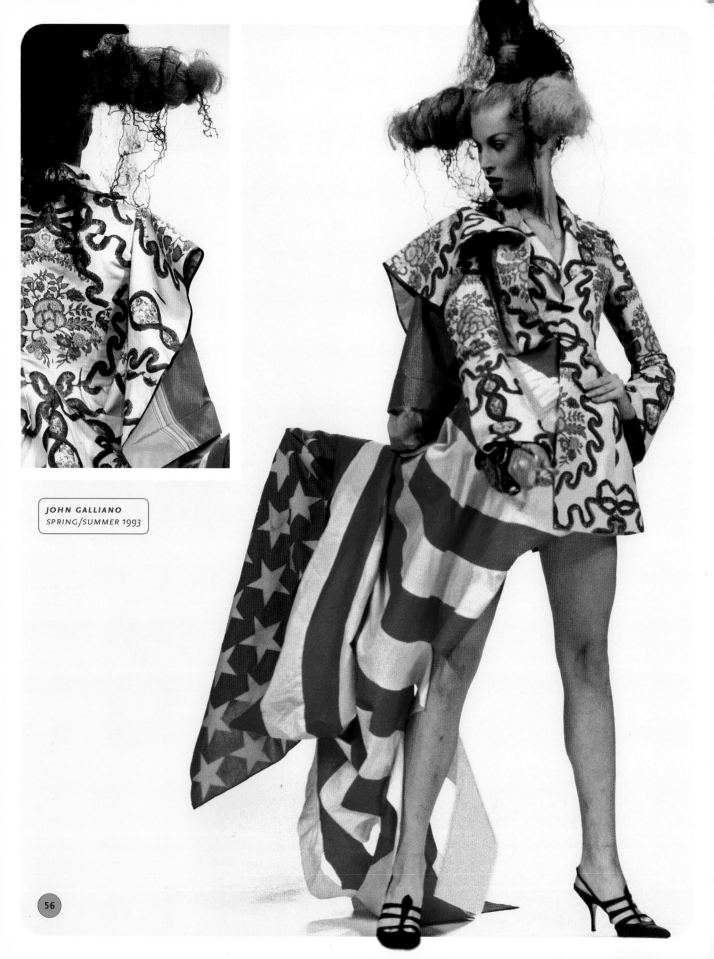

JOHN GALLIANO
SPRING/SUMMER 1993

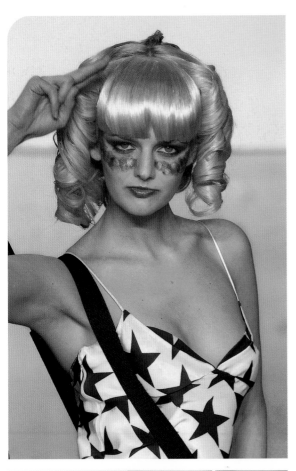

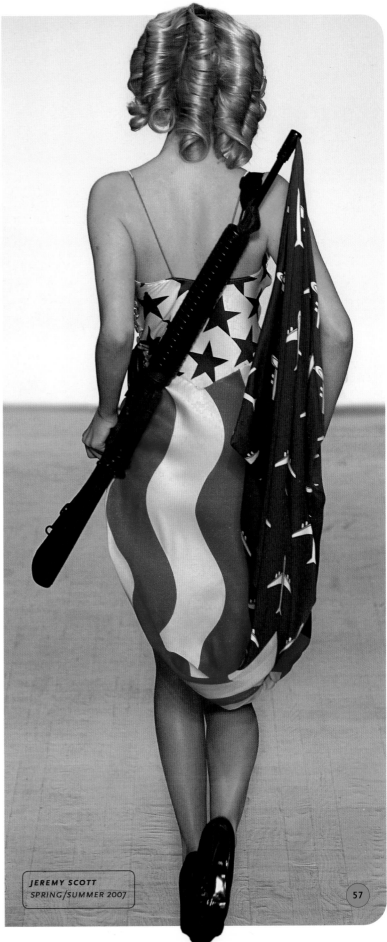

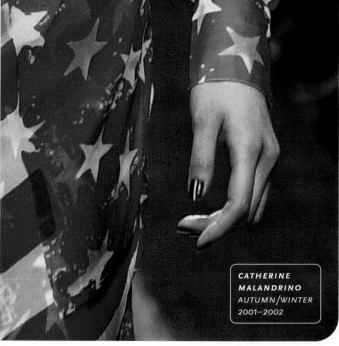

CATHERINE
MALANDRINO
AUTUMN/WINTER
2001–2002

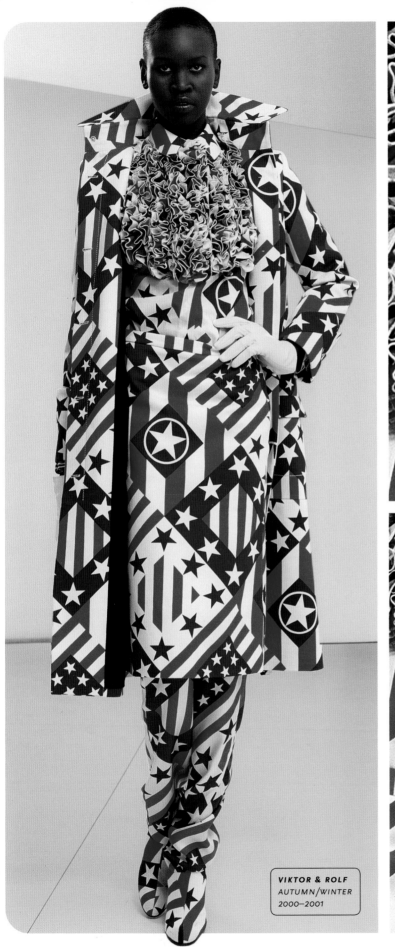

VIKTOR & ROLF
AUTUMN/WINTER
2000–2001

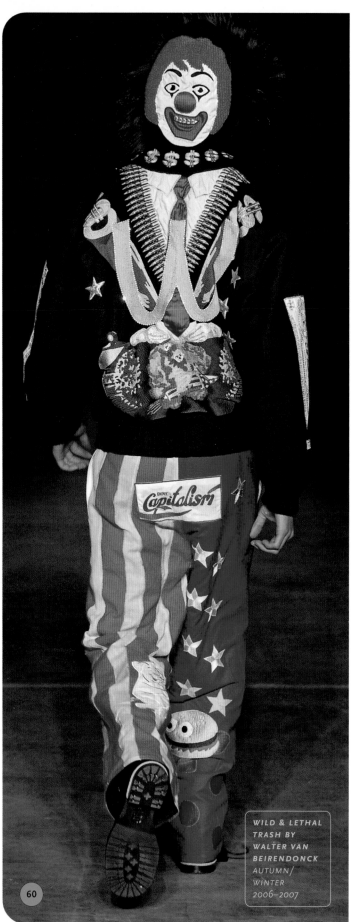

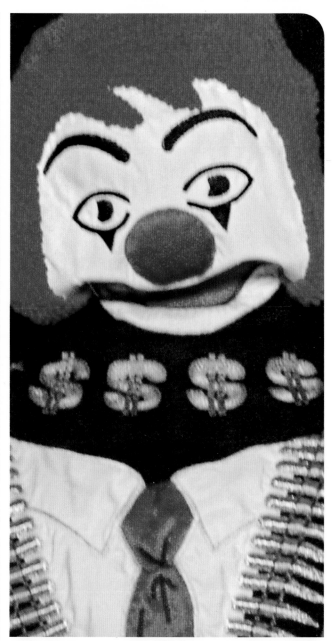

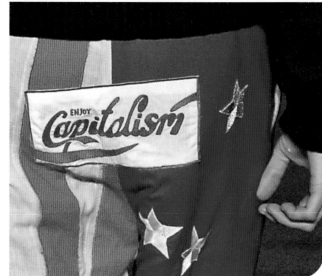

WILD & LETHAL
TRASH BY
WALTER VAN
BEIRENDONCK
AUTUMN/
WINTER
2006–2007

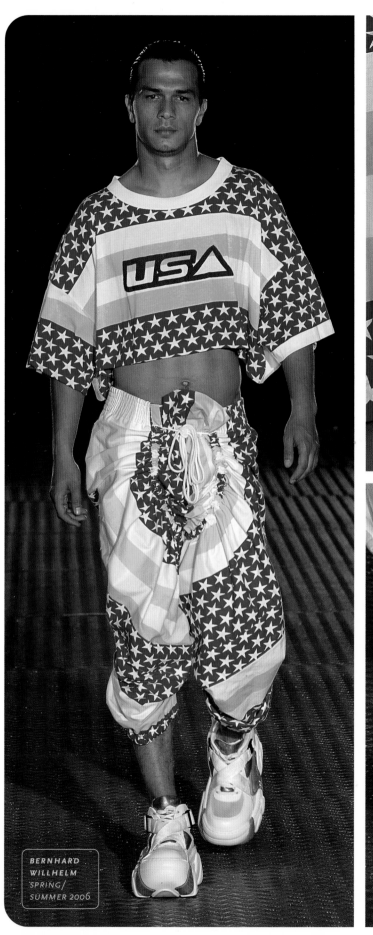

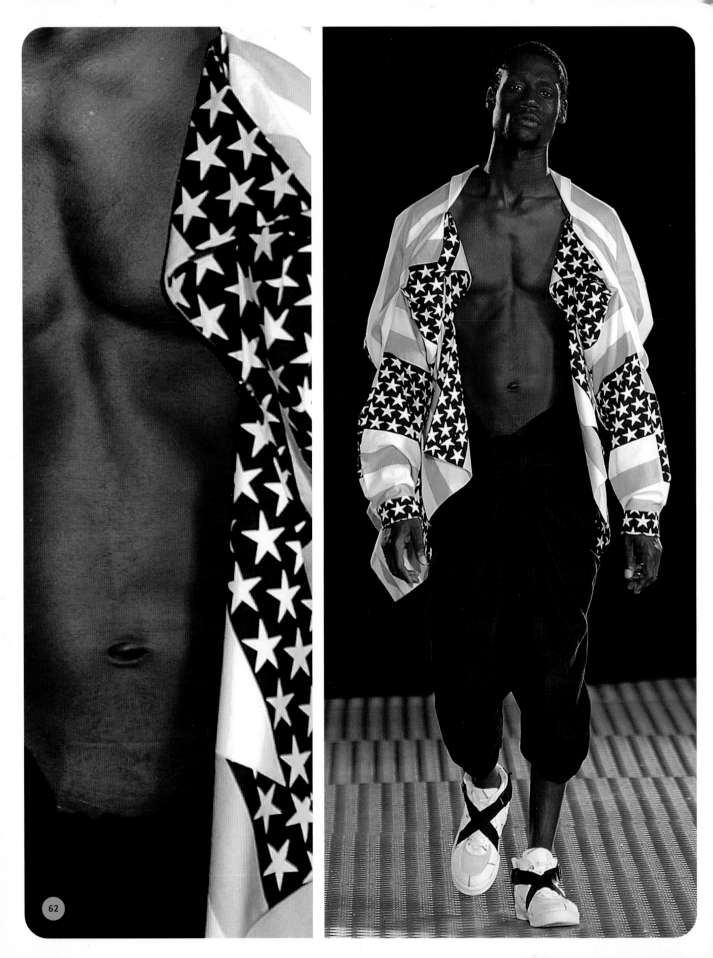

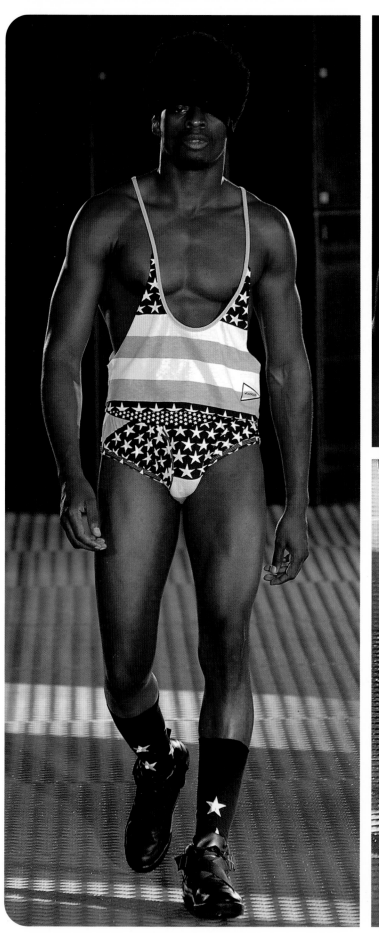

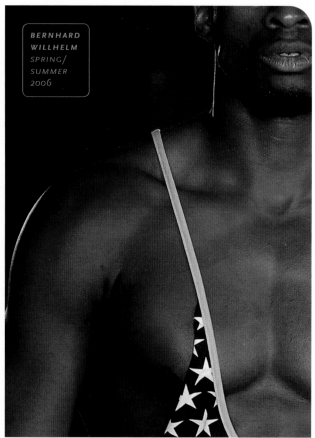

THE VIRILE BODY

Compared to their presence in World War II narratives, superheroes played a minor role in the mythologizing of the Cold War. An exception was the Hulk, created by writer Stan Lee and artist Jack Kirby, and inspired by Mary Shelley's Frankenstein. Debuting in *The Incredible Hulk* No. 1, May 1962, the Hulk was a response to fears inherent in the atomic age. Dr. Bruce Banner, the inventor of the "gamma bomb," was caught in the bomb's first test blast owing to the machinations of a communist spy. Despite absorbing massive amounts of radiation, Banner seemed unharmed. Later, however, he undergoes a monstrous metamorphosis as the Hulk. Originally, Banner's transformation was triggered by sundown but later it was prompted by emotion, usually anger or frustration. In the first issue, the Hulk was gray in response to Stan Lee's request for a color that did not suggest any particular ethnicity. By issue two, however, the Hulk had acquired his green coloration. At the time, little was known about the effects of radiation on the human body. As the terrible by-product of nuclear science, the Hulk represented an escalation of this uncertainty to paranoiac proportions.

Beyond this paranoia, however, the Hulk is the embodiment of hegemonic masculinity. As Alan M. Klein has observed, "Comic-book depictions of masculinity are so obviously exaggerated that they represent fiction twice over, as genre and as gender representation." Klein compared the hyperbolic musculature of superheroes to bodybuilding, an appropriate comparison considering that superheroes have been closely aligned with bodybuilders since their inception. Indeed, the concept and the costume of late-nineteenth- and early-twentieth-century strongmen like Eugen Sandow provided inspiration for Superman. When casting the Hulk in the television series *The Incredible Hulk* (1978), Lou Ferrigno, a former Mr. America and Mr. Universe, seemed an obvious selection. As a child, the Hulk was one of his role models. Indeed, the Hulk, in all his overstated supersolidity, incarnates adolescent fantasies of physical empowerment. Massively muscled, this stiffly posed pinup is forever

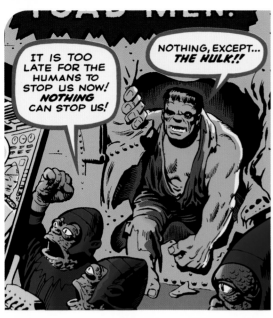

IT IS TOO LATE FOR THE HUMANS TO STOP US NOW! *NOTHING* CAN STOP US!

NOTHING, EXCEPT... *THE HULK!!*

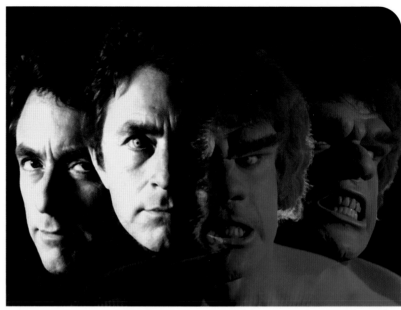

THE STRANGEST MAN OF ALL TIME!!

IS HE MAN OR MONSTER OR...

IS HE BOTH

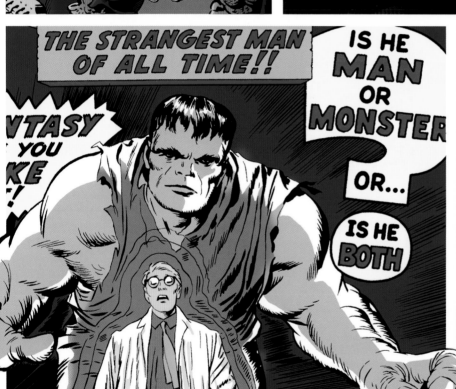

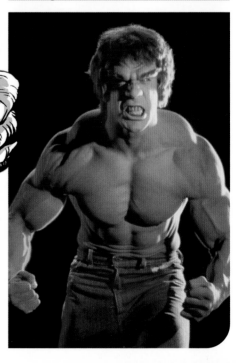

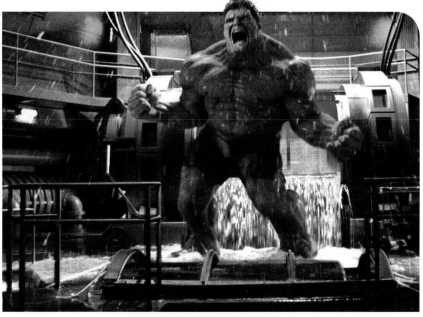

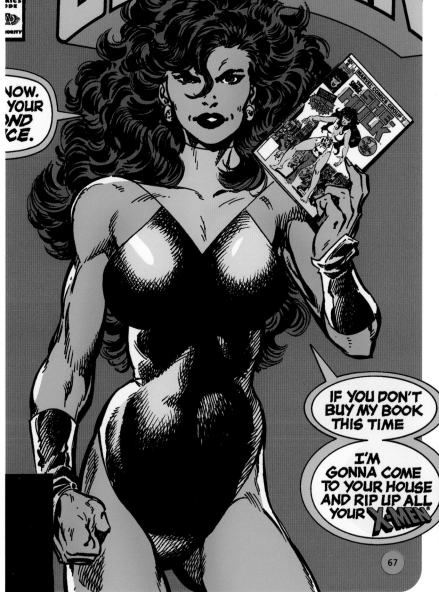

NOW.
YOUR
OND
CE.

IF YOU DON'T BUY MY BOOK THIS TIME

I'M GONNA COME TO YOUR HOUSE AND RIP UP ALL YOUR X-MEN!

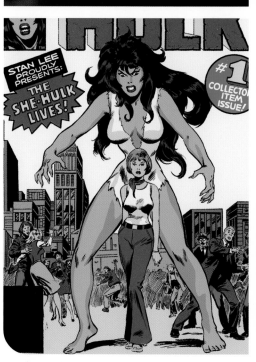

STAN LEE PROUDLY PRESENTS: THE SHE-HULK LIVES!

#1 COLLECTOR ITEM ISSUE!

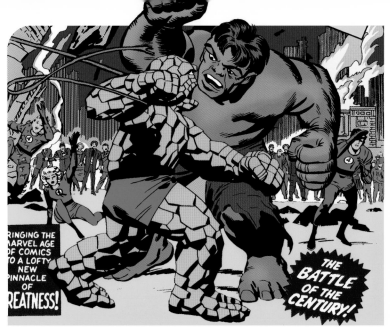

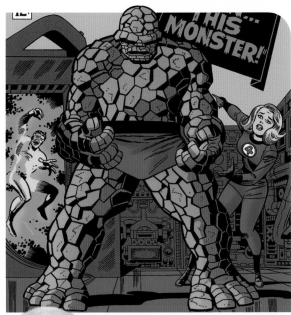

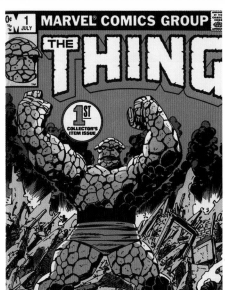

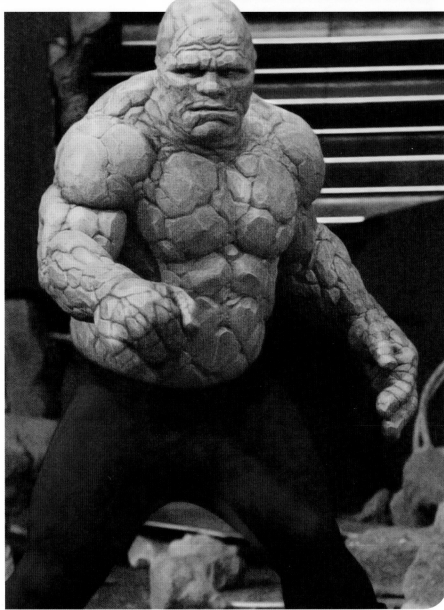

frozen in a display of bodily strength. But the Hulk also personifies pubescent metamorphosis. As Peter Coogan has noted, "When soft, flabby, small Bruce Banner gets excited he swells into the hard, strong, large Hulk...." While phallic symbolism is implicit in the representation of most superheroes, their hard bodies swathed in prophylactic unitards, it is explicit in the case of the Hulk. With his thick neck, bulging tendons, and throbbing veins, he suggests the turgidity of male arousal.

The Hulk as a metaphor for male potency finds many resonances in fashion. Most graphically, Walter van Beirendonck, a designer known for galvanizing the iconography of the superhero, created a series of jackets with air pockets that inflated to establish an immediate and exaggerated musculature. Part of his spring/summer 1996 collection entitled "Killer / Astral Travel / 4D-Hi-D," they were shown on black models whose own bodies were megamuscled, creating the optical illusion of double-exposure doubled amplitude. Naoki Takizawa played with a similar concept of the pneumatic physique in his spring/summer 2001 collection. Seemingly inspired by protective sportswear, specifically that used in American football and baseball, the ensembles were less mimetic than fantastic in their pumped-up-by-exercise musculature. One ensemble included inflated horizontal rows of padding to create the effect of ripped and rippled abdominals. Another featured inflatable pectorals and had the ithyphallic distension of a football player in his padded uniform.

Other designers have been more directly inspired by the vigorous masculinity of the American footballer. Bernhard Willhelm's autumn/winter 2004–2005 collection featured garments puffed up to Hulk-like bulk through protective shoulder pads. Presented by a football team, the collection included ensembles with digital prints on the themes of "fire, ice, and brickstones," the title of the collection. The brick-printed clothes, in particular, evoked the craggy, stonelike appearance of the Thing, another rock-hard, tumescent superhero. Like the Hulk, the Thing (Ben Grimm) was the creation of Stan Lee and Jack Kirby. Appearing six months before the green goliath in *The Fantastic Four* No. 1, November 1961, he was also the product of Cold War mentality. Unlike the Hulk, however, the Thing's monstrous conversion is permanent. He is, effectively, in a persistent state of vascular distension. The Hulk's cousin, She-Hulk (Jennifer Walters), after exposure to additional gamma radiation makes her transformation permanent, is also presented in a state of obdurate "minerality," a paradox of masculine power in feminine form. Created by Stan Lee and artist John Buscema, her Amazonian appearance resonates in the ensemble by Alexander McQueen, which also relies on football shoulder pads to convey an image of sexual power. The brute force and invincibility of the Hulk, the Thing, and She-Hulk coalesce in the ensemble by John Galliano. With its padded shoulders, fetishistic hardware, and enormous hose-pipe phallus, it both reflects and represents the pulsing force of the virile body.

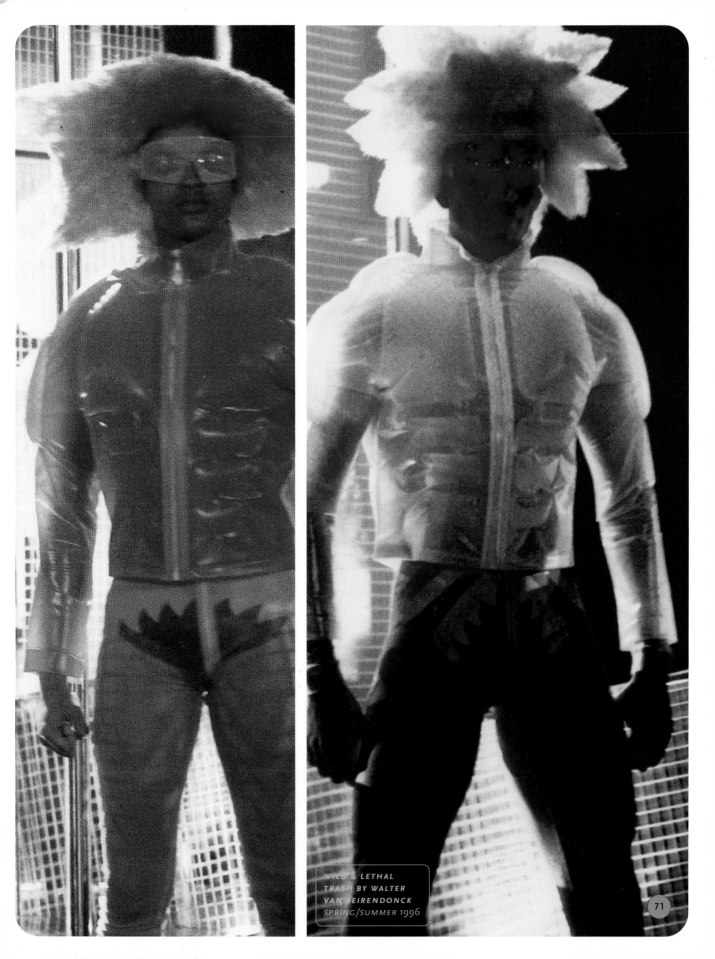

WILD & LETHAL
TRASH BY WALTER
VAN BEIRENDONCK
SPRING/SUMMER 1996

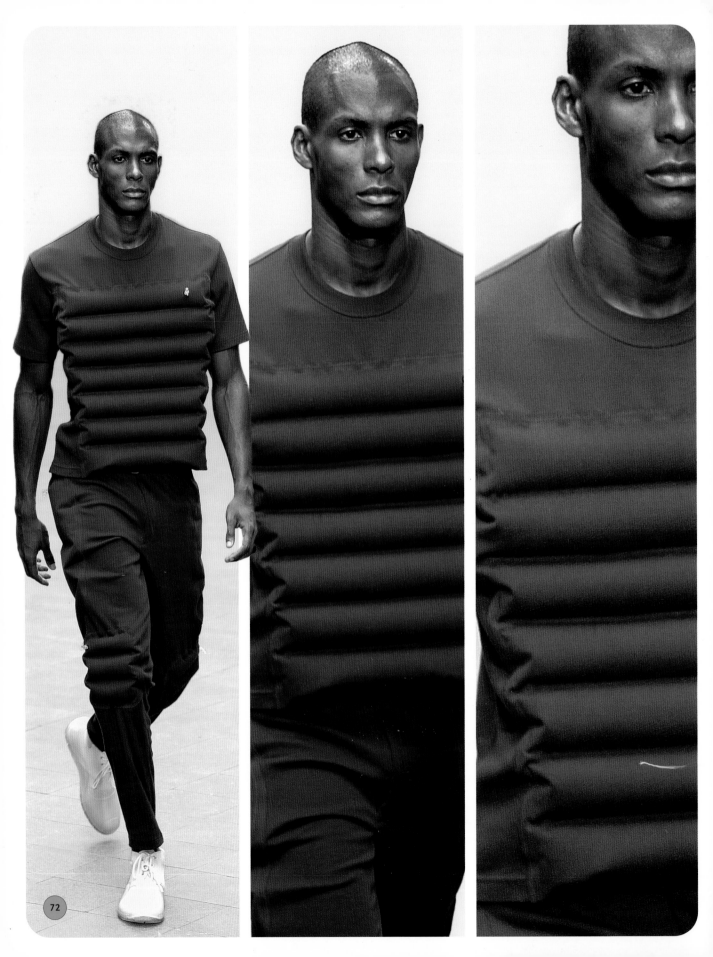

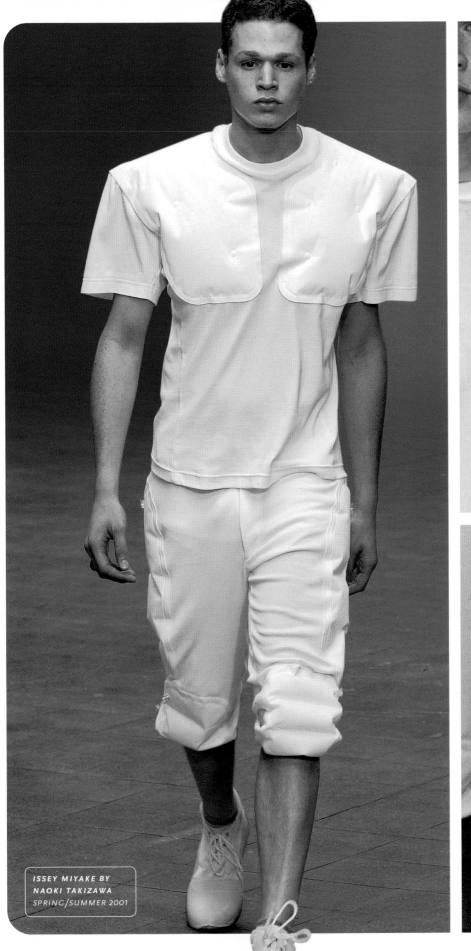

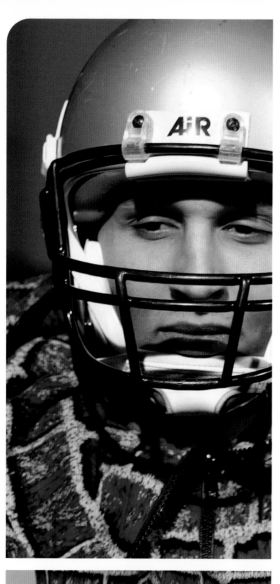

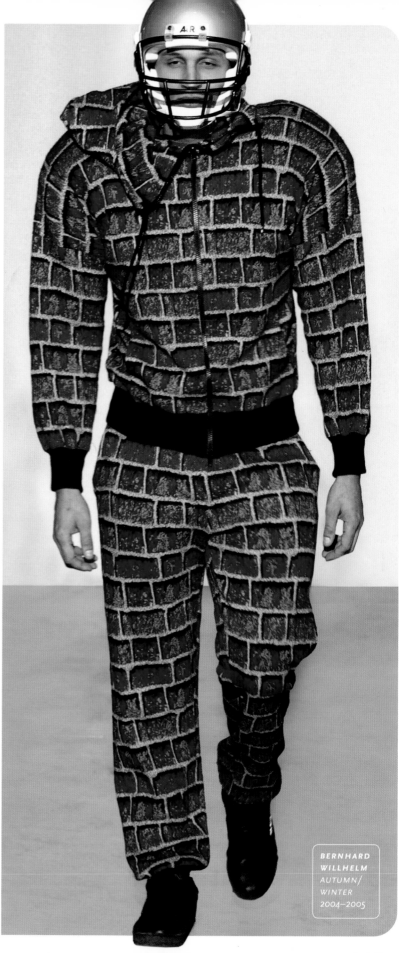

BERNHARD
WILLHELM
AUTUMN/
WINTER
2004–2005

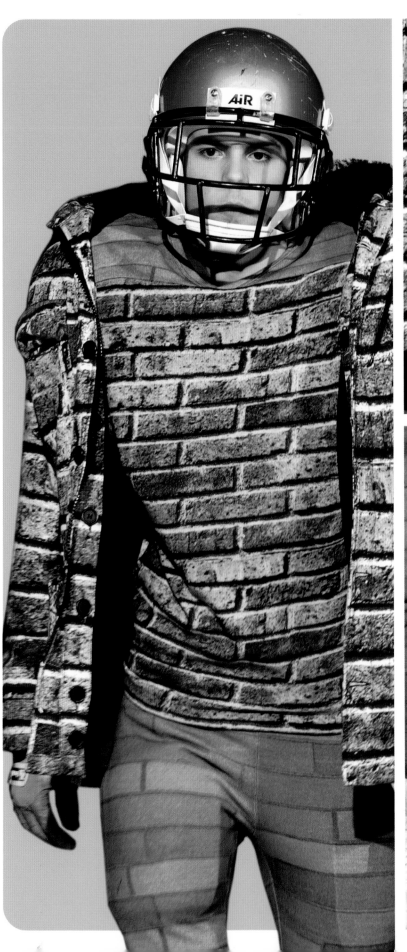

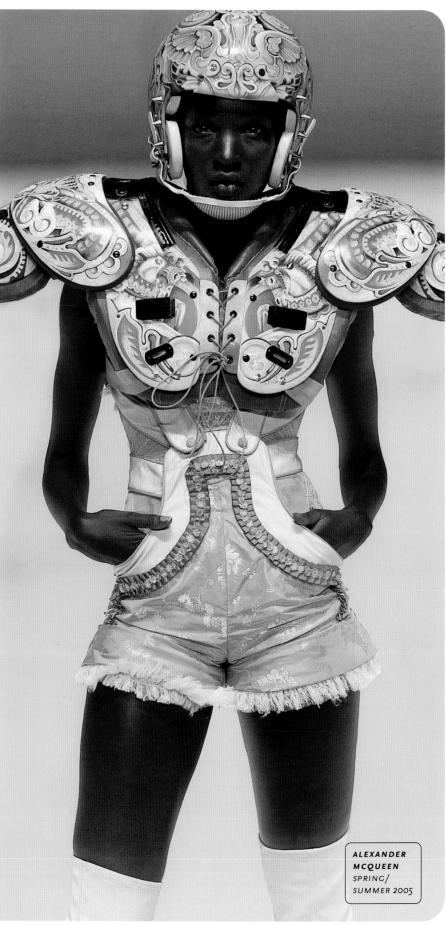

ALEXANDER
MCQUEEN
SPRING/
SUMMER 2005

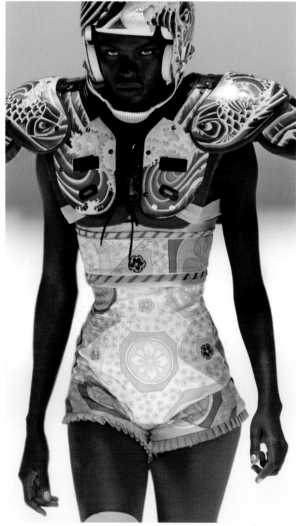

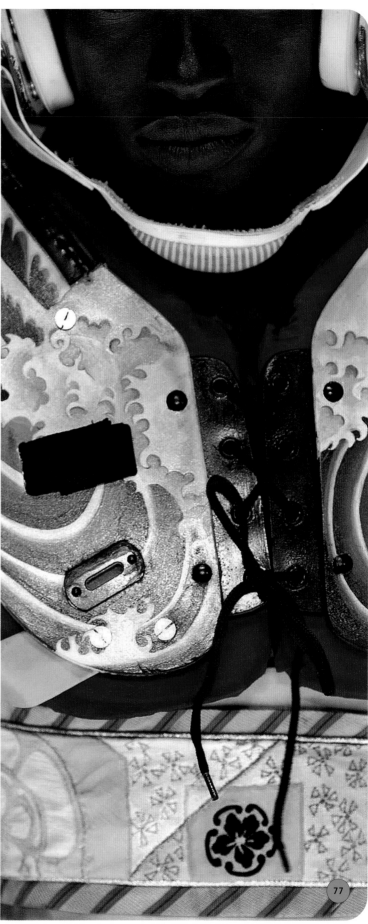

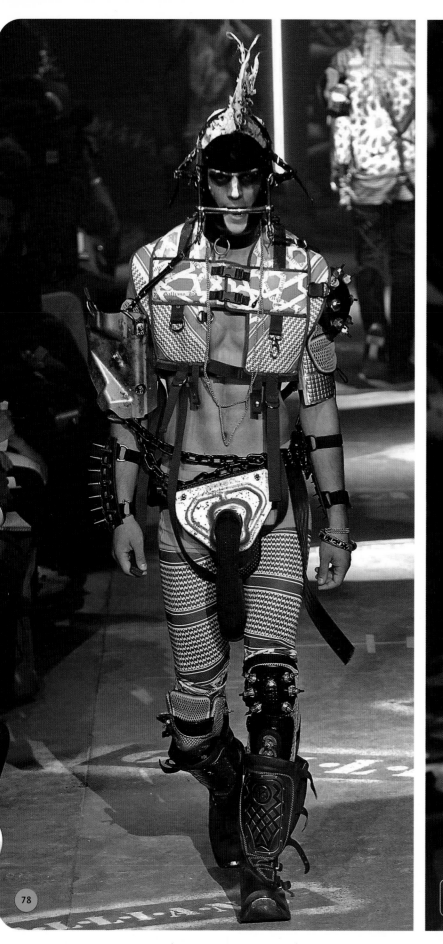
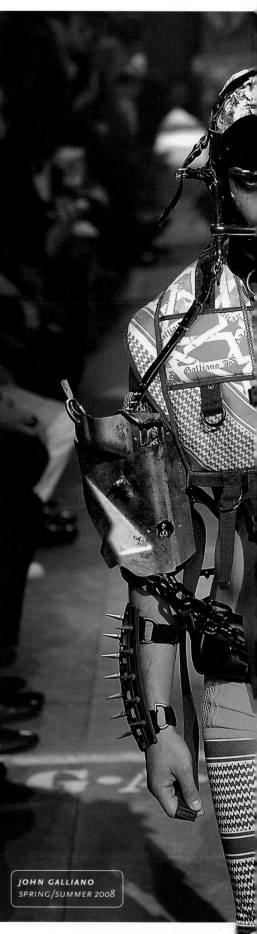

JOHN GALLIANO
SPRING/SUMMER 2008

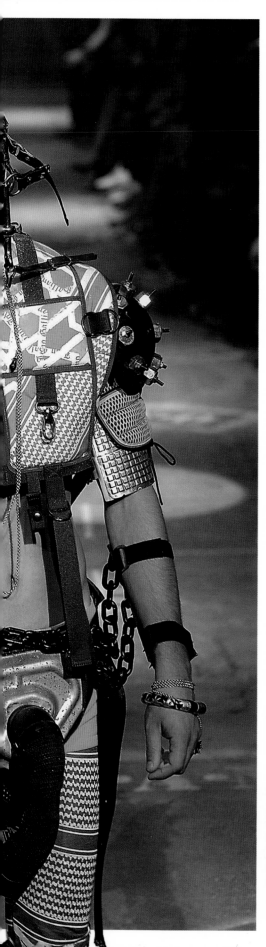

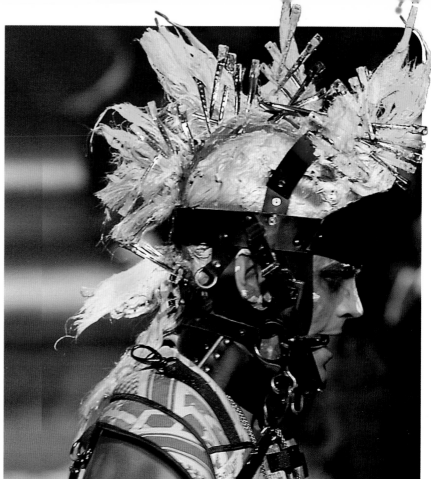

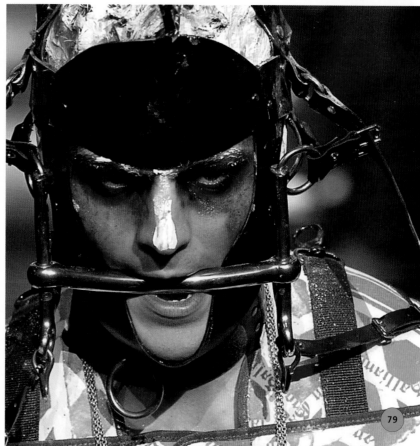

THE PARA-
DOXICAL BODY

Superhero comics have tended to promote an ideology that is both masculinist and driven to mastery. Nowhere are these biases more blatant than in the representation of female superheroes. With unabashed and unapologetic obviousness, women are portrayed as objects of male desire and fantasy with absurdly exaggerated sexual characteristics. Thin waists, pert bottoms, large silicone breasts, and long, shapely legs are fetishized in costumes that are in themselves fetishistic. While it is true that the costumes worn by male superheroes can also be defined by an overt sex appeal, a fact that goes some way in readdressing the chauvinism of comic books, those worn by their female counterparts tend to reveal a lot more bare flesh. Indeed, the standard formula seems to be minimum costuming and maximum body exposure. But, as scholar Richard Reynolds has observed, the frisson of fetishistic sexuality presented by female superheroes is adduced with one hand only to be dismissed with the other. "Sexuality," he has argued, "is simultaneously presented—from the male point of view—in all its erotic trappings—and then controlled, or domesticated, by a simple denial of its power and appeal." This offering and denying of sexuality, which helps to resolve the sexual fears and desires of developing males, is the eternal paradox of the superheroine.

Catwoman, through her radical split of conscience between "good girl" and "bad girl," literalizes this contradiction. Created by artist Bob Kane, she was inspired, in part, by Hedy Lamarr, whom Kane admired for her "great feline beauty." When she first appeared in *Batman* No. 1, Spring 1940, she was known simply as The Cat, a female burglar (and an obvious reference to the recently coined term "cat burglar"). Her real name was Selina Kyle, and originally she was characterized as a sybaritic socialite whose initial impulse to steal stemmed from ennui. Over the years, however, her origin story has undergone several rewritings to include an amnesiac stewardess, the wife of a wealthy tyrannical husband, a prostitute with a vicious pimp, the daughter

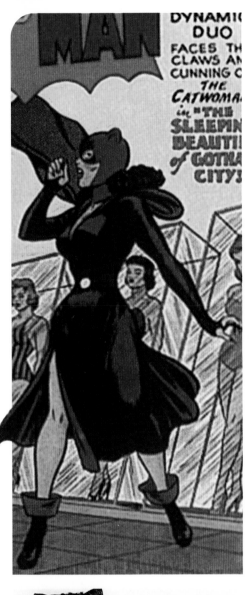

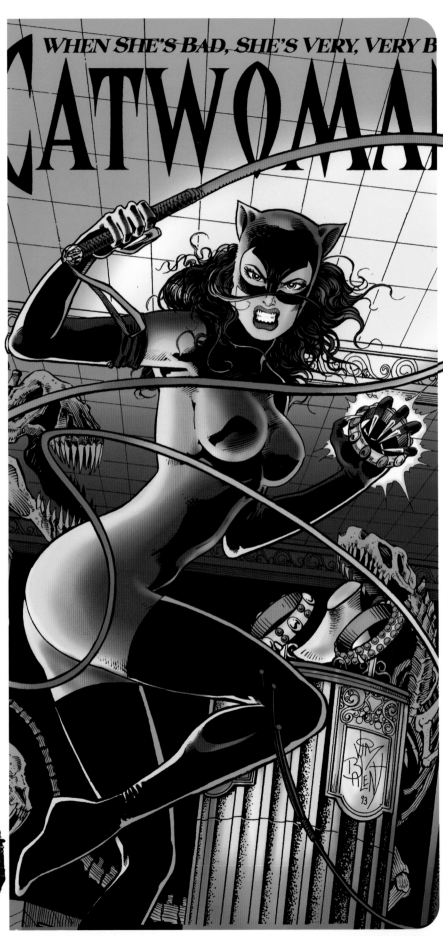

WHEN SHE'S BAD, SHE'S VERY, VERY B

CATWOMA

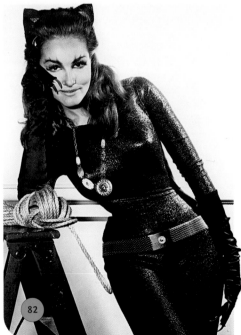

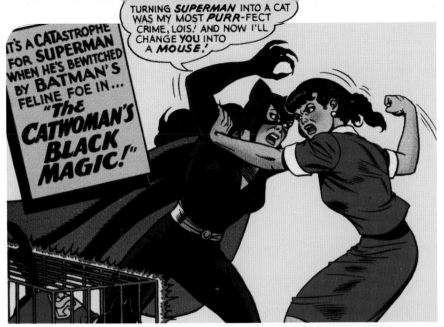

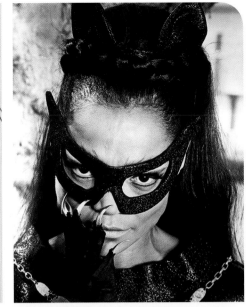

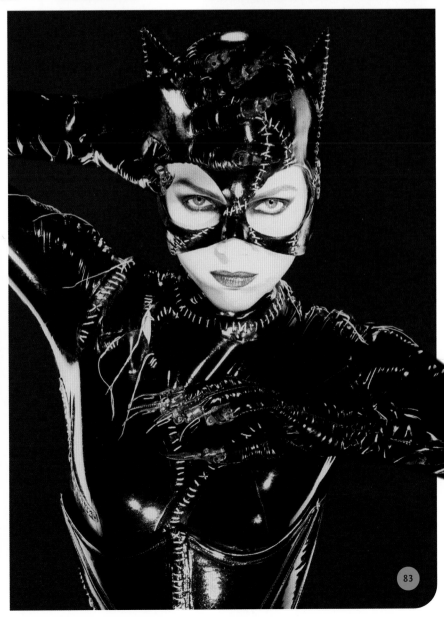

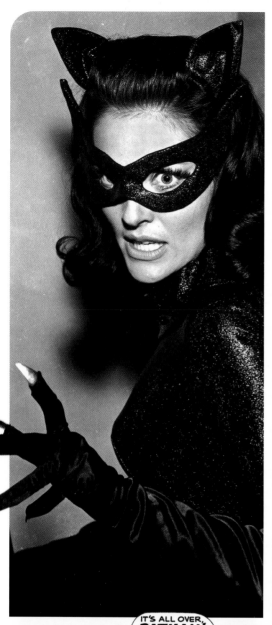

HAVE IT YOUR OWN WAY, BATGIRL!

YOU'LL TAKE BATMAN TO YOUR CATACOMBS OVER MY DEAD BODY, CATWOMAN!

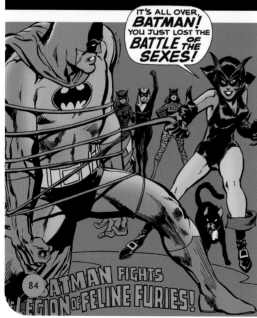

IT'S ALL OVER, BATMAN! YOU JUST LOST THE BATTLE OF THE SEXES!

BATMAN FIGHTS LEGION OF FELINE FURIES!

84

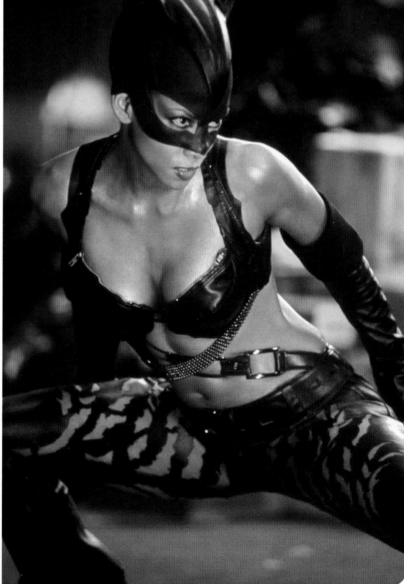

of an alcoholic father, and, most recently, continuing the theme of abuse that seems to underlie her metamorphoses as well as her motivations for criminality, another prostitute. Catwoman's costume, similarly, has undergone several redesigns. While in some cases these changes parallel (and signal) character transformations, in others they seem to be purely for the sake of fashionable appearances. Indeed, in another instance of comic-book chauvinism, female characters are typically subject to more stylistic makeovers, whether radical or restrained, than their male counterparts. Submission to the dialectics of fashion is presented as another expression of a fetishized femininity. Fetishism is a defining ingredient in Catwoman's wardrobe, which has included dresses with plunging necklines and thigh-revealing apertures, and catsuits that cleave to the body like a second skin, leaving little, if anything, to the imagination. She is best known, perhaps, for the latter, due in large part to the portrayals of the character by Julie Newmar in the television series Batman (1966) and Michelle Pfeiffer in the film Batman Returns (1992). Typical of the intermedia cross-pollination for which superheroes are famous, the costumes of both actresses served to inspire and influence those worn by Catwoman in her comic-book representation.

As apparel, the catsuit has long been identified with the dominatrix, an archetype frequently associated with Catwoman. Michelle Pfeiffer's performance strengthened this connection by spotlighting the themes of alpha-cat and submissive kittenlike behavior. These themes were played out not only in her character, but also in her costume, which co-opted the traditional iconography of the dominatrix, including associated paraphernalia such as a whip, gloves, and high-heel shoes. Indeed, Catwoman, with her black, shiny, smooth second-skin catsuit (which in the film is made from a patent leather raincoat) is the embodiment of Jacques Lacan's poststructural "phallic woman" of male fantasy. The visual and symbolic language of Catwoman resonates strongly in fashion, especially in the work of Thierry Mugler, John Galliano, Dolce & Gabbana, Gianni Versace, Jean Paul Gaultier, and Alexander McQueen. All these designers, like Catwoman (and, indeed, female comic-book characters generally), have been attracted to the wardrobe of the dominatrix and its associations of a liberated sexuality. Conceptually loaded and psychologically coded items such as catsuits, corsets, bustiers, and harness bras, usually in black "wet-look" materials like leather, rubber, and polyvinyl chloride, have in the hands of these outré designers achieved widespread acceptance as exotic-erotic haute couture. But in co-opting these sexual clichés, fashion has, in the process, muted their meanings and sanitized their subtexts. In much the same way as comic books, fashion presents elements of fetishistic sexuality stereotypically, undermining, or at least redirecting and repositioning, its subversive, sadomasochistic underpinnings. While presented blatantly, erotic energies, like the feral nature of Catwoman, are tamed, neutered, and, ultimately, neutralized.

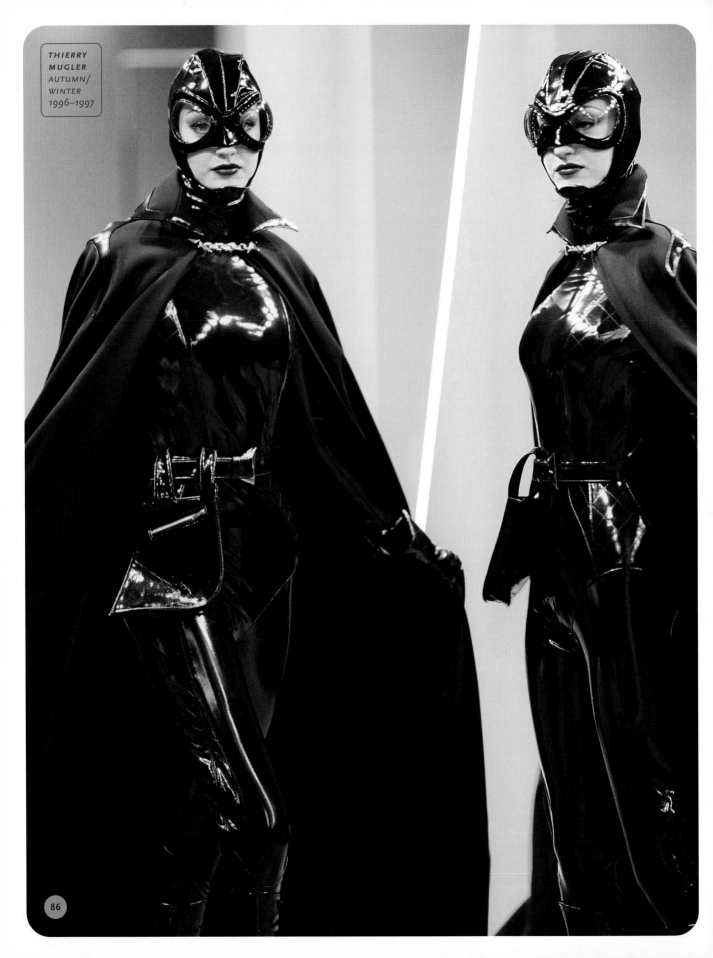

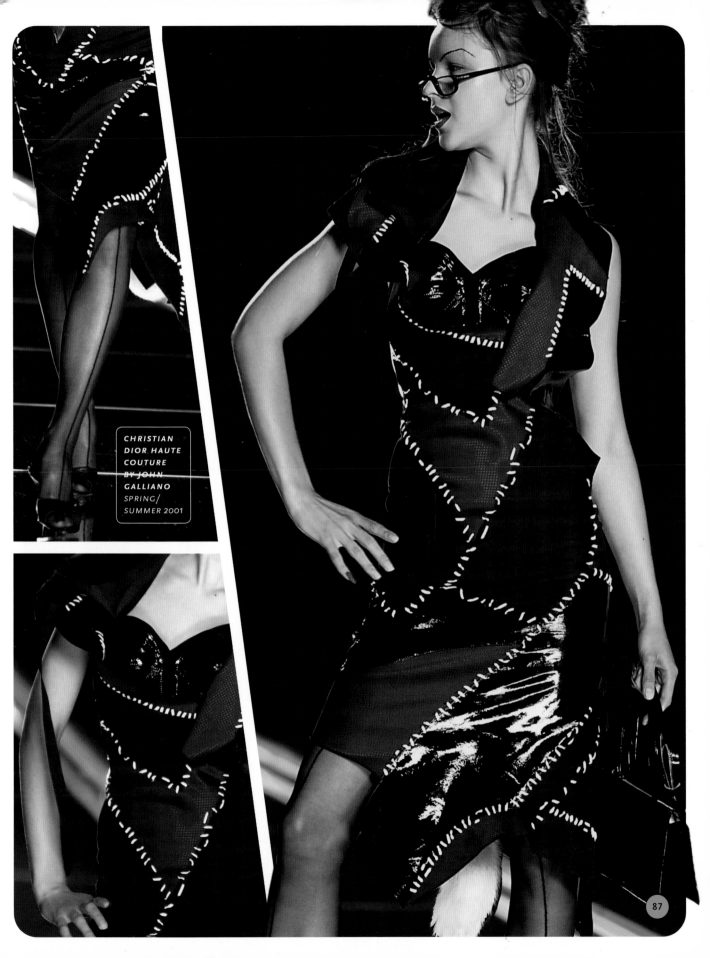

CHRISTIAN
DIOR HAUTE
COUTURE
BY JOHN
GALLIANO
SPRING/
SUMMER 2001

87

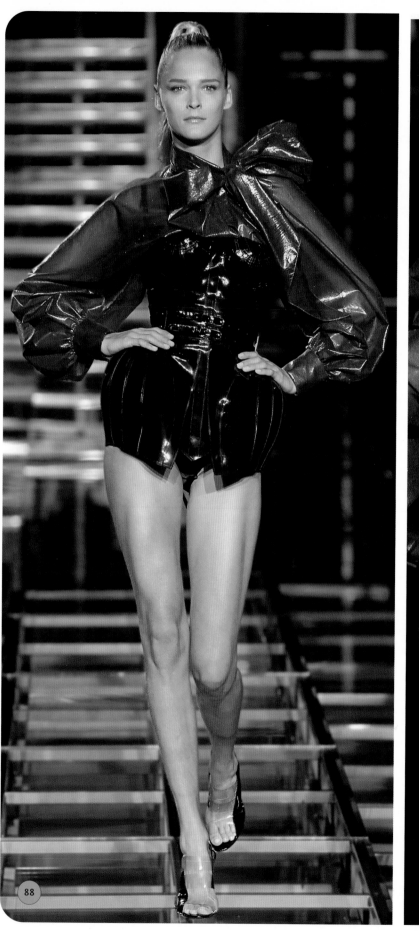
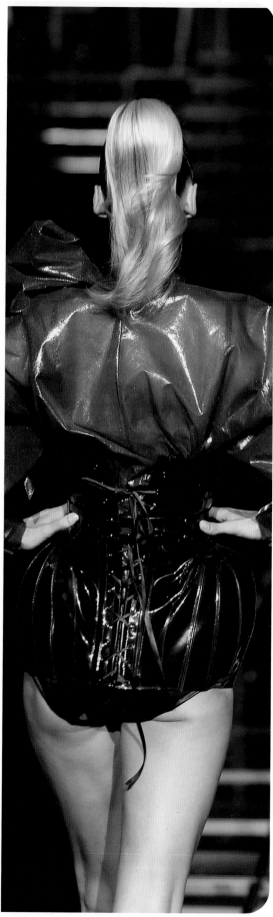

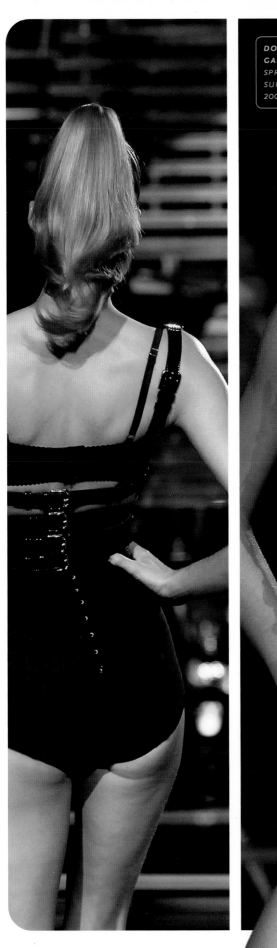

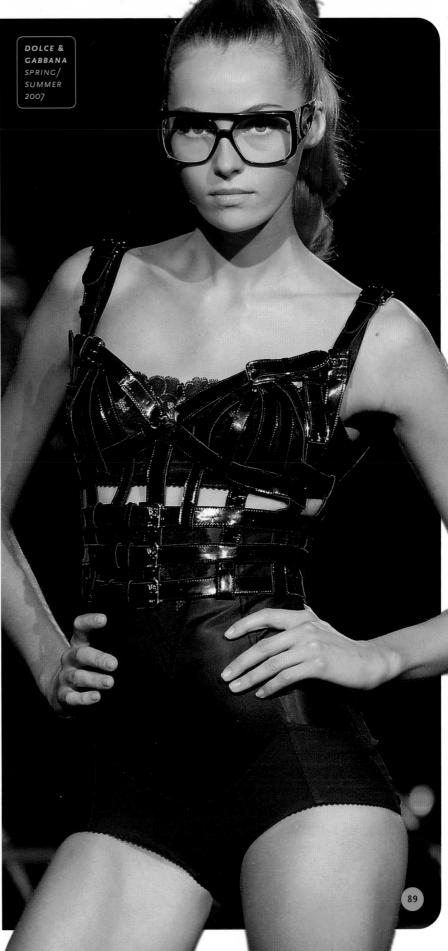

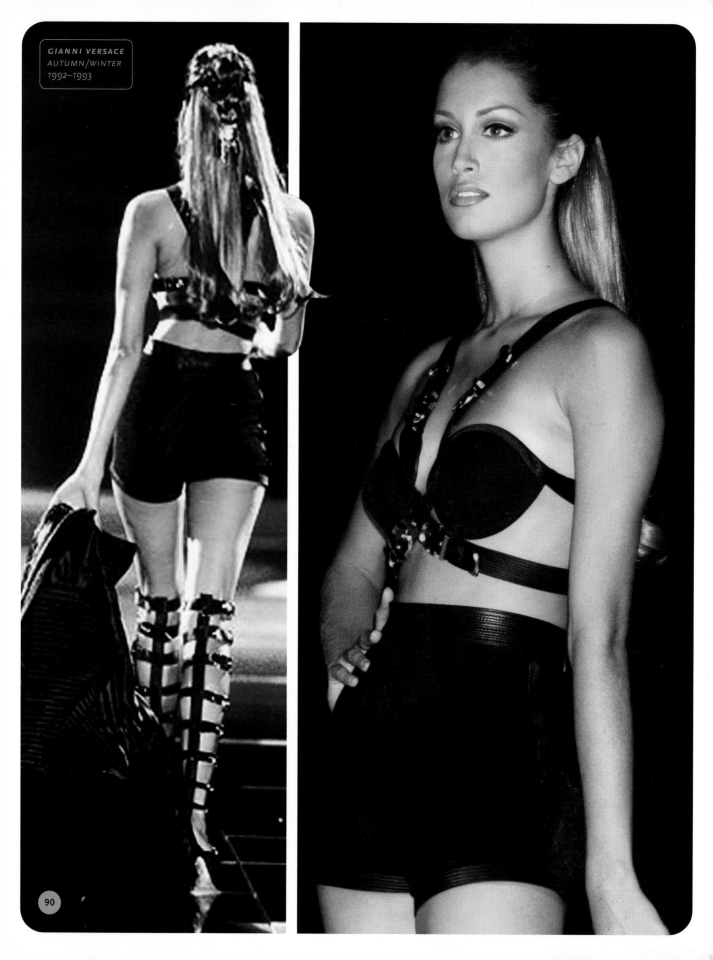

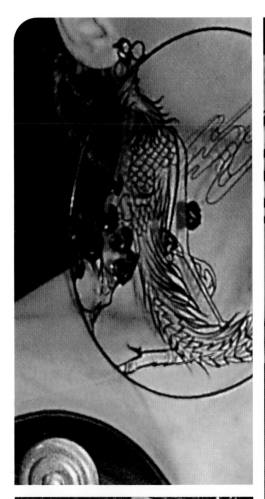

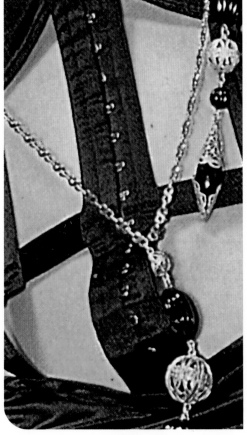

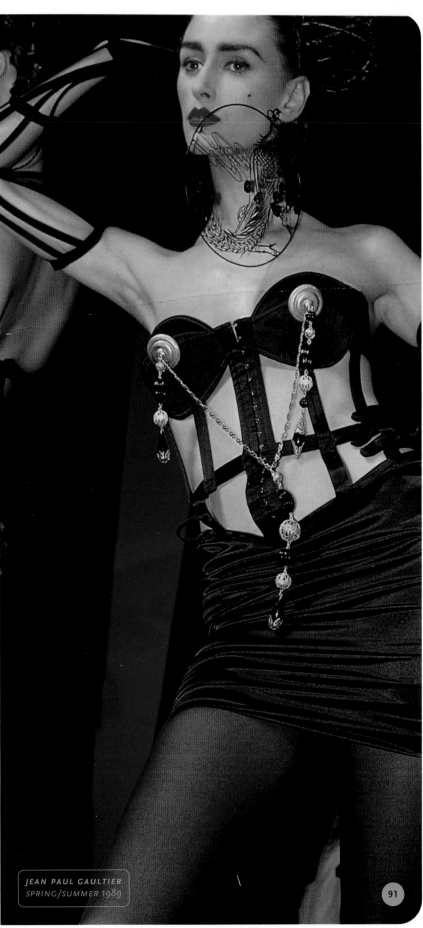

JEAN PAUL GAULTIER
SPRING/SUMMER 1989

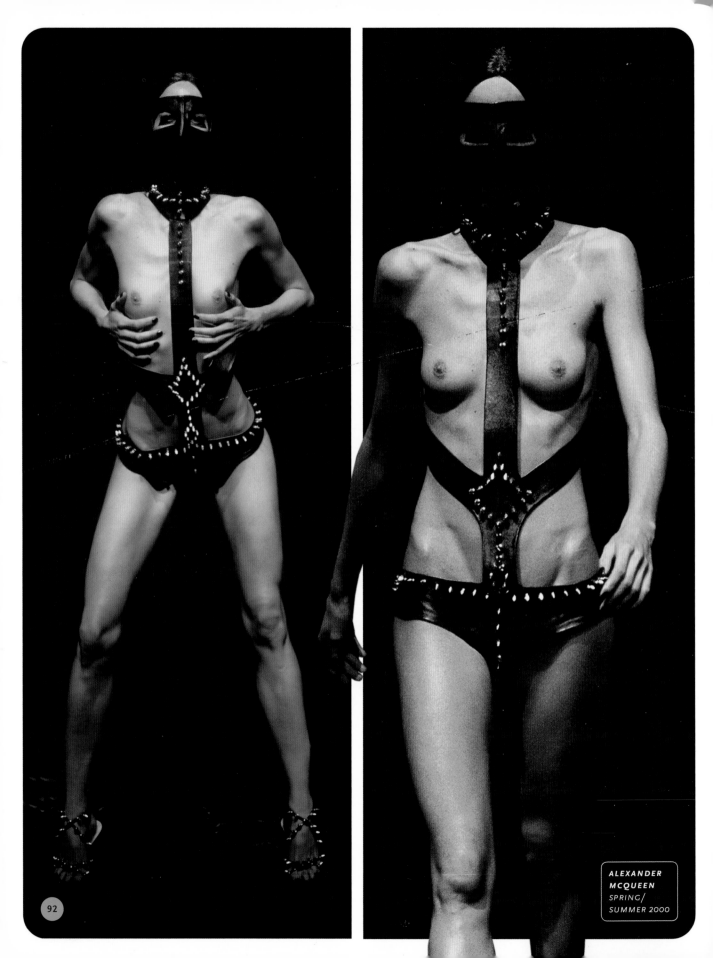

ALEXANDER
MCQUEEN
SPRING/
SUMMER 2000

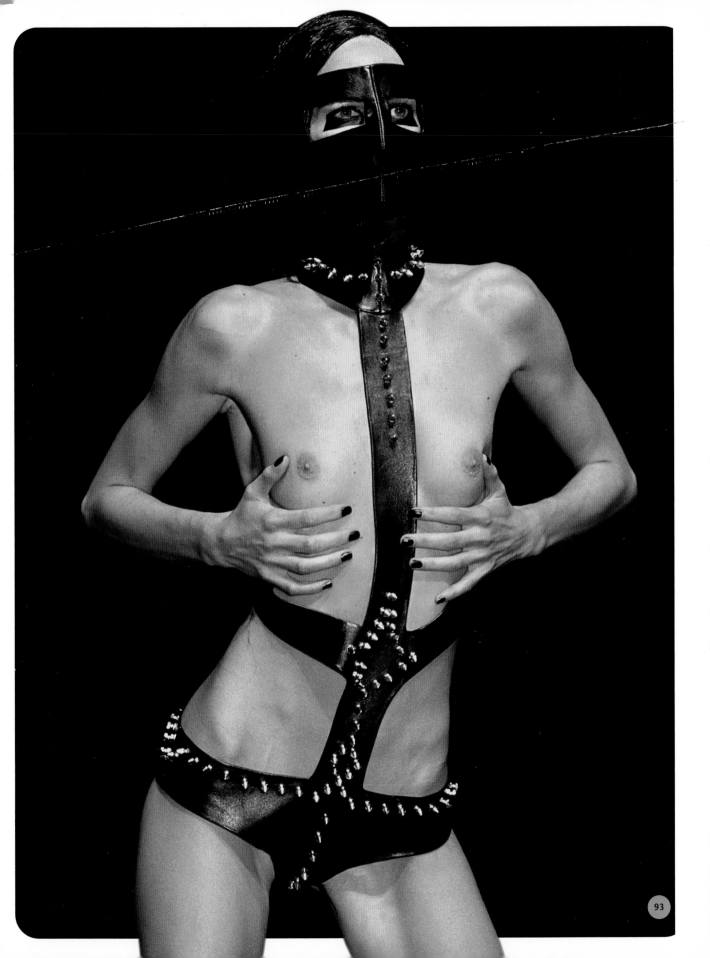

THE ARMORED BODY

The two primary paradigms of superherodom are the superpowered superhero, epitomized by Superman, and the non-superpowered superhero, embodied by Batman. Like Superman, Batman was the first of his breed, debuting eleven months after the Man of Steel in *Detective Comics* No. 27, May 1939. Created by artist Bob Kane, he was a synthesis of several pop-culture characters, including the Bat, Zorro, Dracula, the Shadow, and the Phantom. While non-superpowered, Batman possessed superhuman characteristics, having honed his mind and trained his body to the peak of his abilities. Through obsessive, military discipline, he turned himself into a self-made fighting machine, armored with an ever-expanding arsenal of crime-fighting gadgetry usually contained within his utility belt and, after a brief flirtation with firearms, always nonlethal (in respect to Batman's adolescent readership as well as to his parents, whose murder was the catalyst for his scourge of crime). Typically, the designs of his armory shared a bat motif and bat prefix, such as the Batarang, modeled after the Australian boomerang. The *Batman* television series, first aired on January 12, 1966, and starring Adam West, stretched this practice to farcical proportions, with such camped-up gadgets as bat radar, bat scanner, bat pontoons, and even a bat drinking-water dispenser.

Batman's armor extends beyond his arsenal to his costume, which over the years and partly inspired by the semirigid exoskeletons worn by his film personas, has come to integrate protective mechanisms such as bulletproof padding, primarily positioned around the bat symbol on his chest. Batman's identity, including his code name and costume, was inspired by Bruce Wayne's encounter with a bat while seeking a disguise to strike terror in the hearts of criminals. The basic components of the costume, styled after Superman's, have remained virtually unchanged, comprising unitard, trunks, gloves, boots, cowl, belt, and cape, the last inspired by Leonardo da Vinci's drawings of an ornithopter. Both its color and design speak of its associations—night, fear,

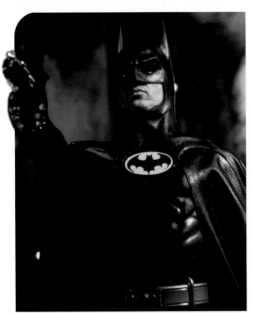
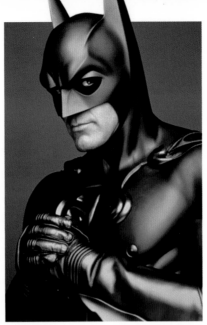
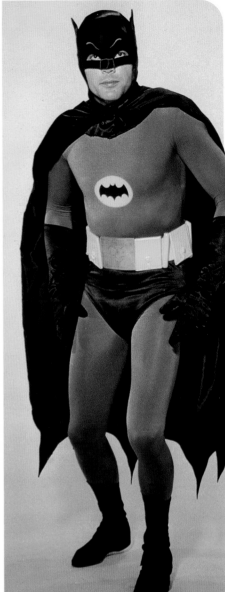

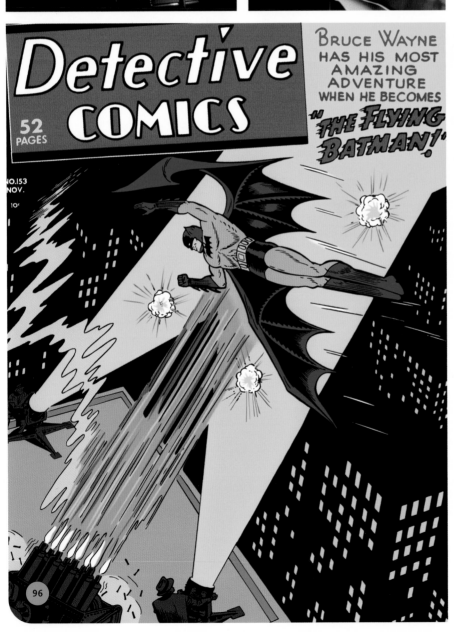

Detective COMICS

52 PAGES

NO.153
NOV.
10¢

BRUCE WAYNE HAS HIS MOST AMAZING ADVENTURE WHEN HE BECOMES "THE FLYING BATMAN!"

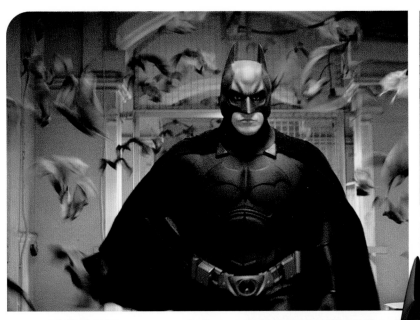

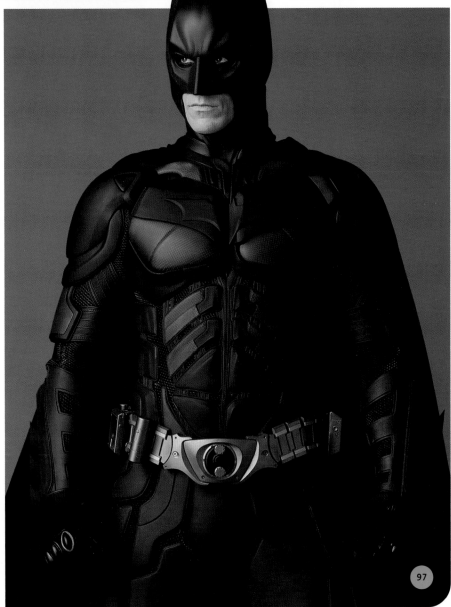

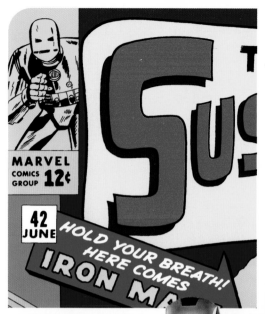

MARVEL COMICS GROUP 12¢

42
JUNE

HOLD YOUR BREATH!
HERE COMES
IRON MA...

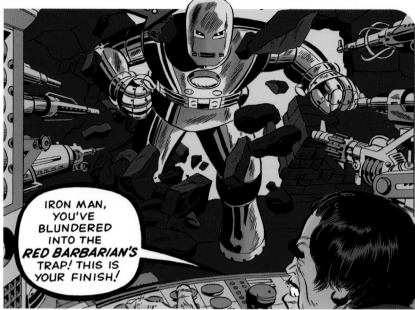

IRON MAN, YOU'VE BLUNDERED INTO THE *RED BARBARIAN'S* TRAP! THIS IS YOUR FINISH!

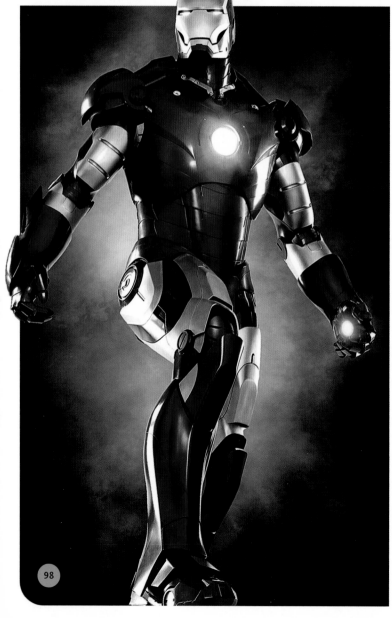

THE INVINCIBLE
IRON MAN

BIG

MARVEL COMICS GROUP 12¢ 1

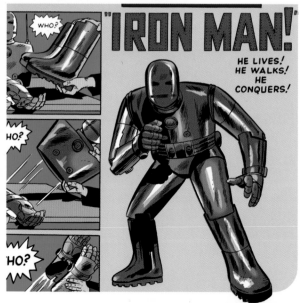

WHO?

HO?

HO?

"IRON MAN!"

HE LIVES!
HE WALKS!
HE CONQUERS!

and the supernatural—as well as its modus operandi—concealment, stealth, and surprise. Indeed, its primary function is camouflage, shrouding the Caped Crusader in darkness and imbuing him with the phantom-like elusiveness of shadows. Batman's restrained sobriety stands in stark contrast to Superman's flamboyant Technicolor. In his ascetic austerity, Batman recalls the figure of the late-eighteenth- and early-nineteenth-century dandy as exemplified by Beau Brummell. Jules Barbey D'Aurevilly noted Brummell's "Air of indifference which he wore like armor, and which made him invulnerable," or, as Barbey then added, "which made him appear invulnerable." Batman's sublime, nocturnal self-containment conveys a similar illusion of invincibility, one that allows him to fight crime alongside his more powerful brethren.

The armored body reaches its apogee in Iron Man, another non-superpowered superhero. Created by writers Stan Lee and Larry Lieber and artists Don Heck and Jack Kirby, he made his first appearance in *Tales of Suspense* No. 39, March 1963. The product of the Cold War, specifically the Vietnam War, Iron Man's costume, like that of so many superheroes, is linked directly to his origin. Tony Stark, munitions manufacturer, visits Vietnam to oversee experiments of his miniaturized transistors, which he tells a general are "capable of solving your problem in Vietnam." A booby trap, which lodges pieces of shrapnel near his heart, results in his capture by the Viet Cong. On learning that he is an inventor, they trick him into designing weapons in exchange for a false promise to remove the shrapnel. Instead, he builds a suit of armor with a life-sustaining pacemaker from scrap iron. Over the next few issues, the armor is redesigned, initially as a golden version of the original and then as the red-and-gold armor that has become his trademark. Transforming Tony Stark into a machine, it quite literally embodies his power. Like Batman, Iron Man serves as an effective metaphor for defensive paranoia, for our fears about human weaknesses, limitations, and vulnerabilities. At the same time, he acts as a metaphor for our social reality, in which the distance between the body and technology is fast disappearing. Both metaphors find resonance in the work of Thierry Mugler, Dolce & Gabbana, Pierre Cardin, Nicolas Ghesquiere, Rudi Gernreich, and Gareth Pugh. In their embrace of the spectacle of the armored body, these designers invoke a heightened, even exaggerated awareness of the frailties of the flesh. Muscle and metal, skin and chromium coalesce to create a hybrid iconography of the body, as if poised in mid-transformation between human and machine. Bodies are presented as rigid and plastic, armored and supple. But whether encased in metal or chromium, the body itself is never denied. As Scott Bukatman has observed in relation to armored, cyborgian superheroes, "The body may be 'simulated, morphed, modified, retooled, genetically engineered, and even dissolved,' but it is never entirely eliminated: the subject always retains a meat component." The armored body, with its projection of implacable strength and indestructible power, shields at its core the essential humanity and touching vulnerability of the mortal superhero.

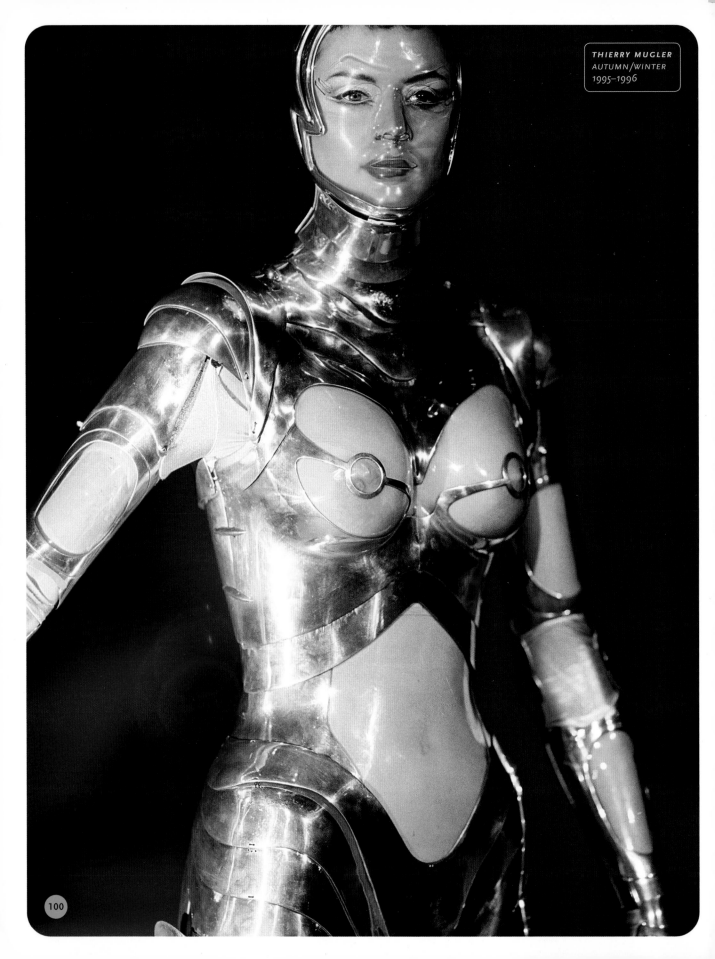

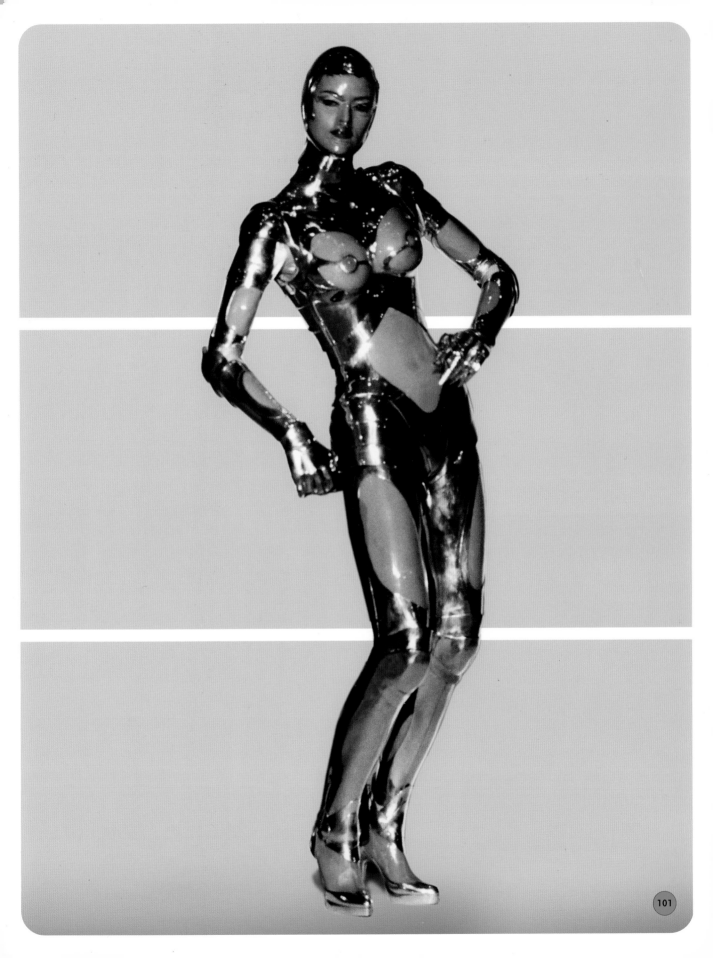

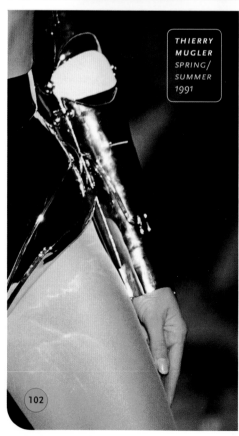

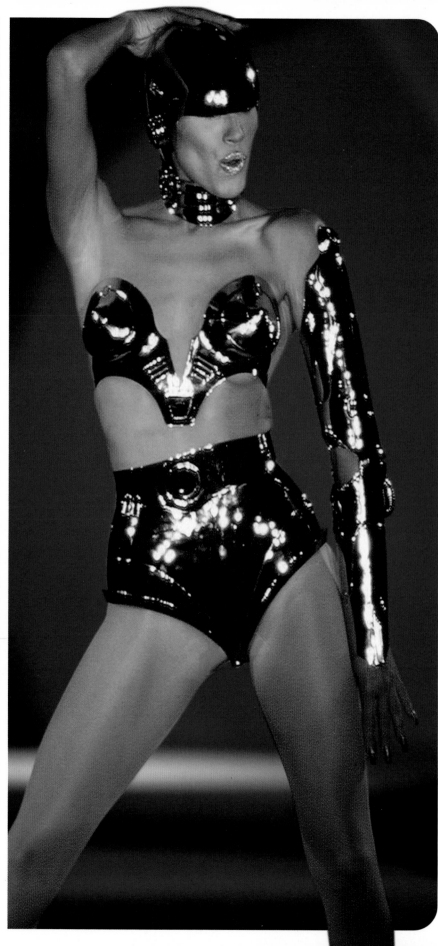

THIERRY
MUGLER
SPRING/
SUMMER
1991

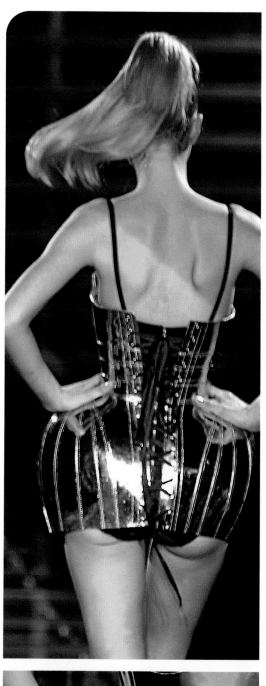

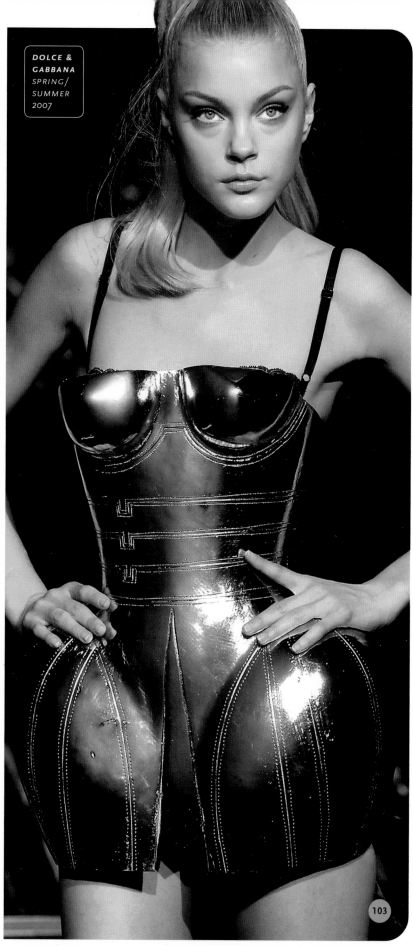

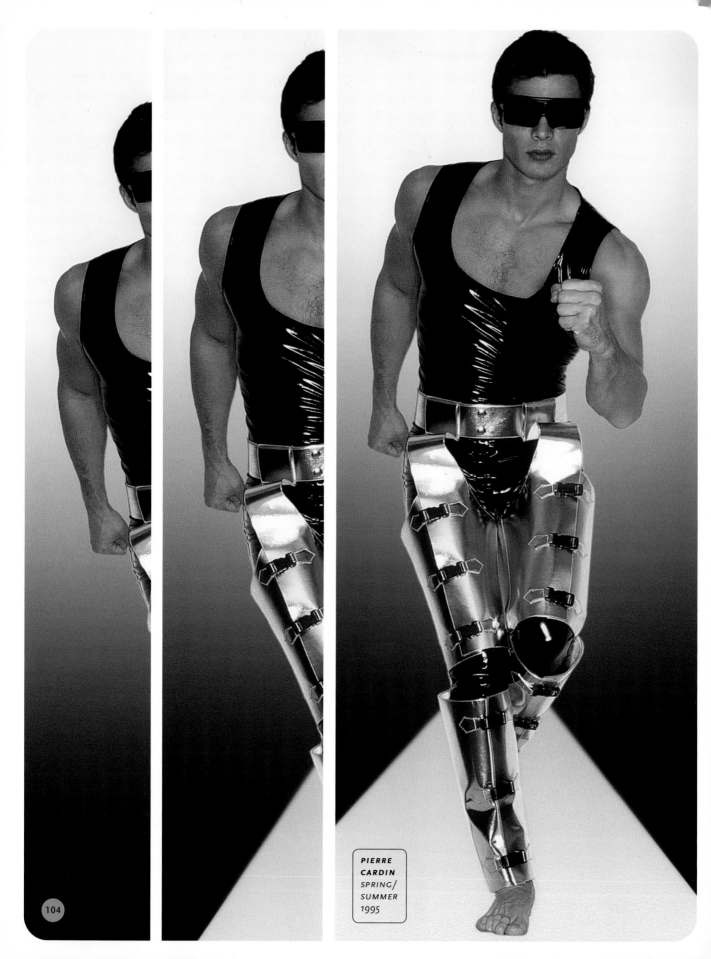

PIERRE
CARDIN
SPRING/
SUMMER
1995

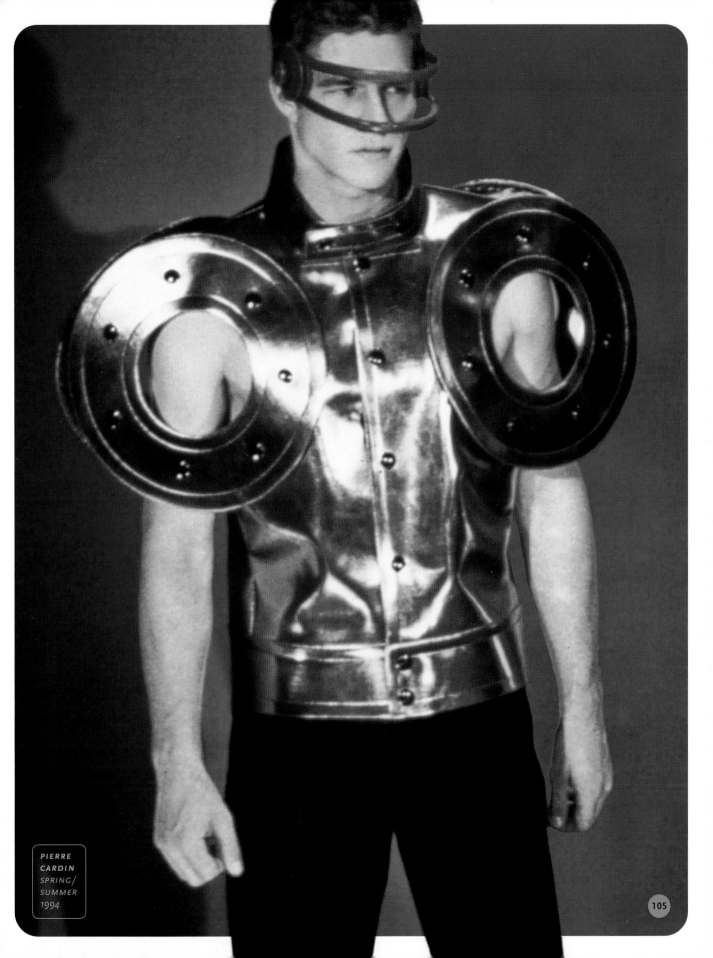

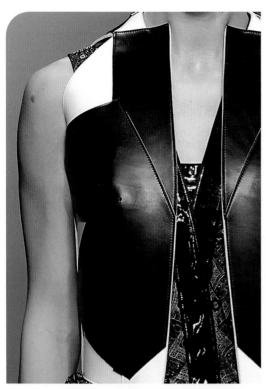

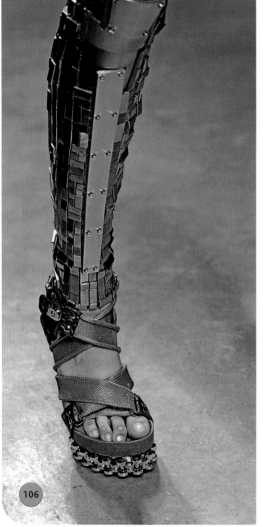

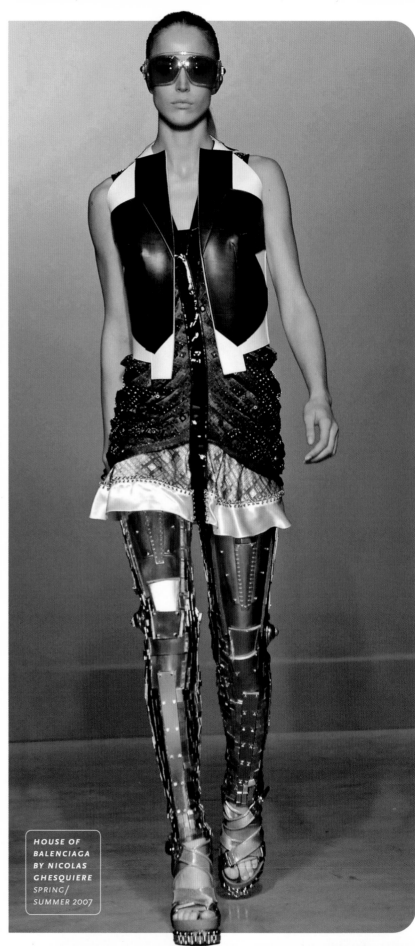

HOUSE OF
BALENCIAGA
BY NICOLAS
GHESQUIERE
*SPRING/
SUMMER 2007*

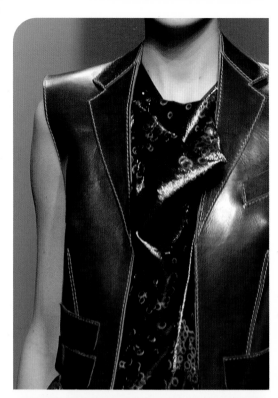

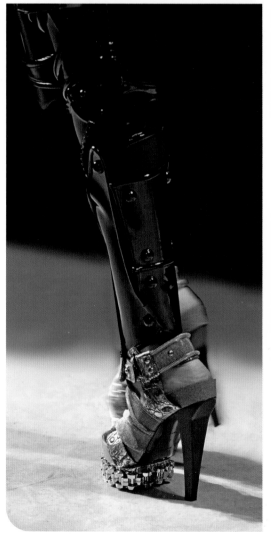

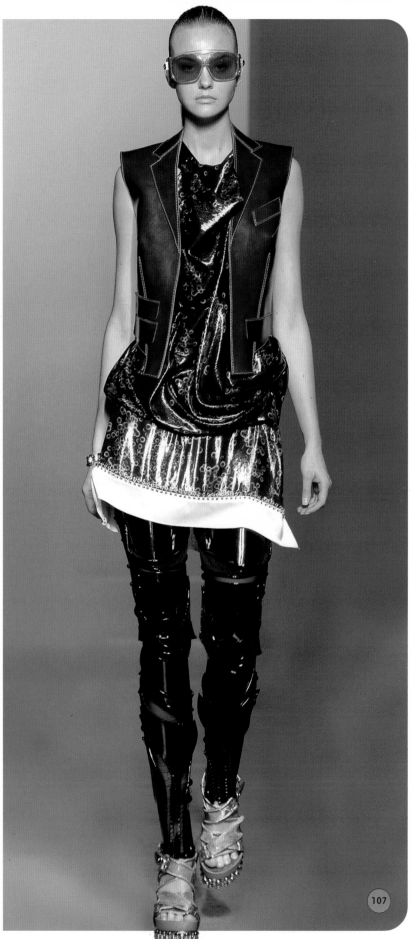

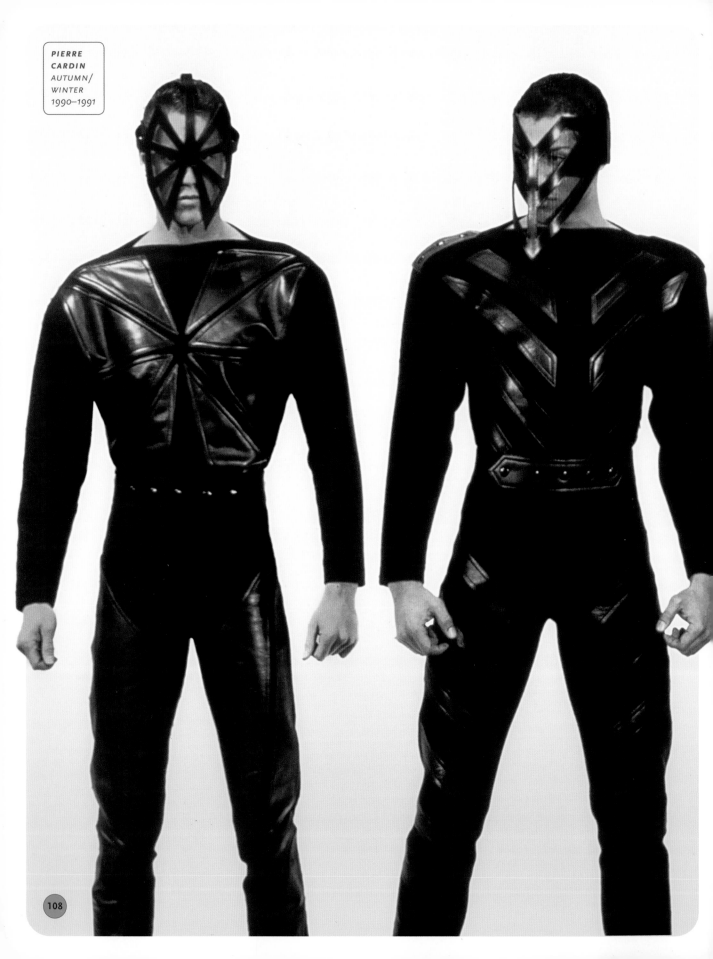

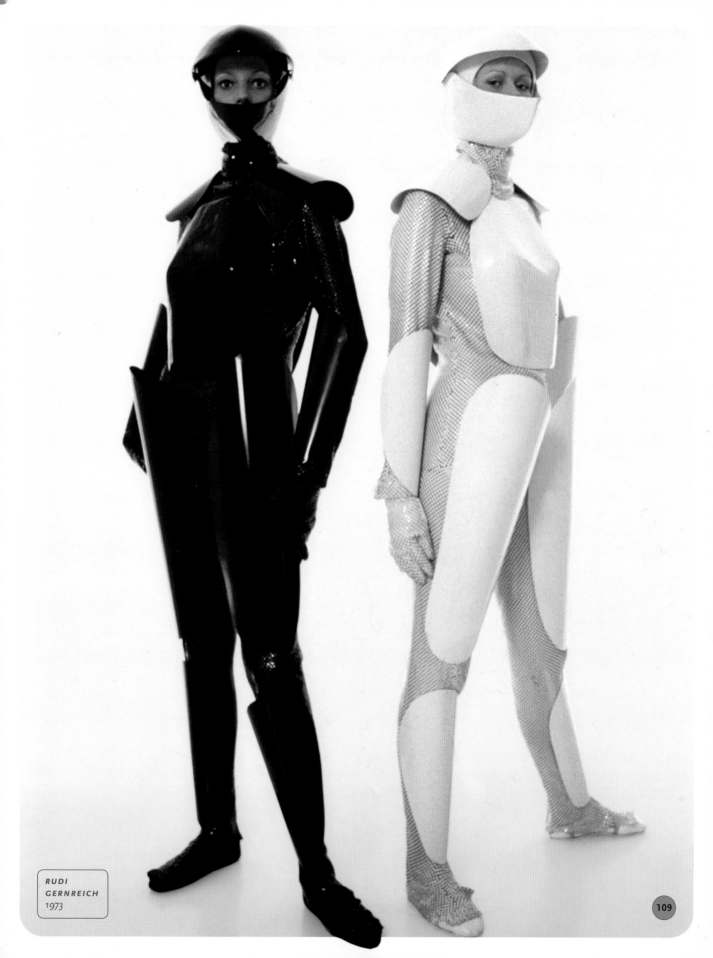

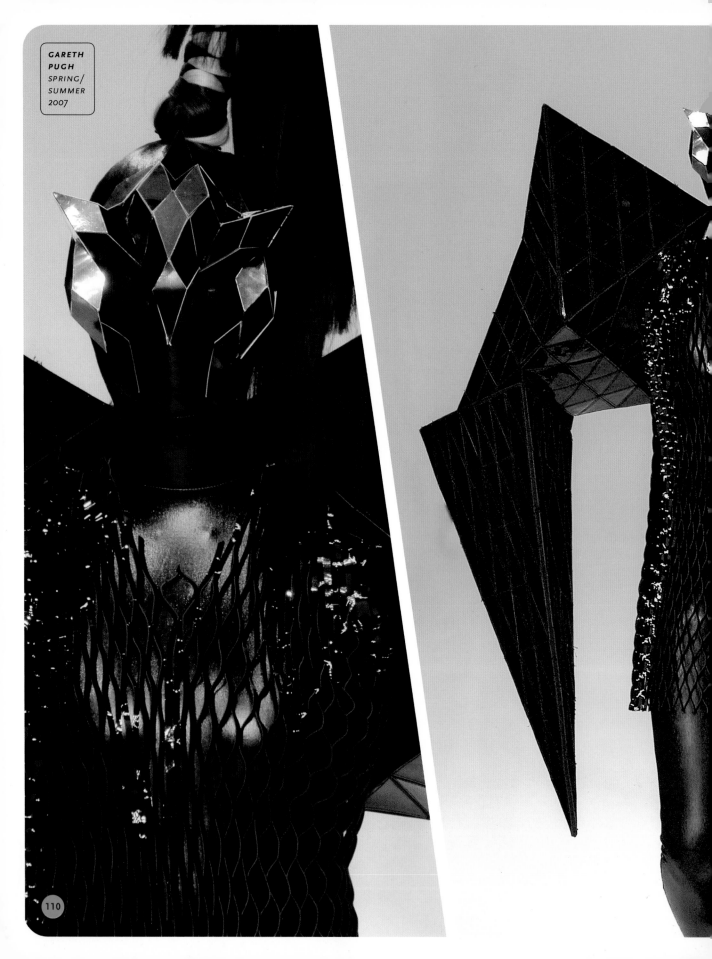

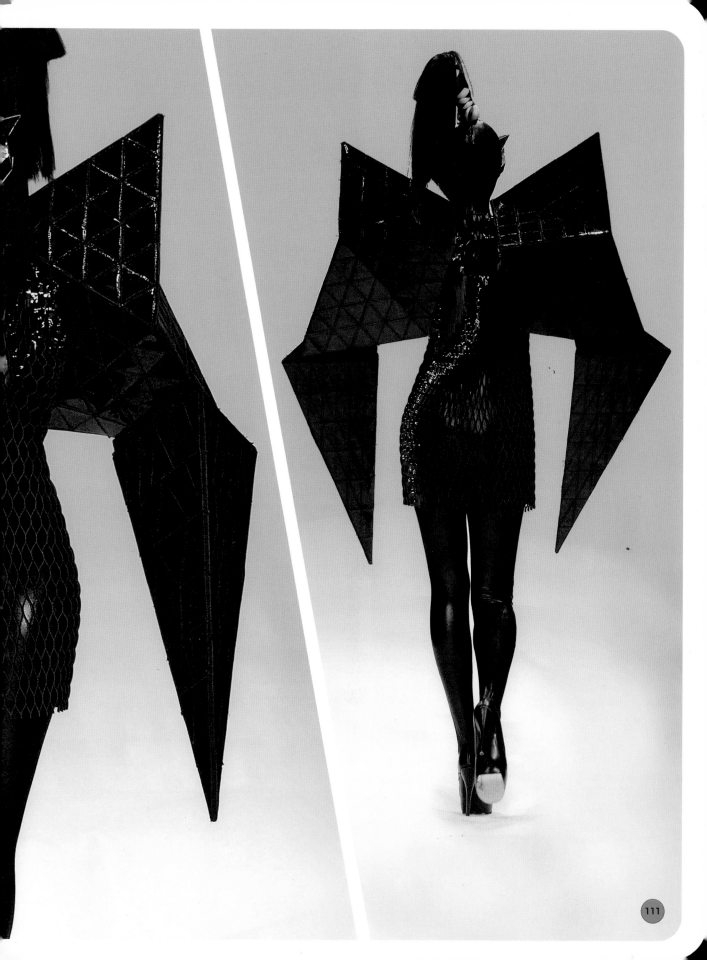

THE AERO-DYNAMIC BODY

Power is central to the definition of the superhero. Power that is transcendent, power that violates the laws of physics, power that surpasses the physical confines of humanity. Most superheroes are gifted with multiple powers, as is Superman, who originally displayed superspeed, superstrength, superleaping, and invulnerability. Over the years, Superman's powers greatly expanded to include flight, X-ray vision, superbreath, and even superventriloquism. Less common are single-powered superheroes, the preeminent archetype of which is The Flash. As devised by writer Gardner Fox and artist Harry Lampert, he possesses superspeed, which includes the ability to "talk, think, act, and run faster than any human being on earth." But in true comic-book style, The Flash uses his speed to produce a range of superpowered effects, such as time travel, whirlwinds, invisibility, intangibility, and appearing to be in more than one place. The Flash, therefore, represents multiple powers conflated into a single power.

Four different characters have assumed the identity of The Flash since his debut in *Flash Comics* No. 1, January 1940. The first was Jay Garrick, a college science student who acquired his superspeed through inhaling "hard water" vapors. His costume consisted of a red shirt inscribed with a stylized lightning bolt and blue trousers, accessorized with a blue metal helmet and red ankle boots adorned with wings. While the lightning symbol served to emblematize his identity and externalize his power, the wings, which drew on the iconography of the Greek god Hermes, invoked mythical speedsters. It was Barry Allen, the second incarnation of The Flash (and the subject of the 1990 television series *The Flash* starring John Wesley Shipp), who first wore the sleek, scarlet bodysuit that has become the character's trademark. Allen was a police scientist who gained his power when a lightning bolt hit a rack of chemicals in his laboratory, dousing him with a mix of electrified solutions. The unitard, which Allen stored in his ring and which expanded on contact with air, retained, in modified forms, the iconographical details of the original costume.

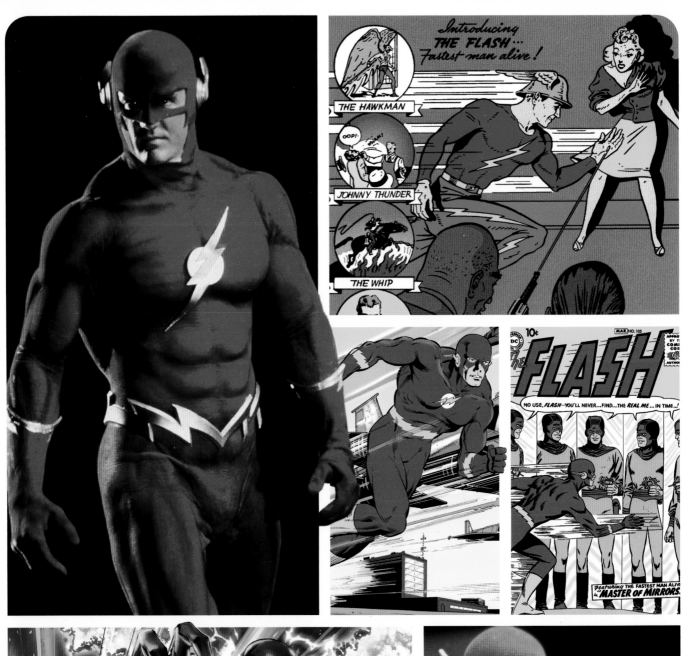

Introducing THE FLASH... Fastest man alive!

THE HAWKMAN

OOP!

JOHNNY THUNDER

THE WHIP

10¢ MAR. NO. 105

DC

The FLASH

NO USE, *FLASH*--YOU'LL NEVER...FIND...THE *REAL ME*...IN TIME...!

Featuring THE FASTEST MAN ALIVE in "MASTER OF MIRRORS!"

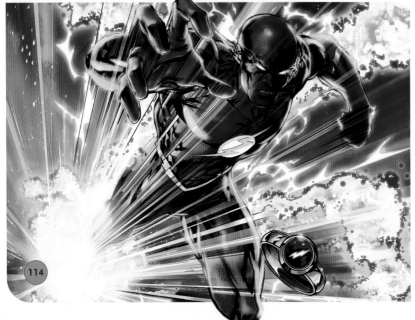

Wally West and Bart Allen, the third and fourth incarnations of The Flash, wore facsimiles of Allen's costume. Both characters were related to Allen (Wally West was his nephew and Bart Allen was his grandson). West even gained his power through an accident identical to Allen's.

Given that speed was one of the principal concerns of the twentieth century, it is unsurprising, perhaps, that the first single-powered superhero should be The Flash. Only eight years before the "Scarlet Speedster" first graced the pages of a comic book, Norman Bel Geddes wrote, "Speed is the cry of our era, and greater speed one of the goals of tomorrow." Certainly, speed was the clarion call of Futurism. In his *Manifesto of Futurism* (1909), Filippo Tommaso Marinetti wrote, "We affirm that the world's magnificence has been enriched by a new beauty: the beauty of speed." Some Futurists, notably Giacomo Balla, translated the Futurist ideal of speed into prescriptive designs for dress. In his *Futurist Manifesto of Men's Clothing* (1913), Balla wrote, "We want Futurist clothes to be comfortable and practical ... dynamic ... energetic ... flying...." Similarly, Volt (aka Vincenzo Fani) spoke of speed in his *Manifesto of Women's Futurist Fashion* (1920), proclaiming, "In woman we can idealize the most fascinating conquests of modern life. And so we will have ... the airplane woman, the submarine woman, the motorboat woman." Volt's vision came to be realized, quite literally, in the superhero, the best ones of which, like The Flash, are graced with the power of advanced velocity.

Superspeed, however, is no longer the preserve of the superhero. Through advances in clothing technology, the gap between fictional superheroes and real-life superheroes is diminishing. Jean Paul Gaultier explored this nexus between fiction and reality in his "Femmes Amazone" collection, which included a series of bodysuits that quoted the aerodynamics of The Flash. While the streamlined styling of Gaultier's bodysuits is an evocation of speed, that of Eiko Ishioka's "Muscle Suit," Nike's "Swift Suit," and Speedo's "Fastskin" suits, are a functional necessity. All three types of bodysuits are aerodynamic solutions to the problem of passive drag. Made from superstretch fabrics that mold to the body like a second skin, they rely on unique seaming and innovative textural surfacing to decrease friction and increase velocity. Atair Aerospace's "Twin-Turbine Powered Exoskeleton Wing Suit," which expands the concept of skydiving into skyflying, allows its wearer to reach speeds of more than two hundred miles per hour. The body's natural capacity for speed was the point of departure for Hussein Chalayan's "Echoform" collection, which featured garments that drew upon the concept of the "man-machine," including an "Aeroplane Dress" that relied on technology from the aircraft industry. Other dresses were inspired by the interiors of cars and featured "neck cushions" based on car seat headrests. For Chalayan, speed transcends the notion of movement to become a symbol, and, ultimately, a form to be developed. As with The Flash's costume, Chalayan's poetic representations of the aerodynamic body serve as metaphors for freedom, efficacy, and progress.

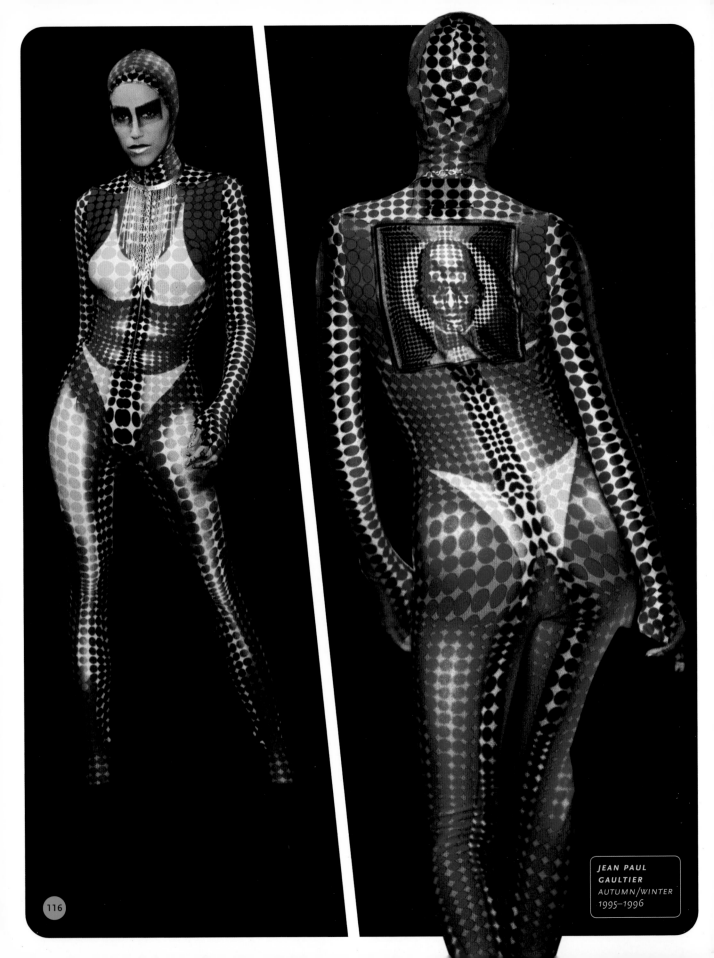

JEAN PAUL
GAULTIER
AUTUMN/WINTER
1995–1996

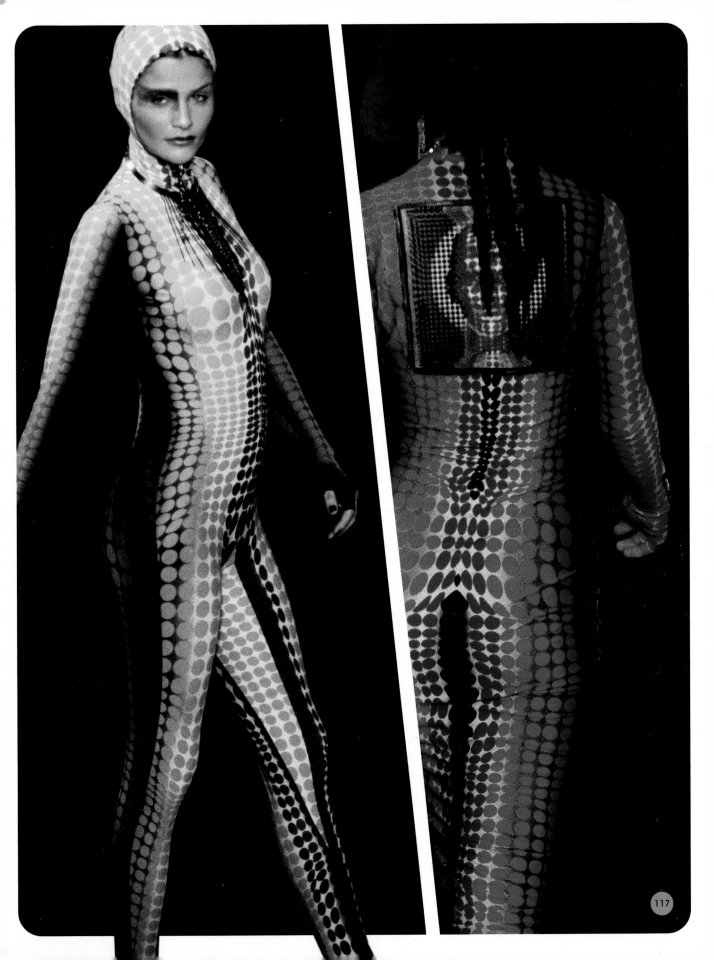

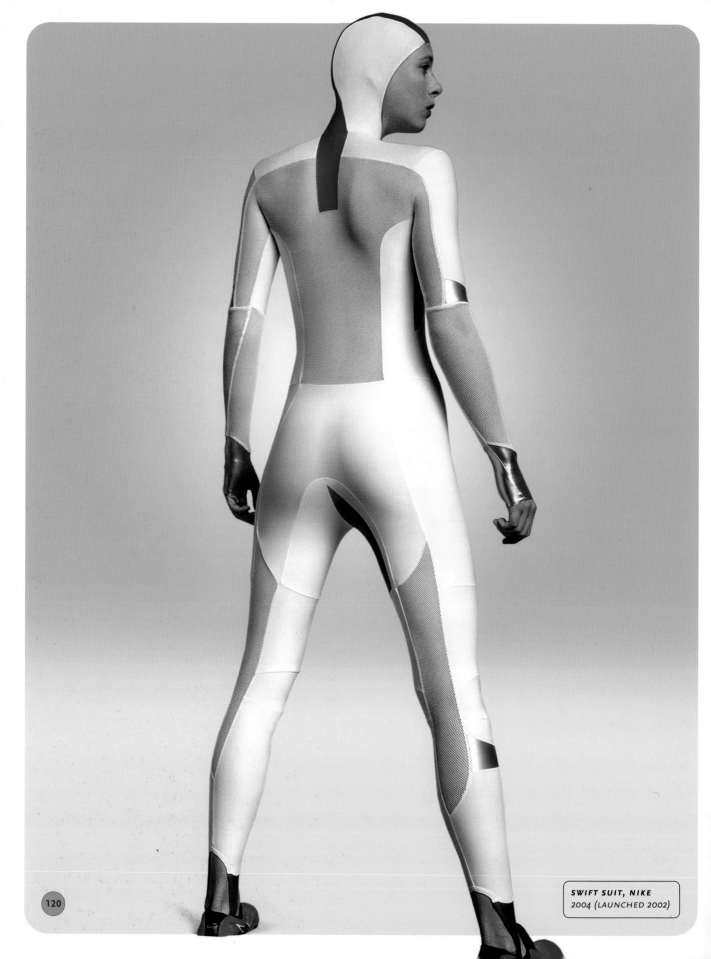

SWIFT SUIT, NIKE
2004 (LAUNCHED 2002)

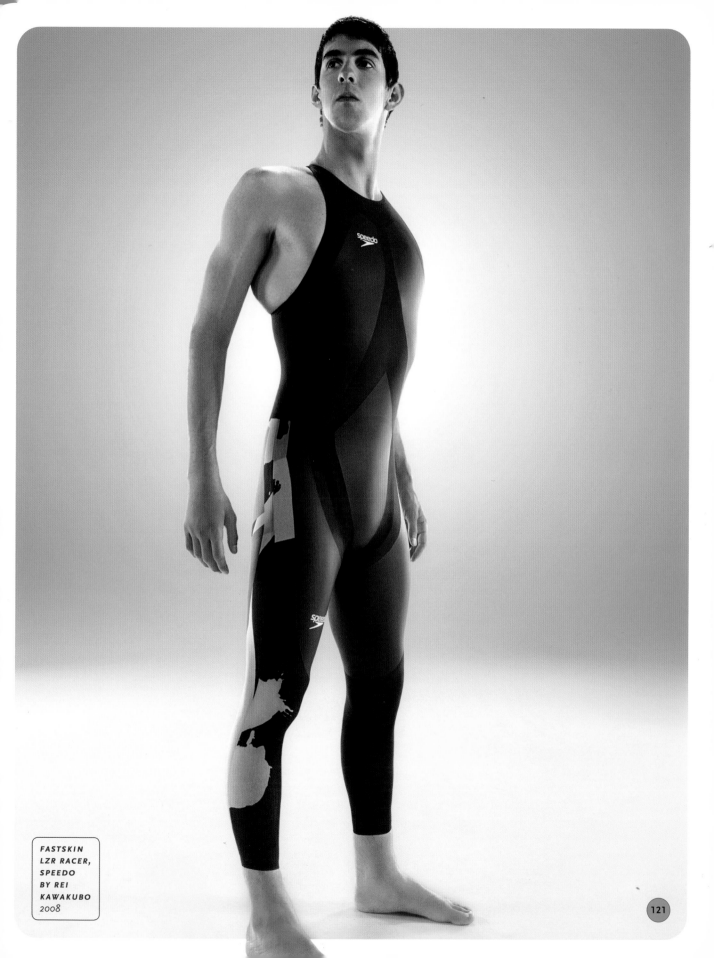

FASTSKIN
LZR RACER,
SPEEDO
BY REI
KAWAKUBO
2008

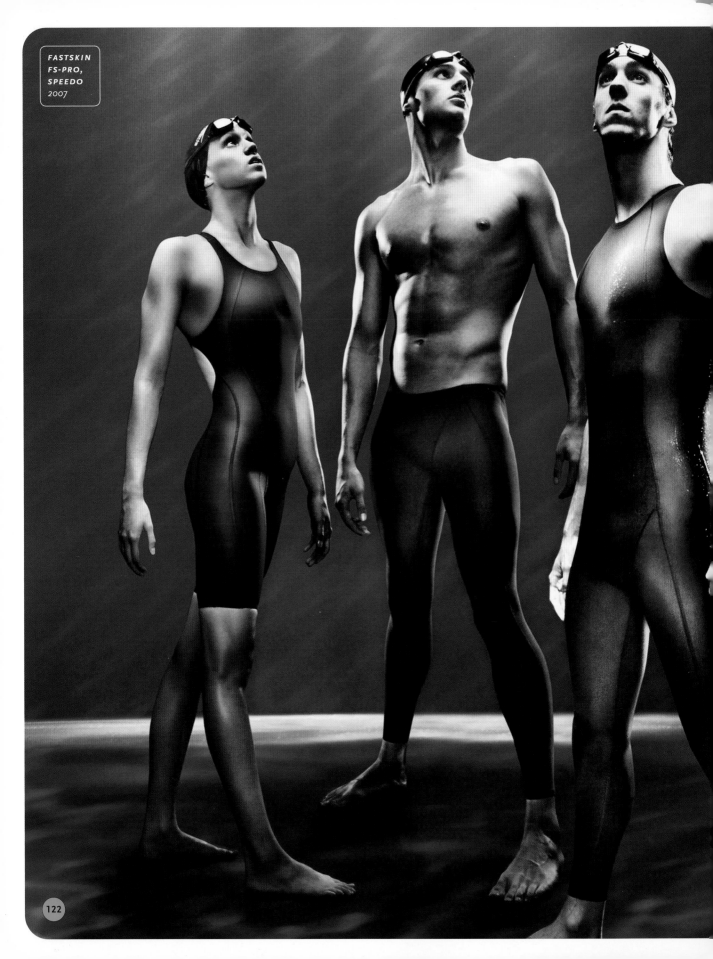

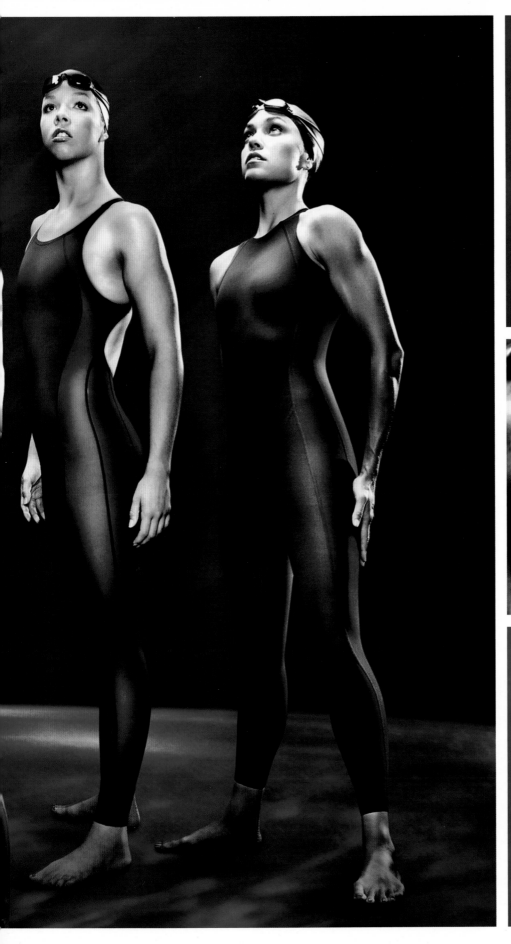

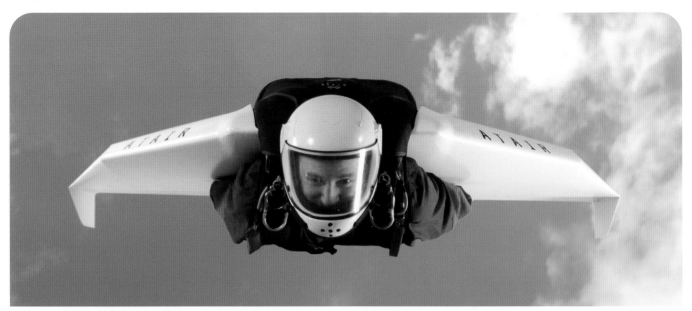

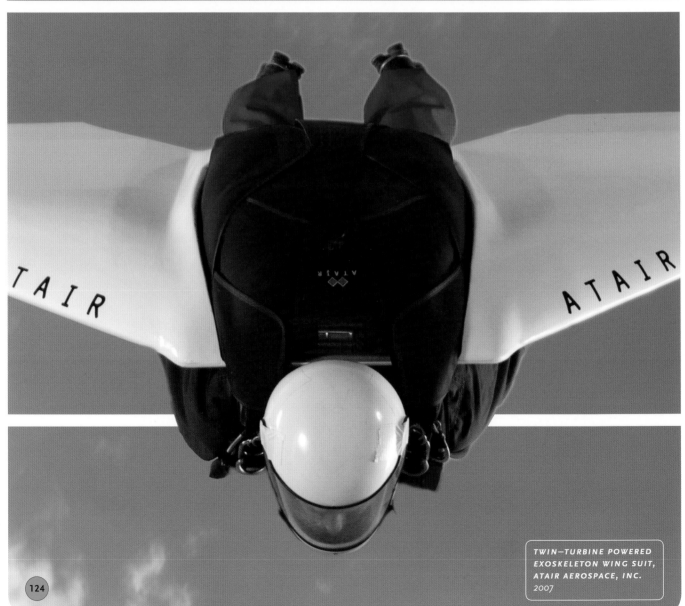

TWIN—TURBINE POWERED
EXOSKELETON WING SUIT,
ATAIR AEROSPACE, INC.
2007

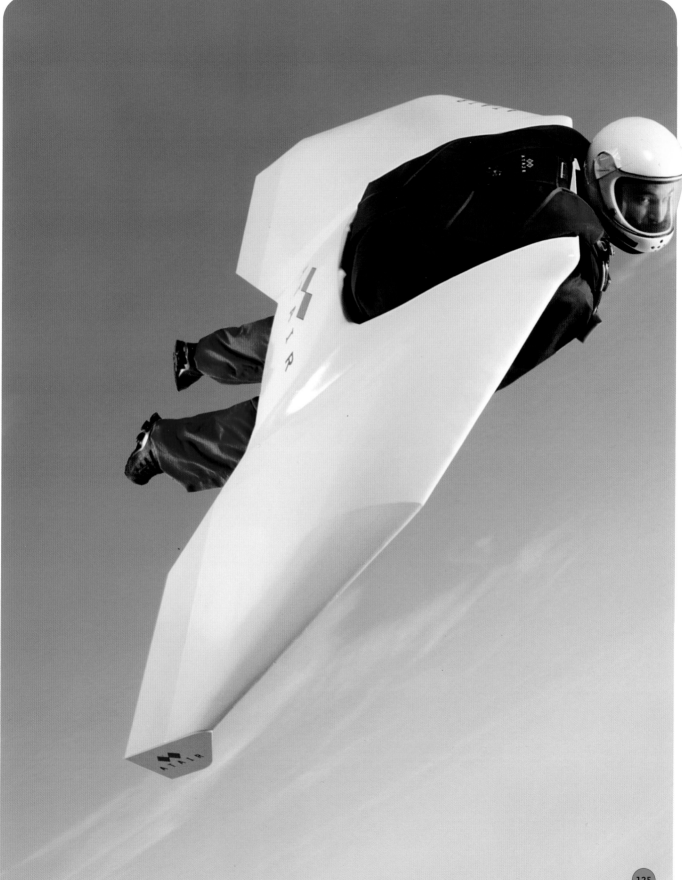

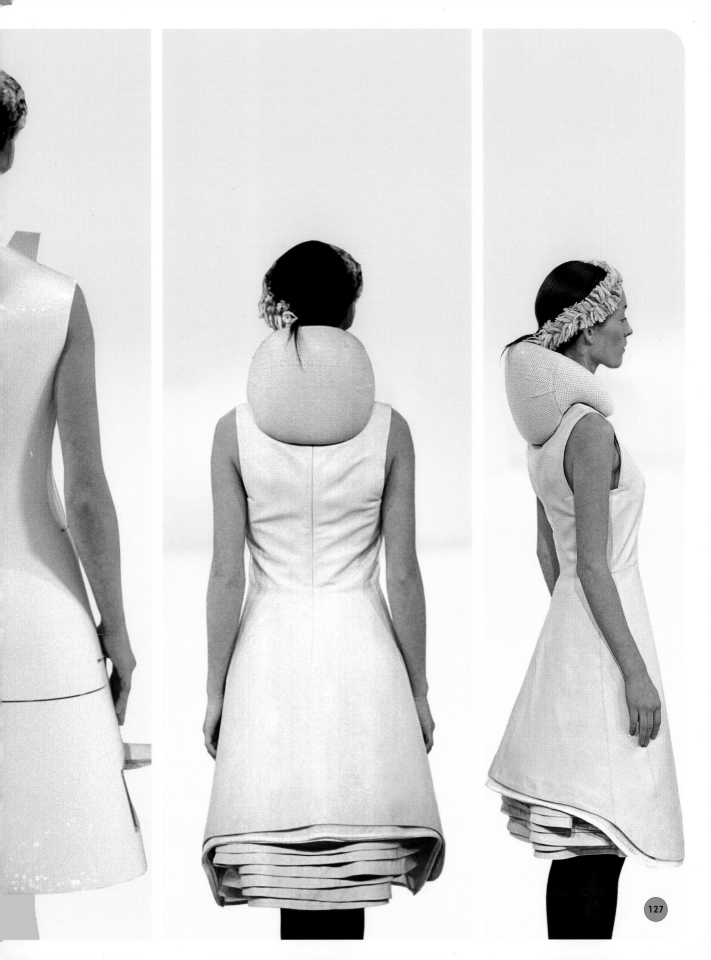

THE MUTANT BODY

While all superheroes represent fantasies of metamorphosis, mutant superheroes embody the agonies rather than the ecstasies of transformation. As epitomized by the X-Men, mutants are genetic accidents, or as Scott Bukatman has referred to them, "categorical mistakes." The results of increased radiation in the atmosphere, several mutants display bizarre, even grotesque, physical characteristics. Born with extraordinary superpowers, which usually develop at puberty, they are regarded by a number of scientists as the dawn of a new evolutionary phase. As such, they are widely viewed as a danger to human civilization and are generally feared and reviled by society. Consequently, many mutants regard their powers as a burden, as stigmata that must be disguised or concealed for fear of rejection and repression. In fact, as the psychologist Mikhail Lyubansky has observed, "The X-Men are less about superpowers and more about human tendencies to fear and hate those who are different." Indeed, over the years, the X-Men have come to serve as objects of prejudice, intolerance, and oppression.

Created by writer Stan Lee and artist Jack Kirby, the X-Men first appeared in *The X-Men* No. 1, September 1963. Their code name is a reference not only to the X gene or "X factor" that causes mutant evolution, but also to Professor Charles Xavier (aka Professor X), who founded the X-Men team. A paraplegic telepath, Professor X teaches mutants how to control and contain their powers at his School for Gifted Youngsters. Since their first and most perilous enemies are their own bodies, he teaches them how to protect and buttress themselves against themselves. Above all, he offers mutants a sanctuary from a world of fear, hatred, and persecution, providing them with a surrogate or substitute family, a model for tolerance, acceptance, cooperation, and, ultimately, belonging. The original X-Men consisted of Angel (Warren Worthington III), Beast (Hank McCoy), Cyclops (Scott Summers), Iceman (Bobby Drake), and Marvel Girl (Jean Grey). All were adolescents, whose bodies were erratic and eruptive, and whose powers were unpredictable and uncontrollable. In effect, they represented metaphors for

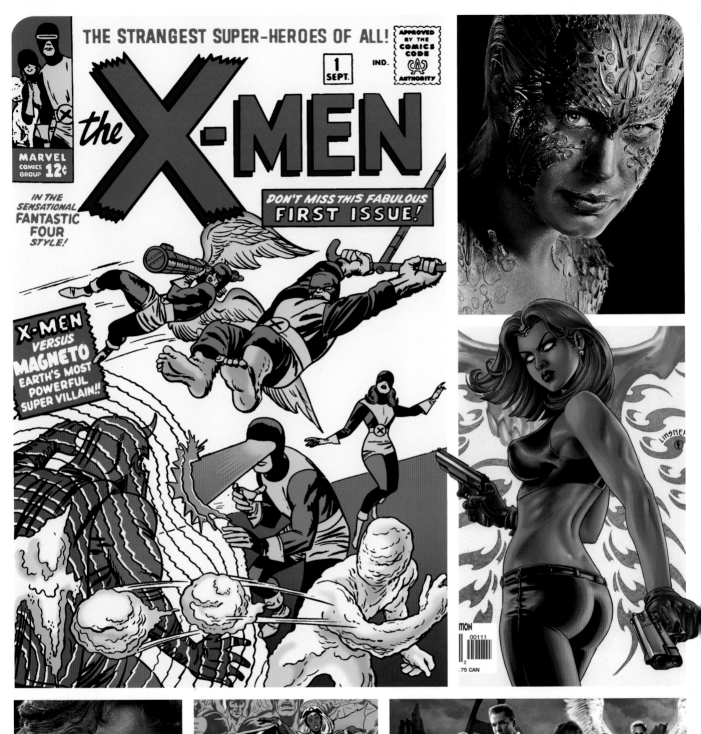

THE STRANGEST SUPER-HEROES OF ALL!

APPROVED BY THE COMICS CODE AUTHORITY

1 SEPT. IND.

the **X-MEN**

MARVEL COMICS GROUP 12¢

IN THE SENSATIONAL FANTASTIC FOUR STYLE!

DON'T MISS THIS FABULOUS FIRST ISSUE!

X-MEN VERSUS **MAGNETO** EARTH'S MOST POWERFUL SUPER VILLAIN!!

adolescent alienation and disaffection, embodiments of the (adult) anxieties surrounding teenagers and their seething emotions and hormones.

The theme of bigotry became more explicit when the X-Men were revamped in *Giant-Size X-Men* No. 1, May 1975. Hailed as the "all-new, all-different X-Men," the team, hitherto all white, was both racially and ethnically diverse. Conceived by writer Len Wein and artist Dave Cockrum, the ensemble, which was headed by Cyclops, included an Apache with superspeed (Thunderbird/John Proudstar), a German teleporter (Nightcrawler/Kurt Wagner), a Japanese with solar radiation powers (Sunfire/Shiro Yoshida), an African with power over the weather (Storm/Ororo Munroe), an Irish ex-villain with a powerful "sonic scream" (Banshee/Sean Cassidy), a Russian who could transform his body into "living steel" (Colossus/Piotr Nikolaievitch Rasputin), and a Canadian with an adamantine skeletal structure and retractable claws (Wolverine/James Howlett). While intended as symbols of the racial and ethnic "other," the X-Men quickly became signifiers of any minority, with antimutant behavior serving as veiled expressions of misogyny, homophobia, and anti-Semitism. As Scott Bukatman has observed, "Mutant bodies are explicitly analogized to Jewish bodies, gay bodies, adolescent bodies, Japanese or Native or African American bodies—they are, first and foremost, subjected and subjugated and colonized figures. If they are victims, however, they are also valuable sources of disruption and challenge—transgressive, uncontrollable, and alternative bodies."

As the site of both commotion and contravention, the mutant body is coincident with the fashionable body. Not unlike comic books, fashion celebrates diversity, difference, and distinction. In terms of its influences and inspirations, it is the first to welcome the outcast or outsider into its midst. And while fashion is known to be the progenitor of idealized, and indeed tyrannical, standards of beauty, it is also known to be fiercely critical of those standards, offering radical, and frequently reactionary, alternatives. Since the 1980s, in particular, fashion has been characterized by its denouncement and destabilization of normative conventions of beauty. Designers like Thierry Mugler, Alexander McQueen, and more recently (although less consistently) ThreeAsFour (formerly As Four), have all gained reputations for challenging the "beautiful people" aesthetic. For them, the body is the place where normalcy is questioned, where the spectacle of marginality and eccentricity is embraced and celebrated. They use the body to transgress corporeal boundaries, to pull the body past its margins and bring into existence new forms of creation. Nowhere is this more evident than in Thierry Mugler's "Chimera" dress, an intensely exaggerated visualization of a body in mutation. Mugler's hybrid possesses the segmented abdomen of an amphibian, the feathered crown of a bird, the iridescent scales of a fish, and the long, wiry hair of a mammal. It is a missing link that effaces the ontological distinction between human and animal. In its catalogue of corporeal citations, the dress transcends sex, gender, and even biology. Like the mutant bodies of the X-Men, it challenges us to open ourselves to the beauty of difference through a liberating embrace of the unfamiliar and unorthodox.

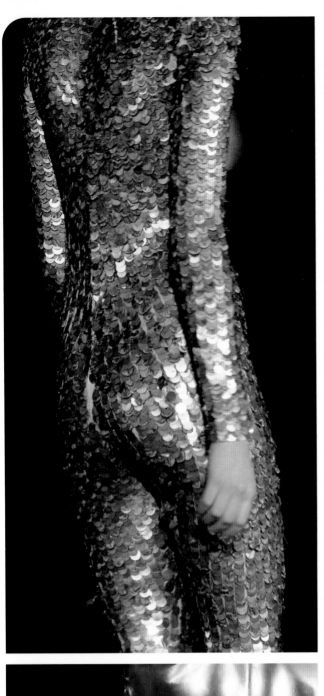

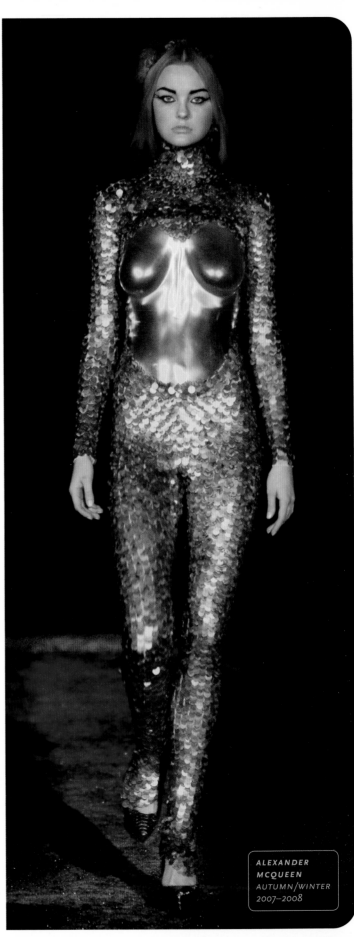

ALEXANDER
MCQUEEN
AUTUMN/WINTER
2007–2008

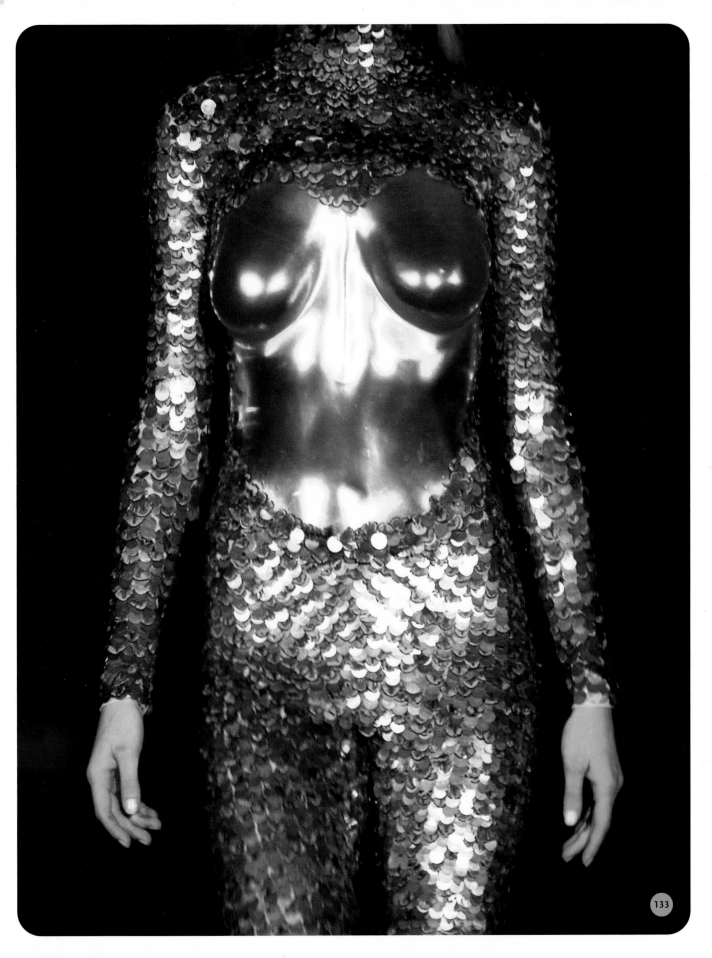

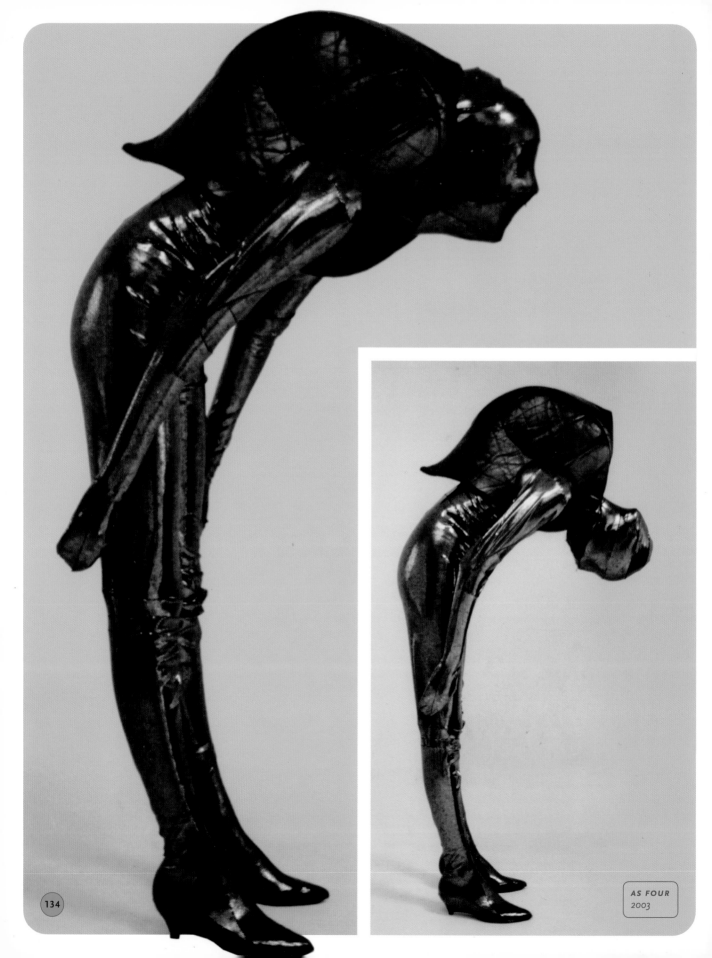

AS FOUR
2003

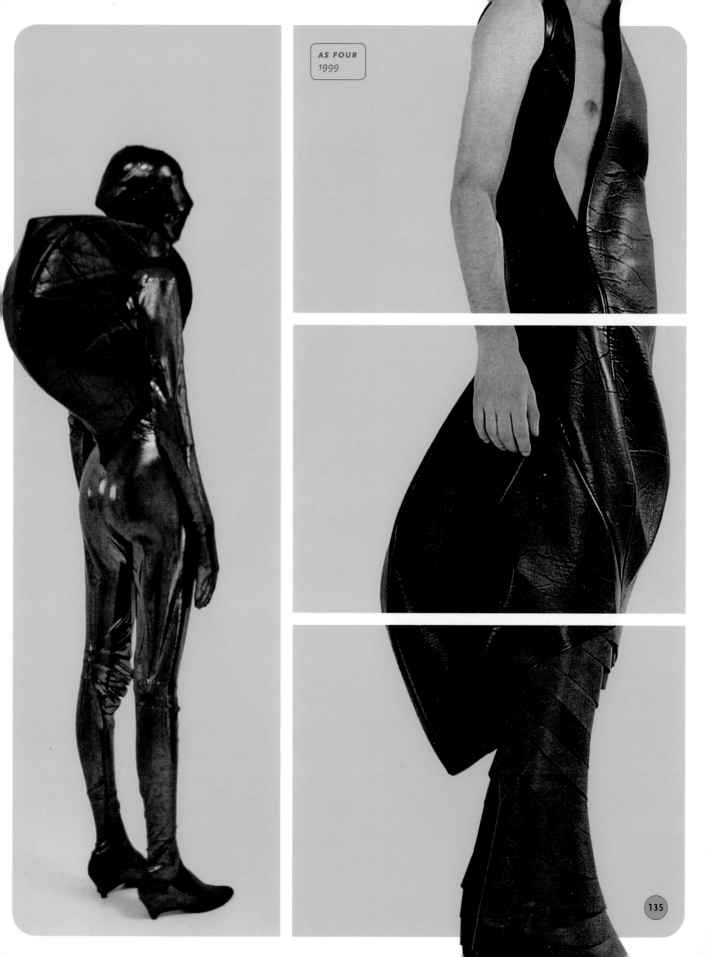

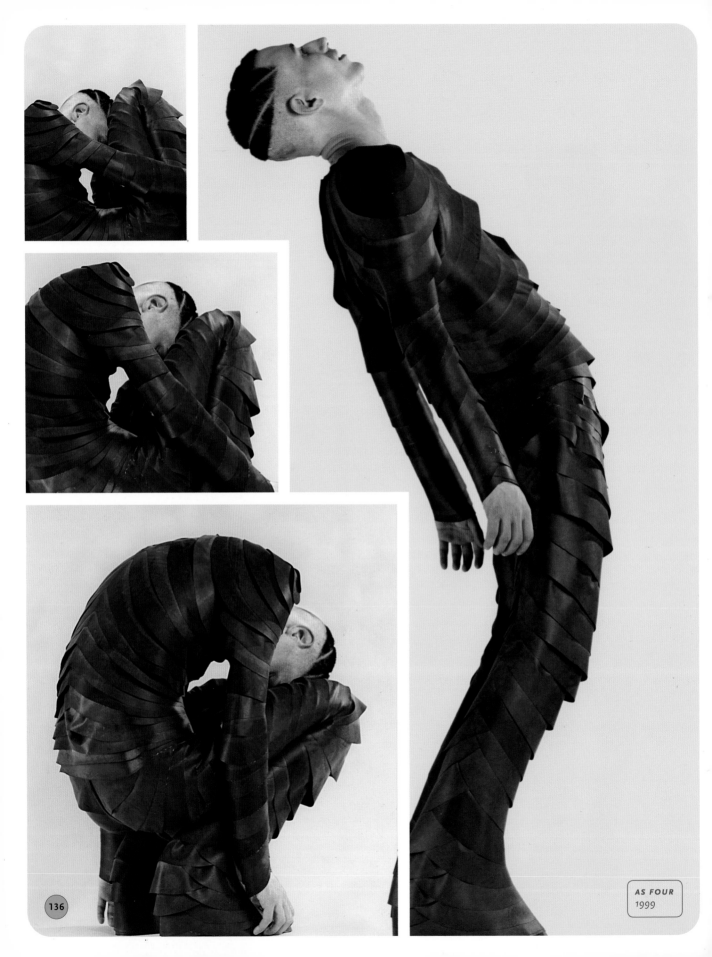

AS FOUR
1999

THIERRY MUGLER
HAUTE COUTURE
SPRING/SUMMER 1997

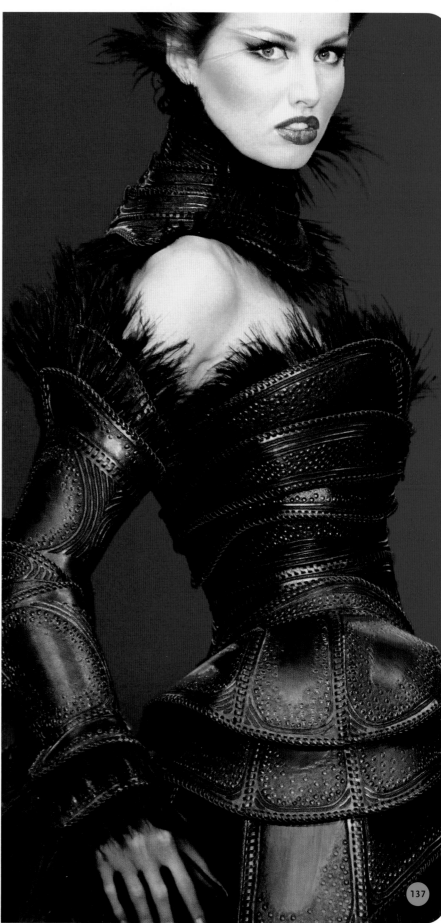

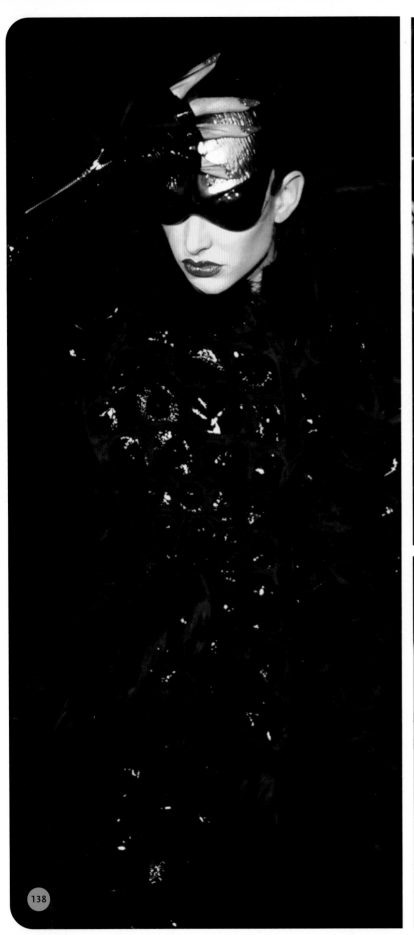

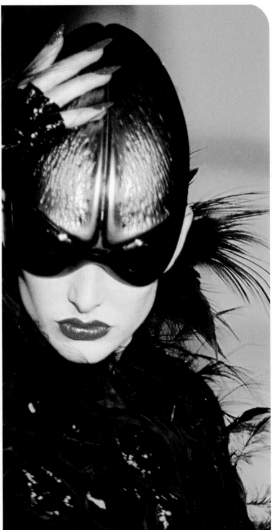

THIERRY MUGLER
HAUTE COUTURE
SPRING/SUMMER 1997

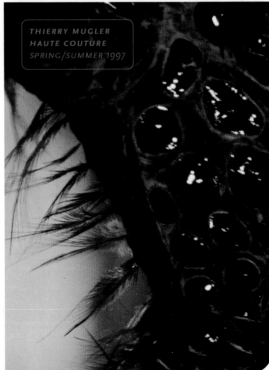

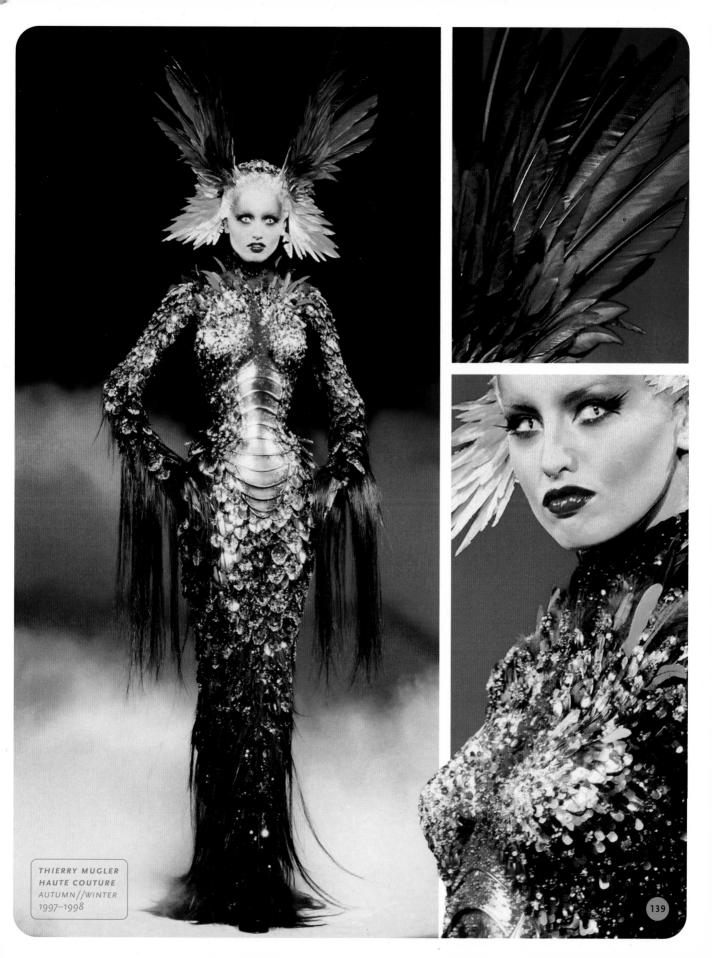

THIERRY MUGLER
HAUTE COUTURE
AUTUMN//WINTER
1997–1998

THE POST-MODERN BODY

As with most other forms of artistic expression, superhero comic books have been influenced significantly by Postmodernism. While in comics the seeds of Postmodernism were planted in the 1970s, it was in the 1980s, during the Iron Age of superhero comics (1980–87), that they took root. Arguably, the first flowering of Postmodernism was *Crisis on Infinite Earths*, a twelve-issue miniseries published by DC Comics from April 1985 through March 1986. Written by Marv Wolfman and drawn by George Pérez, Jerry Ordway, Mike DeCarlo, and Dick Giordano, *Crisis* was an attempt to restore clarity to DC's multiple narratives, which over the years had become plagued with internal contradictions. Most of DC's superheroes, including Batman and Superman, were given a makeover, one that was intended to simplify their histories and eliminate inconsistencies and discontinuities from their backstories. But as Geoff Klock has observed, "*Crisis on Infinite Earths* was not designed to simply change the DC universe, but to retroactively restructure it around a new organizing principle, specifically, the 'adult ethos'." This ethos was embodied in *Batman: The Dark Knight Returns* and *Watchmen*, the two key texts of the 1980s that employ various Postmodern strategies to deconstruct the superhero, including parody and pastiche, revision and reinvigoration, and self-consciousness and self-reflexiveness.

Batman: The Dark Knight Returns, written and penciled by Frank Miller and inked by Klaus Janson, was published as a four-issue series (February–June 1986), and *Watchmen*, written by Alan Moore and illustrated by Dave Gibbons, as a twelve-issue series (September 1986–October 1987). However, both titles form texts that stand alone as graphic novels. Through their concatenation of Postmodernist preoccupations, *Dark Knight* and *Watchmen* are conscious attempts to elevate the cultural prestige of comic books. They represent meditations on the nature of the superhero as well as on the nature of superheroism. Before the 1980s, heroes were seen as a social and political necessity, but *Dark Knight* and *Watchmen* questioned the absolutism of this

Text on image 4:

P. 142 *(clockwise from top left)*

Thomas Jane in *The Punisher*, 2004.
Costumes by Lisa Tomczeszyn.

The Punisher, No. 1, July 1987

The Punisher, No. 1, July 1987

Nicholas Cage in *Ghost Rider*, 2007.
Costumes by Lizzy Gardiner.
Ghost Rider created by Sony Pictures
Imageworks (SPI).

Ghost Rider, No. 1, September 1973

Ghost Rider, No. 1, September 1973

assumption. Neither Batman nor Rorschach, the hero of *Watchmen*, enjoys the support of the consensus. Both are depicted as morally ambiguous, and Rorschach, especially, is portrayed as essentially psychotic. Like Batman, Rorschach is a vigilante superhero without superpowers, but unlike Batman, he lacks any veneer of glamour. His alter ego, Walter Kovacs, lives in a filthy bed-sitter owned by a woman he accuses of being a whore. Kovacs's mother was, herself, a prostitute who mistreated him mercilessly, and who died when her pimp forced her to drink a bottle of Drano. He is known for his acrid body odor and his disheveled, down-at-the-heels appearance. His costume, among other items, consists of a trench coat with several missing buttons, and a latex mask with a Rorschach inkblot pattern made from the fabric of a dress that a young woman had ordered, but decided not to purchase, from the factory where he once worked. Rorschach believes the woman to have been murdered in a sexual assault, fueling his resolve to avenge the powerless victims of crime. He has no qualms about killing people, and one of his methods of making criminals talk is breaking their fingers one by one.

Watchmen and *Dark Knight Returns* spawned a movement of "grim-and-gritty guy-with-a-gun" superheroes, the quintessential representation of which was the Punisher. Created by writer Gerry Conway and artists Ross Andru and John Romita Sr., he first appeared in *Amazing Spider-Man* No. 129, February 1974. While popular in the 1970s, his status as an antihero, with a dark, cynical, even nihilistic worldview, ensured his success in the 1980s. In fact, along with Wolverine of the X-Men, the Punisher became the symbol of the Iron Age. Partly inspired by Charles Bronson in *Death Wish* (1974), the Punisher (Frank Castle) is driven to wage a one-man war against crime by the deaths of his wife and children, who were killed by the Mob after witnessing a gangland execution in Central Park. Like Rorschach, he is willing to murder his enemies, a threat made explicit by the death's-head inscribed on his costume. The Punisher's memento mori iconography and grim reaper characterization were literalized in Ghost Rider, another popular superhero of the 1980s. As created by writers Roy Thomas and Gary Friedrich and artist Mike Ploog, Ghost Rider was a supernatural antihero who first appeared in *Marvel Spotlight* No. 5, August 1972. His alter ego is Johnny Blaze, a stunt motorcyclist, who, in order to save the life of his mentor and stepfather, "Crash" Simpson, sold his soul to Satan (later revealed to be the archdemon Mephisto). Blaze's soul was bound to the demon Zarathos, and when using his powers Blaze is transformed into a leather-clad skeleton with a flaming skull. Both Ghost Rider and the Punisher embodied the Iron Age's focus on death, a focus that finds resonance in the costumes of John Galliano, Thierry Mugler, Alexander McQueen, and Walter van Beirendonck. Adorned with skulls, hellfire, and other symbols of mortality, they embody both the multifocal eclecticism and semiological complexity that characterize the Postmodern body of both fiction and fashion and the darker terrors of our contemporary world.

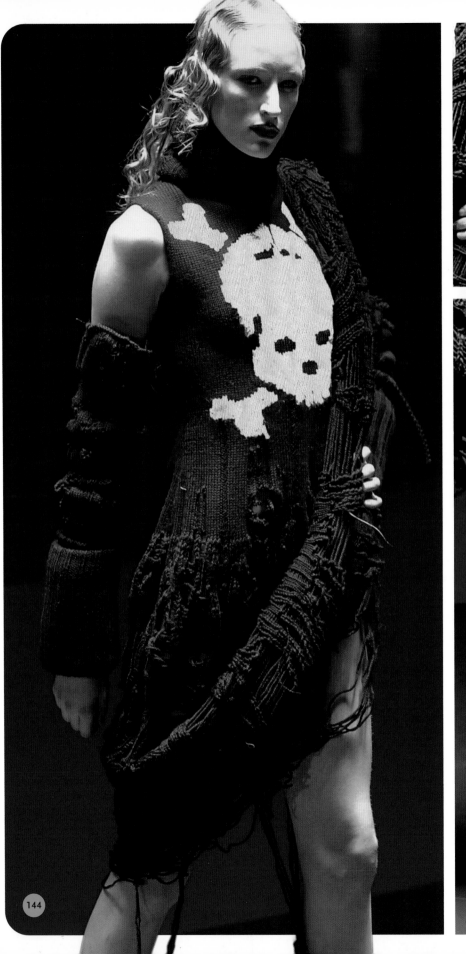

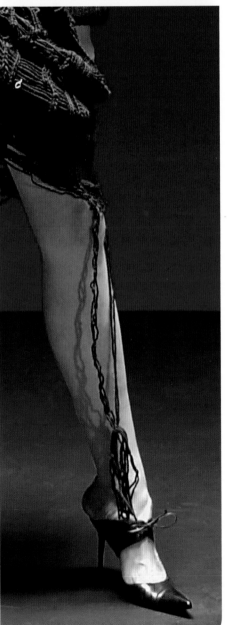

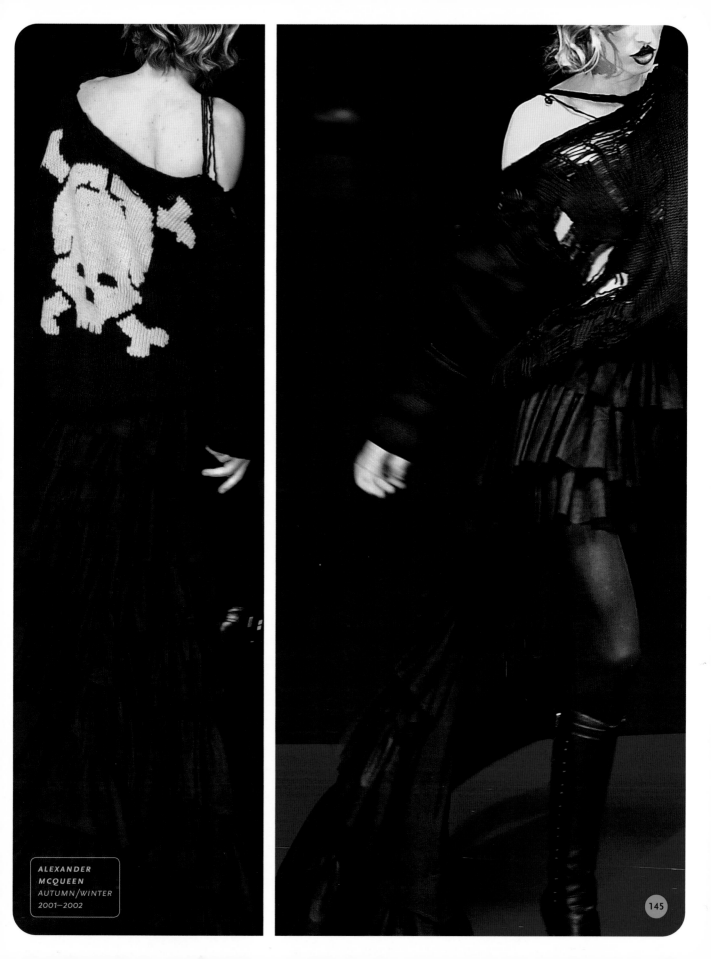

ALEXANDER
MCQUEEN
AUTUMN/WINTER
2001–2002

145

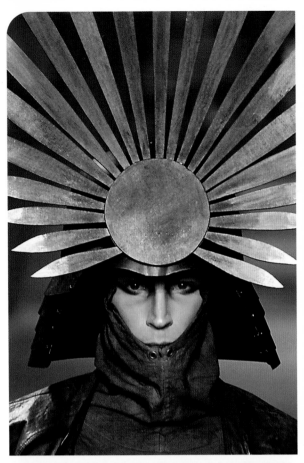

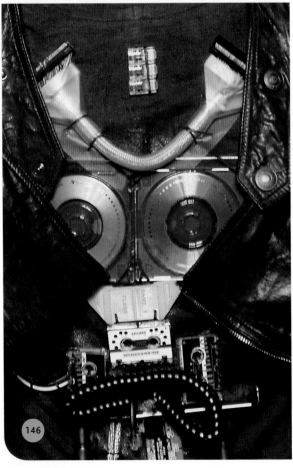

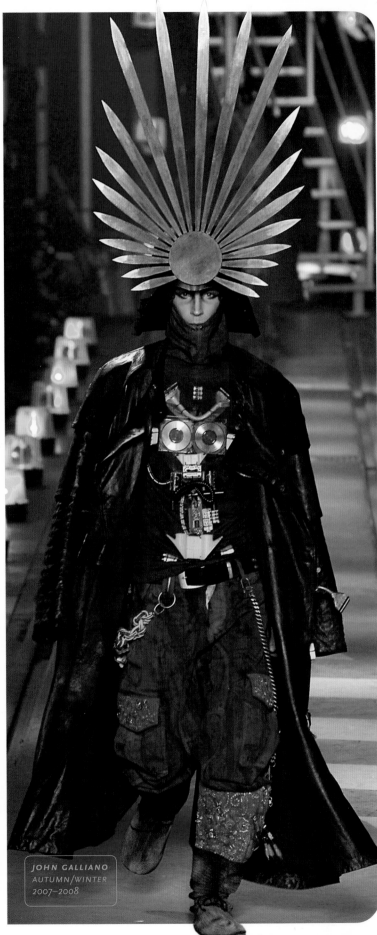

JOHN GALLIANO
AUTUMN/WINTER
2007–2008

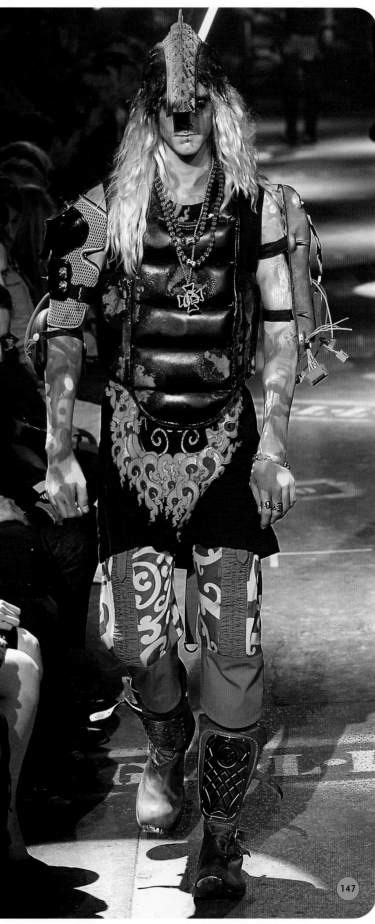

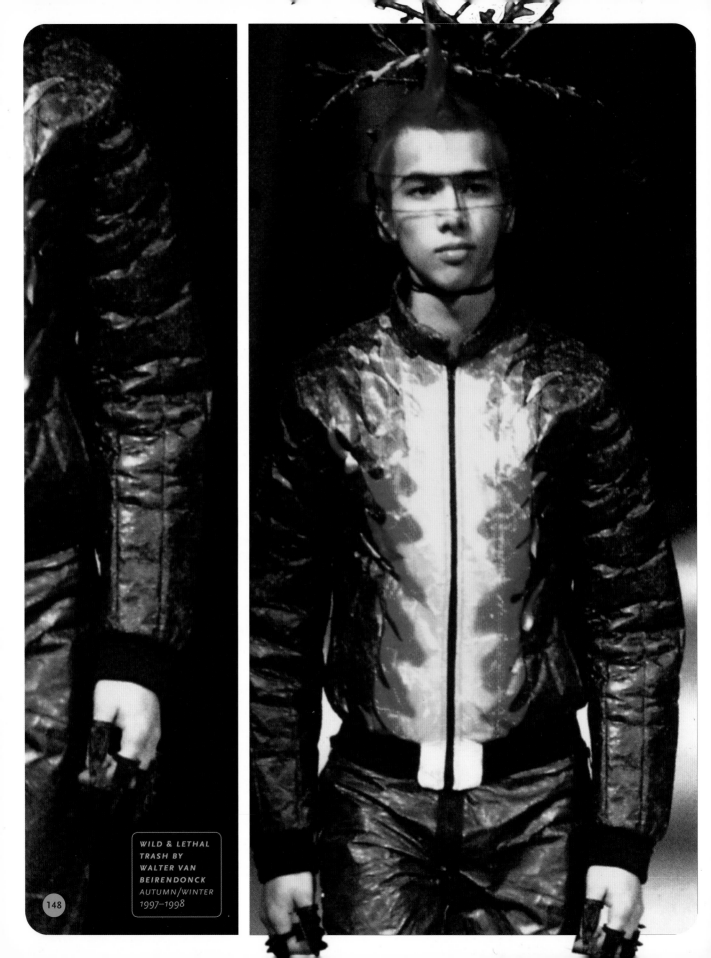

WILD & LETHAL
TRASH BY
WALTER VAN
BEIRENDONCK
AUTUMN/WINTER
1997–1998

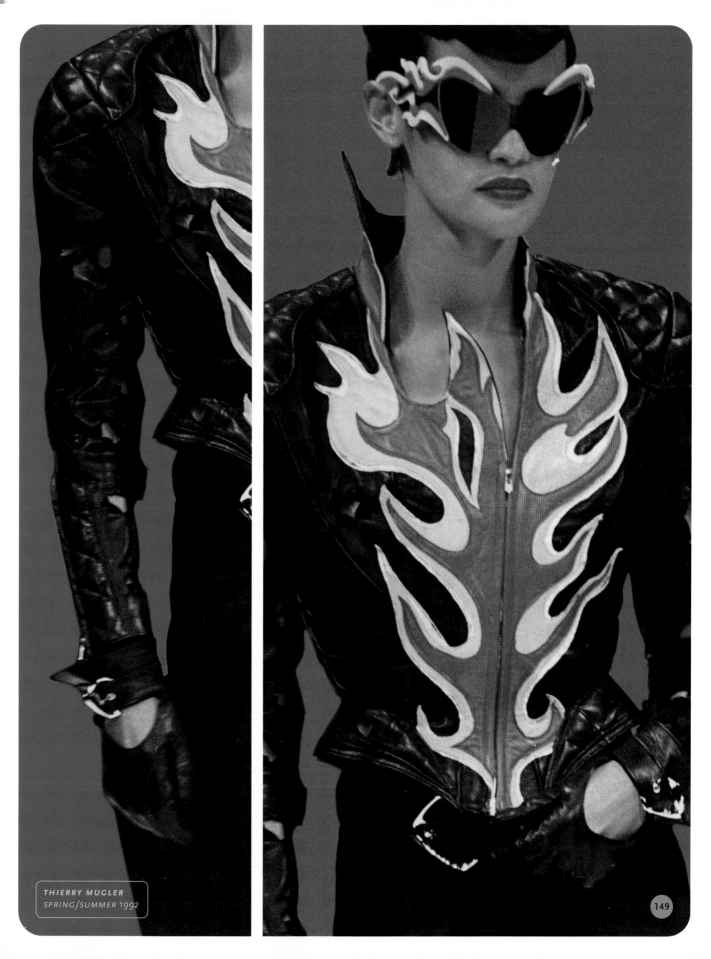

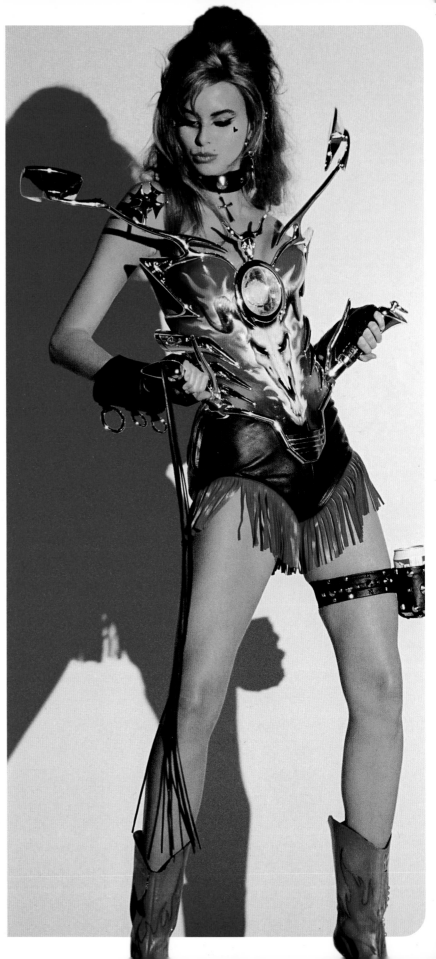

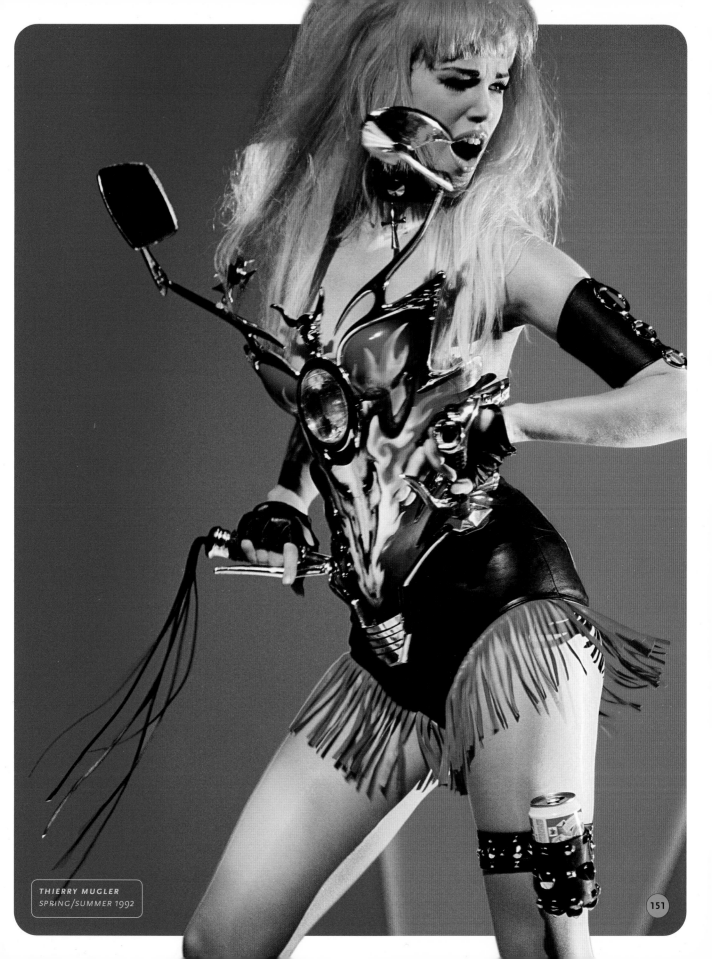

THIERRY MUGLER
SPRING/SUMMER 1992

151

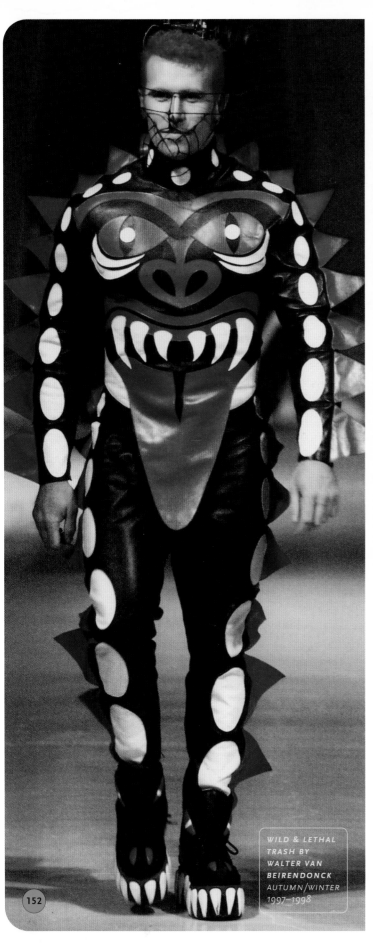

WILD & LETHAL
TRASH BY
WALTER VAN
BEIRENDONCK
AUTUMN/WINTER
1997–1998

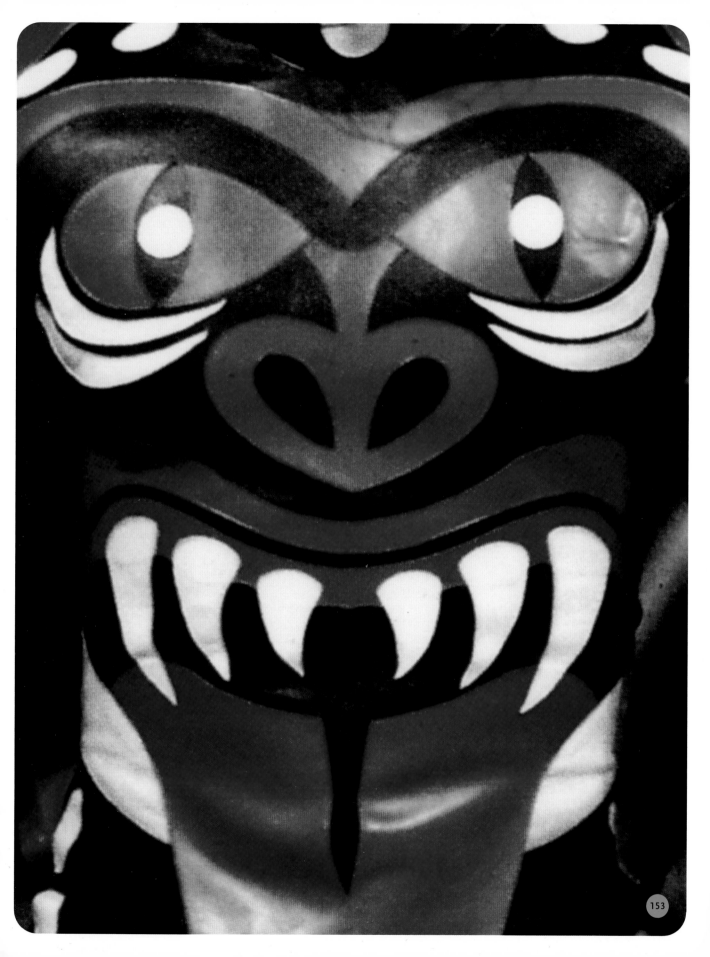

NOTES AND SELECT BIBLIOGRAPHY

NOTES

1. Principal Superman writer circa 1971.
2. So indispensable is the origin story that Steve Gerber created one of the most radical and disturbing Marvel heroes of the 1970s, Omega the Unknown, simply by refusing ever to provide one.
3. In this regard he or she is closer kin to the giant-killing clever fools and brave tailors of folklore than to Hercules or Samson.
4. This kind of thinking is typically more in the line of the supervillain.
5. A fixation that helps explain the disproportionately high price among collectors of number-one issues, and renders tedious the first acts of superhero film adaptations.
6. Watching as the Serpent Squad makes good its escape, Cap disgustedly tears the offending garment in half.
7. For *The Ghost Who Walks*.

SELECT BIBLIOGRAPHY

Apollonio, Umbro. *Futurist Manifestos*. London: Thames & Hudson, 1973.

Arnold, Rebecca. *Fashion, Desire and Anxiety: Image and Morality in the 20th Century*. London: I.B. Tauris, 2001.

Bolton, Andrew. *The Supermodern Wardrobe*. London: V&A Publications, 2002.

Boscagli, Maurizia. *Eye on the Flesh: Fashions of Masculinity in the Early Twentieth Century*. Boulder: Westview Press, 1996.

Bukatman, Scott. *Matters of Gravity: Special Effects and Supermen in the 20th Century*. Durham, N.C.: Duke University Press, 2003.

Colón, Suzan. *Catwoman: The Life and Times of a Feline Fatale*. San Francisco: Chronicle Books, 2003.

Coogan, Peter. *Superhero: The Secret Origin of a Genre*. Austin, Tex.: Monkey Brain Books, 2006.

Daniels, Les. *Superman: The Complete History*. San Francisco: Chronicle Books, 1998.

Daniels, Les. *Batman: The Complete History*. San Francisco: Chronicle Books, 1999.

Daniels, Les. *Wonder Woman: The Complete History*. San Francisco: Chronicle Books, 2000.

DC Comics. *Catwoman: Nine Lives of a Feline Fatale*. New York: DC Comics, 2004.

Dooley, Dennis, and Gary Engle, eds. *Superman at Fifty: The Persistence of a Legend*. Cleveland: Octavia Press, 1987.

Ellin, Nan, ed. *Architecture of Fear*. New York: Princeton Architectural Press, 1997.

Evans, Caroline. *Fashion at the Edge: Spectacle, Modernity and Deathliness*. New Haven: Yale University Press, 2003.

Fingeroth, Danny. *Superman on the Couch: What Superheroes Really Tell Us About Ourselves and Our Society*. New York: Continuum, 2004.

Galerie Enrico Navarra. *Le corps mutant*. Paris: Galerie Enrico Navarra, 2000.

Gresh, Lois, and Robert Weinberg. *The Science of Superheroes*. Hoboken, N.J.: J. Wiley, 2002.

Hayward Gallery. *Addressing the Century: 100 Years of Art & Fashion*. London: Hayward Gallery Publishing, 1998.

Klein, Alan M. *Little Big Men: Bodybuilding Subculture and Gender Construction*. Albany: State University of New York Press, 1993.

Koda, Harold. *Extreme Beauty: The Body Transformed*. New York: Metropolitan Museum of Art, 2001.

Lee, Suzanne. *Fashioning the Future: Tomorrow's Wardrobe*. London: Thames & Hudson, 2005.

Lupton, Ellen. *Skin: Surface, Substance + Design*. New York: Princeton Architectural Press, 2002.

Mancin, Marco. *Futurismo & Sport Design*. Cornuda: Edizioni Antiga, 2007.

O'Mahony, Marie. *Cyborg: The Man Machine*. London: Thames & Hudson, 2002.

O'Mahony, Marie, and Sarah E. Braddock. *SportsTech: Revolutionary Fabrics, Fashion and Design*. London: Thames & Hudson, 2002.

Quinn, Bradley. *Techno Fashion*. Oxford: Berg, 2002.

Reynolds, Richard. *Super Heroes: A Modern Mythology*. Jackson: University Press of Mississippi, 1994.

Robinson, Lillian S. *Wonder Women: Feminisms and Superheroes*. New York: Routledge, 2004.

Rosenberg, Robin S., ed. *The Psychology of Superheroes: An Unauthorized Exploration*. Dallas: BenBella Books, 2008.

Steele, Valerie. *Fetish: Fashion, Sex, and Power*. New York: Oxford University Press, 1996.

Wilk, Christopher, ed. *Modernism: Designing a New World, 1914–1939*. London: V&A Publications, 2006.

ACKNOWLEDGMENTS

I AM GRATEFUL to the many people who provided generous support for the exhibition "Superheroes: Fashion and Fantasy" and this associated publication. I am particularly fortunate to have had the advice and encouragement of Philippe de Montebello, director of The Metropolitan Museum of Art; Emily K. Rafferty, president of The Metropolitan Museum of Art; Nina McN. Diefenbach, vice president for Development and Membership; Harold Koda, curator in charge of The Costume Institute; Anna Wintour, editor in chief of American *Vogue*; and Giorgio Armani, who generously underwrote the exhibition and this publication. I also thank Condé Nast for providing additional financial support for both projects.

My sincerest appreciation goes to Nathan Crowley, creative consultant, and Shane Valentino for staging the exhibition's extraordinary scenography. Special thanks also go to Michael Batista and Sue Koch of the Design Department.

I also wish to thank, wholeheartedly, the staff of DC Comics, particularly Thomas King, Jay Kogan, Paul Levitz, Barbara Rich, and Cheryl Rubin; and the staff of Marvel Comics, especially Michael Chong, Jeremy Latcham, and Carol Pinkus. Without their generous advice and support, we would not have been able to realize either the exhibition or this publication.

The Editorial Department of The Metropolitan Museum of Art, under the guidance of John P. O'Neill, publisher and editor in chief, provided the expertise to make this book a reality, and it was managed under rigorous circumstances by Gwen Roginsky, General Manager of Publications. Special thanks go to Joan Holt for her astute editing skills, and to Margaret R. Chace, Mary Jo Mace, Paula Torres, and Chris Zichello. Special thanks also go to Abbott Miller at Pentagram, who, assisted by John Kudos, carried out the book's remarkable design.

My colleagues in The Costume Institute have been invaluable every step of the way. I extend my deepest gratitude to Verrinia Amatulli, Elizabeth Bryan, Carolina Bermudez, Elyssa Dimant, Michael Downer, Joyce Fung, Jessica Glasscock, Francesca Granata, Amanda Haskins, Anna Hodson, Stéphane Houy-Towner, Philis Kreitzman, Michelle Malone, Bethany Matia, Marci Morimoto, Tatyana Pakhladzyhan, Christine Paulocik, Shannon Price, Jessica Regan, Lisa Santandrea, Lita Semerad, Kristen Stewart, Yer Vang, and Kirsta Willis.

I would also like to express my sincere appreciation to the docents, interns, and volunteers of The Costume Institute, Ajiri Aki, Kitty Benton, Barbara Brickman, Jane Butler, Patricia Corbin, Eileen Ekstract, Betsy Kallop, Elizabeth Kehler, Susan Klein, Susan Lauren, Nina Libin, Joan Lufrano, Rena Lustberg, Butzi Moffitt, Doris Nathanson, Ellen Needham, Wendy Nolan, Julia Orron, Patricia Peterson, Christine Petschek, Phyllis Potter, Rena Schklowsky, Eleanor Schloss, Bernice Shafton, Nancy Silbert, Judith Sommer, Clark Sui, Andrea Vizcarrondo, Bernice Weinblatt, DJ White, and Sonja Wong.

For the ongoing support of Friends of The Costume Institute, co-chairs Cathryn Collins, Lauren Davis, and Patsy Tarr, and The Visiting Committee of The Costume Institute, I am especially grateful.

I would also like to thank colleagues from various departments at The Metropolitan Museum of Art for their assistance, including Pamela T. Barr, Kay Bearman, Linda Borsch, Einar Brendalen, Nancy C. Britton, Cindy Caplan, Nancy Chilton, Jennie Choi, Aileen K. Chuk, Clint Coller, Willa M. Cox, Cristina del Valle, Aimee Dixon, Jennifer Dodge, Michael Dominick, Helen Garfield, Andrew Gessner, Rebecca Gideon, Patricia Gilkison, Jessica Glass, Katie Holden, Harold Holzer, Edward Hunter, Marilyn Jensen, Andrea Kann, Hermes Knaur, Kerstin Larsen, Richard Lichte, Kristin M. MacDonald, Nina S. Maruca, Missy McHugh, Brigid Merriman, Taylor Miller, Mark Morosse, Herbert M. Moskowitz, Rebecca L. Murray, Chris Noey, Diana Pitt, Doralynn Pines, Lasley Steever Poe, Ashley Potter, Sabine Rewald, Tom Scally, Emilie Schlegel, Crayton Sohan, Linda Sylling, Elyse Topalian, Valerie Troyansky, Philip T. Venturino, Jenna Wainwright, Alexandra Walcott, Karin L. Willis, and Steve Zane.

I am extremely grateful to the lenders to the exhibition not only for their loans, but also for allowing me to reproduce their costumes in this catalogue. My thanks go to 20th Century Fox Studios (Victoria Snow), Alexander McQueen (Aiden Aldred, Preia Narendra), Atair Aerospace (Rick Zaccari), Balenciaga (Pierre Rougier, Lionel Vermeil), Bernhard Willhelm (Jonathan Moscatelli, Jutta Kraus), Christian Dior (Olivier Bialobos, Cyrille Borel, Soizic Pfaff), Dava J. Newman (Massachusetts Institute of Technology), Dolce & Gabbana (Lauren Clarke, Cara Forte), Eiko Ishioka (Tracy Roberts), Gareth Pugh (Abby Bennett, Mandi Lennard, Cathal O'Brien), Gianni Versace (Stacie Henderson), Giorgio Armani (Andrea Ciaraldi, George Kolasa, Rob Manley, Massimiliano Riboni, Robert Triefus), Jean Paul Gaultier (Lisa Lawrence, Mylène Lajoix, Jelka Music), John Galliano (Delli Avdali, Gerald Chevalier), Julien MacDonald (Alice Deen, Sara Forage, Hongyi Huang), Moschino (Lisa Lawrence, Sarah Monti), MoMu, Antwerp (Kaat Debo), Nike (Jacie Prieto), Pierre Cardin (Laurence Damoiseau, Jean Pascal Hesse), Rick Owens (Anne Van Den Bossche), Sony Pictures Entertainment (Colin Greene), Spectral Motion (Mike Elizalde, Robin Hatcher), SPEEDO (Carrie Grandits), Spyder (Erika Berg), Thierry Mugler (Carole Barlot, Joel, Palix, Tanya Pushkine Rojas, Jonathan Zrihen), threeASFOUR (Marie-Therese Francke), Walter Van Beirendonck, and Warner Bros. (Scott Gaba, Leith Adams, Lisa Perkins, Kristin Moffett).

I would also like to thank the following photo agencies and individuals for their prompt responses in obtaining images for the exhibition and this catalogue: Catwalking.com (Holly Daws, Maxine Miller, Zoe Roberts), firstVIEW.com (Lyndsay Black), JAVA Fashion Press Agency (Ludwig Bonnet), MCV Photo (Maria Valentino), Niall McInerney, and Studio Milpat (Patrice Stable).

Special thanks to Harry Bolton, Marion Bolton, Melissa Bolton, Hamish Bowles, Christopher Buczek, Deborah Cavanagh, Michael Chabon, Oriole Cullen, Fiona Da Rin, Alice Fleet, Shawn Hallinan, Tina Hammond, Bernice Kwok-Gabel, Deborah Landis, Stacey Lieberman, Kate Lindsay, John Myhre, Jana Nesbitt Gale, Patrick O'Connell, Bob Ringwood, Alex Ross, David Vincent, Mark Walsh, and Stephanie Winston.

PREFACE

P. 8 Brandon Routh in *Superman Returns*, 2006/SUPERMAN RETURNS © Warner Bros. Entertainment Inc./Courtesy Everett Collection

SECRET SKIN

P. 10 "Superman" #1 © 1939 DC Comics.

THE GRAPHIC BODY

P. 26 (clockwise from top left) Kirk Alyn in *Superman* (serial), 1948/SUPERMAN (1948) Courtesy of Warner Bros. Entertainment Inc. and DC Comics/Courtesy Everett Collection; "Action Comics" #63 © 1943 DC Comics; George Reeves in *Adventures of Superman*, 1952–58/ THE ADVENTURES OF SUPERMAN © DC Comics. Licensed by Warner Bros. Entertainment Inc. All Rights Reserved/Courtesy Everett Collection; "Action Comics" #63 © 1943 DC Comics; "Action Comics" #426 © 1973 DC Comics; **P. 27** (clockwise from top left) Brandon Routh in *Superman Returns*, 2006/SUPERMAN RETURNS © Warner Bros. Entertainment Inc./Courtesy Everett Collection; "Action Comics" #426 © 1973 DC Comics; Christopher Reeve in *Superman*, 1978/SUPERMAN: The Movie © Warner Bros. Entertainment Inc./Courtesy Everett Collection; "Action Comics" #222 © 1956 DC Comics; **P. 28** (clockwise from top left) Tobey Maguire in *Spider-Man 3*, 2007/© Columbia Pictures Industries, Inc. All Rights Reserved. MARVEL, and all Marvel characters including the Spider-Man, Sandman and Venom characters TM and © 2008 Marvel Characters, Inc. All Rights Reserved/Courtesy The Kobal Collection; "Amazing Fantasy" # 15 (1962) TM and © 2008 Marvel Characters, Inc. Used with permission; Tobey Maguire in *Spider-Man*, 2002/© 2002 Columbia Pictures Industries, Inc. All Rights Reserved. Spider-Man Character ® and © 2008 Marvel Characters, Inc. All Rights Reserved/Courtesy Everett Collection; "Amazing Spider-Man" #252 (1984) TM and © 2008 Marvel Characters, Inc. Used with permission; Tobey Maguire in *Spider-Man 3*, 2007/© Columbia Pictures Industries, Inc. All Rights Reserved. MARVEL, and all Marvel characters including the Spider-Man, Sandman and Venom characters TM and © 2008 Marvel Characters, Inc. All Rights Reserved. Courtesy of Columbia Pictures; "Amazing Spider-Man" #252 (1984) TM and © 2008 Marvel Characters, Inc. Used with permission; **P. 30** All courtesy of Chris Moore; **P. 31** All courtesy of firstVIEW; **P. 32** (left top and bottom) Courtesy of firstVIEW; (right) Courtesy of Chris Moore; **PP. 33–35** All courtesy of Chris Moore; **PP. 36–39** All courtesy of firstVIEW; **P. 40** (left) Courtesy of Chris Moore; (right top and bottom) Courtesy of firstVIEW; **P. 41** (left top, center and right top) All courtesy of Chris Moore; (right bottom) Courtesy of firstVIEW; **P. 42** © copyright Patrice Stable/Courtesy of John Galliano; **P. 43** Photograph by Jacques Olivar/Courtesy of Giorgio Armani; **P. 44** (left) Courtesy of firstVIEW; (right top and bottom) Courtesy of Chris Moore; **P. 45** Courtesy of Chris Moore

THE PATRIOTIC BODY

P. 48 (clockwise from top left) Lynda Carter in *Wonder Woman*, 1976–79/WONDER WOMAN © Warner Bros. Entertainment Inc. and DC Comics/Courtesy Everett Collection; "Sensation Comics" #1 © 1942 DC Comics; "Sensation Comics" #13 © 1943 DC Comics; "Sensation Comics" #13 © 1943 DC Comics; **P. 49** (clockwise from top left) "Wonder Woman" #178 © 1968 DC Comics; Lynda Carter in *Wonder Woman*, 1976–79/WONDER WOMAN © Warner Bros. Entertainment Inc. and DC Comics/ Courtesy Everett Collection; "Wonder Woman" #305 © 1983 DC Comics; **P. 50** (clockwise from top left) "Captain America and The Falcon" #180 (1974) TM and © 2008 Marvel Characters, Inc. Used with permission; "Captain America Comics" #1 (1941) TM and © 2008 Marvel Characters, Inc. Used with permission; "Captain America and The Falcon" #180 (1974) TM and © 2008 Marvel Characters, Inc. Used with permission; "Captain America" #13 (1942) TM and © 2008 Marvel Characters, Inc. Used with permission; Matt Salinger in *Captain America*, 1991/© 2008 Marvel Characters, Inc./ 21st Century Film Corporation/Marvel Enterprises/Courtesy Everett Collection; **P. 52** Courtesy of Chris Moore; **P. 53** (left top and bottom) Courtesy of Chris Moore; (right) Courtesy of firstVIEW; **PP. 54–55** Photographs by Maria Ziegelböck/Courtesy of Bernhard Willhelm; **P. 56** All courtesy of Chris Moore; **PP. 57–58** All courtesy of firstVIEW; **P. 59** Photograph by Anuschka Blommers and Niels Schumm/Courtesy of Viktor & Rolf; **P. 60** All courtesy of Chris Moore; **P. 61** All courtesy of firstVIEW; **P. 62** All courtesy of Chris Moore; **P. 63** All courtesy of firstVIEW

THE VIRILE BODY

P. 66 (clockwise from top left) "The Incredible Hulk" #2 (1962) TM and © 2008 Marvel Characters, Inc. Used with permission; Bill Bixby and Lou Ferrigno as Dr. David Banner/The Hulk in *The Incredible Hulk*, 1978–82/© Universal TV. © 2008 Marvel Characters, Inc./Courtesy of Photofest; "The Incredible Hulk" #2 (1962) TM and © 2008 Marvel Characters, Inc. Used with permission; Lou Ferrigno in *The Incredible Hulk*, 1978–82/© Universal TV. © 2008 Marvel Characters, Inc./Photo © Sunset Boulevard/Corbis; "The Incredible Hulk" #1 (1962) TM and © 2008 Marvel Characters, Inc. Used with permission; **P. 67** (clockwise from top left) *Hulk* with Eric Bana, 2003/© 2008 Marvel Characters, Inc./Universal/Courtesy Everett Collection; *Hulk* with Eric Bana, 2003/© 2008 Marvel Characters, Inc./Universal/Courtesy Everett Collection; "The Sensational She-Hulk" #1 (1989) TM and © 2008 Marvel Characters, Inc. Used with permission; "The Savage She-Hulk" #1 (1980) TM and © 2008 Marvel Characters, Inc. Used with permission; **P. 68** (clockwise from top left) "Fantastic Four" #25 (1964) TM and © 2008 Marvel Characters, Inc. Used with permission; "Fantastic Four" #51 (1966) TM and © 2008 Marvel Characters, Inc. Used with permission; Michael Chiklis as The Thing in *Fantastic Four*, 2005/© 2008 Marvel Characters, Inc./20th Century-Fox Film Corporation. Photo: Kerry Hayes/Courtesy of Photofest; "The Fantastic Four" #1 (1961) TM and © 2008 Marvel Characters, Inc. Used with permission; "The Thing" #1 (1983) TM and © 2008 Marvel Characters, Inc. Used with permission; **PP. 70–71** All courtesy of Walter Van Beirendonck archive; **PP. 72–73** All courtesy of firstVIEW; **PP. 74–75** All courtesy of Chris Moore; **PP. 76–77** All courtesy of firstVIEW; **PP. 78–79** (left) Courtesy of firstVIEW; (center, right top and bottom) All courtesy of Chris Moore

THE PARADOXICAL BODY

P. 82 (clockwise from top left) "Batman" #84 © 1954 DC Comics; "Catwoman" #1 © 1993 DC Comics; Julie Newmar in *Batman* (television series), 1966–67/TM and © DC Comics/20th Century Fox Film Corporation. All Rights Reserved/Courtesy Everett Collection; **P. 83** (clockwise from top left) "Superman's Girl Friend Lois Lane" #70 © 1966 DC Comics; Eartha Kitt in *Batman* (television series), 1967–68/TM and © DC Comics/20th Century Fox Film Corporation. All rights reserved/Courtesy Everett Collection; Michelle Pfeiffer in *Batman Returns*, 1992/BATMAN RETURNS © Warner Bros. Inc. All Rights Reserved/Courtesy Everett Collection; "Batman" #355 © 1983 DC Comics; **P. 84** (clockwise from top left) Lee Meriwether in *Batman*, 1966/TM and © DC Comics/20th Century Fox Film Corporation. All Rights Reserved/Courtesy Everett Collection; "Batman" #197 © 1967 DC Comics; Halle Berry in *Catwoman*, 2004/CATWOMAN © WV Films III LLC. ALL RIGHTS RESERVED. Photo: Doane Gregory/Courtesy Photofest; "Batman" #210 © 1969 DC Comics; **P. 86** All © copyright Patrice Stable; **P. 87** All courtesy of Chris Moore; **P. 88** All courtesy of firstVIEW; **P. 89** (left) Courtesy of firstVIEW; (right) Courtesy of Chris Moore; **P. 90** (left) Courtesy of Niall McInerney; (right) Photograph by Beppe Caggi/Courtesy of Versace; **P. 91** Courtesy of Niall McInerney; **P. 92** (left) Courtesy of Chris Moore; (right) Courtesy of firstVIEW; **P. 93** Courtesy of firstVIEW

THE ARMORED BODY

P. 96 (clockwise from top left) Michael Keaton in *Batman*, 1989/TM and © DC Comics/Warner Brothers/Courtesy Everett Collection; George Clooney in *Batman and Robin*, 1997/TM and © DC Comics/Warner Brothers/Courtesy Everett Collection; Adam West in *Batman* (television series), 1966–68/TM and © DC Comics/Fox/ABC/Courtesy The Kobal Collection; Val Kilmer in *Batman Forever*, 1995/TM and © DC Comics/Warner Brothers/Courtesy Everett Collection; "Detective Comics" #153 © 1949 DC Comics; **P. 97** (clockwise from top left) Christian Bale in *Batman Begins*, 2005/BATMAN BEGINS © Patalex III Productions Limited. Licensed by Warner Bros. Entertainment Inc. All Rights Reserved/Courtesy Everett Collection; detail from "Batman: The Dark Knight Returns" #1 © 1986 DC Comics; Christian Bale in *The Dark Knight*, 2008/ THE DARK KNIGHT © Warner Bros. Entertainment Inc. All Rights Reserved. Photo: Stephen Vaughan; Courtesy of Warner Bros; detail from "Batman: The Dark Knight Returns" #1 © 1986 DC Comics; **P. 98** (clockwise from top left) "Tales of Suspense" #42 (1963) TM and © 2008 Marvel Characters, Inc. Used with permission; "Tales of Suspense" #42 (1963) TM and © 2008 Marvel Characters, Inc. Used with permission; "The Invincible Iron Man" #1 (1968) TM and © 2008 Marvel Characters, Inc. Used with permission; "Tales of Suspense" #39 (1963)

TM and © 2008 Marvel Characters, Inc. Used with permission; Robert Downey Jr. in *Iron Man*, 2008/© 2008 MVLFFLLC. TM and © 2008 Marvel. All Rights Reserved. Photo: Jamie Bivers. Courtesy of Paramount Pictures; "The Invincible Iron Man" #1 (1968) TM and © 2008 Marvel Characters, Inc. Used with permission; **PP. 100–101** All © copyright Patrice Stable; **P. 102** (left top, center and bottom) © copyright Patrice Stable; (right) © Orban Thierry/Corbis Sygma; **P. 103** (left top and right) Courtesy of Chris Moore; (left bottom) Courtesy of firstVIEW; **PP. 104–105** Photographs by Yoshi Takata and Sergio Altieri. Elisabeth Längle, *Pierre Cardin: Fifty Years of Fashion and Design*, 2005; **P. 106** (left top) Courtesy of Chris Moore; (left bottom and right) Courtesy of firstVIEW; **P. 107** (left top and right) Courtesy of Chris Moore; (left bottom) Courtesy of firstVIEW; **P. 108** Photograph by Yoshi Takata and Sergio Altieri. Elisabeth Längle, *Pierre Cardin: Fifty Years of Fashion and Design*, 2005; **P. 109** Photograph by William Claxton/ Courtesy Demont Photo Management; **PP. 110–111** (left and right) Courtesy of Chris Moore; (center) Courtesy of firstVIEW

THE AERODYNAMIC BODY

P. 114 (clockwise from top left) John Wesley Shipp in *The Flash*, 1990/THE FLASH © Warner Bros. Inc. All Rights Reserved/Courtesy The Kobal Collection; "Flash Comics" #1 © 1940 DC Comics; "The Flash" #105 © 1959 DC Comics; John Wesley Shipp in *The Flash*, 1990/THE FLASH © Warner Bros. Inc. All Rights Reserved/Courtesy The Kobal Collection; "The Flash: The Fastest Man Alive" #1 © 2006 DC Comics; "The Flash" #1 © 1987 DC Comics; **PP. 116–117** All courtesy of Chris Moore; **P. 118** *W Magazine*, December 2002, "Chrysler presents The Line on Design" (A special advertising section); **P. 119** Olympic Speed Skater Jeremy Wotherspoon. Photograph by Mike Ridewood/Courtesy of Eiko Ishioka for Descente; **P. 120** Photograph by Steven Klein/Icon International; **P. 121** Olympic Swimmer Michael Phelps. Photograph by Michael Muller for Speedo; **PP. 122–123** Courtesy of Speedo; **PP. 124–125** All courtesy of Atair Aerospace, Inc.; **PP. 126–127** (far left, left, far right and right) All courtesy of Chris Moore; (center) Courtesy of firstVIEW

THE MUTANT BODY

P. 130 (clockwise from top left) "The X-Men" #1 (1963) TM and © 2008 Marvel Characters, Inc. Used with permission; Rebecca Romijn in *X-Men: The Last Stand*, 2006/© 2008 Marvel Characters, Inc./20th Century Fox Film Corporation. All Rights Reserved/Courtesy Everett Collection; "Mystique" #1 (2003) TM and © 2008 Marvel Characters, Inc. Used with permission; Shawn Ashmore, Ellen Page, Halle Berry, Daniel Cudmore, Hugh Jackman, Kelsey Grammer, James Marsden, Anna Paquin, Patrick Stewart, Ben Foster in *X-Men: The Last Stand*, 2006/© 2008 Marvel Characters, Inc./20th Century Fox Film Corporation. All Rights Reserved/Courtesy Everett Collection; "Giant-Size X-Men" #1 (1975) TM and © 2008 Marvel Characters, Inc. Used with permission; Kelsey Grammer in *X-Men: The Last Stand*, 2006/© 2008 Marvel Characters, Inc./20th Century Fox Film Corporation. All Rights Reserved/Courtesy Everett Collection; **PP. 132–133** All courtesy of Chris Moore; **PP. 134–136** All courtesy of threeASFOUR; **P. 137** (left top and right) © copyright Patrice Stable; (left bottom) Courtesy of Chris Moore; **P. 138** (left) © Orban Thierry/Corbis Sygma; (right top and bottom) © copyright Patrice Stable; **P. 139** All © copyright Patrice Stable

THE POSTMODERN BODY

P. 142 (clockwise from top left) Thomas Jane in *The Punisher*, 2004/© 2008 Marvel Characters, Inc./© 2003 Artisan Pictures Inc. All Rights Reserved/Courtesy Photofest; "The Punisher" #1 (1987) TM and © 2008 Marvel Characters, Inc. Used with permission; "The Punisher" #1 (1987) TM and © 2008 Marvel Characters, Inc. Used with permission; Nicholas Cage in *Ghost Rider*, 2007/© 2007 Columbia Pictures Industries, Inc. and GH One LLC. All Rights Reserved. Ghost Rider character TM and © 2008 Marvel Characters, Inc. All Rights Reserved/Courtesy of Columbia Pictures; "Ghost Rider" #1 (1973) TM and © 2008 Marvel Characters, Inc. Used with permission; "Ghost Rider" #1 (1973) TM and © 2008 Marvel Characters, Inc. Used with permission; **P. 144** All courtesy of Chris Moore; **P. 145** (left) Courtesy of firstVIEW; (right) Courtesy of Chris Moore; **PP. 146–147** All courtesy of Chris Moore; **P. 148** Courtesy of Walter Van Beirendonck archive; **P. 149** Photograph by Piero Cristaldi. GAP Japan Co., *Collections*, Spring/Summer 1992; **PP. 150–151** All © copyright Patrice Stable; **PP. 152–153** All courtesy of Walter Van Beirendonck archive